ON ASSIGNMENT
Projects in Photojournalism

ON ASSIGNMENT
Projects in Photojournalism

BY TONY SPINA

AMPHOTO
American Photographic Book Publishing
An Imprint of Watson-Guptill Publications
New York, New York

Copyright © 1982 by Tony Spina.

First published in New York, New York by American Photographic
Book Publishing: an imprint of Watson-Guptill Publications, a
division of Billboard Publications, Inc., 1515 Broadway, New
York, NY 10036.

Library of Congress Cataloging in Publication Data

Spina, Tony.
 On assignment, projects in photojournalism.

 Includes index.
 1. Photography, Journalistic. I. Title.
TR820.S678 1982 778.9'907 82-13831
ISBN 0-8174-5275-3

Manufactured in U.S.A.

First Printing, 1982
1 2 3 4 5 6 7 8 9 10/87 86 85 84 83 82

To my wife
Frances
for her constant
thoughtfulness,
encouragement, and
assistance during the
making of this book

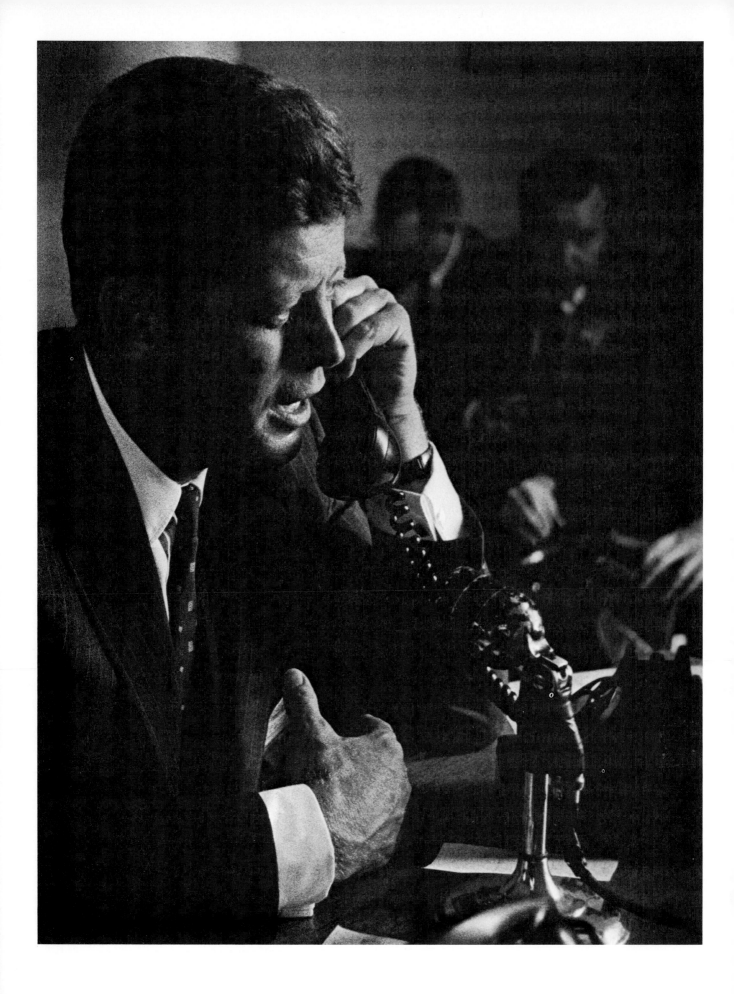

Contents

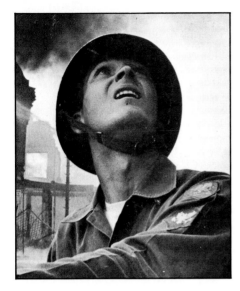
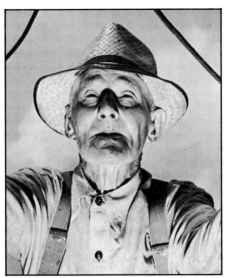

Introduction

Photojournalism can mean different things to different people. For some, photojournalism refers only to major newsworthy events. For others, it refers to photos that accompany a news story. But for me photojournalism involves all aspects of life and experience that can evoke a human response through the medium of the camera. It necessitates a love of people and a love of current events. It also means that I am a photo-reporter, a visual communicator who records history with a camera—capturing events in a photograph that often is remembered more easily than the words written about them.

Today's photojournalist has to be well disciplined because every section of the paper is equally important and must have visual display. The photojournalist has to be able to cover all types of assignments, from the chef of the day to the breaking news story, from sports to social events. Even one-column-type head shots are important. The photographer must utilize creative talents when shooting any assignment, from the simple head shot to the spectacular breaking news stories. The photojournalist who does a good job on all of the various assignments, from the least important to the very important, is a well-disciplined photographer. The good photojournalist is a thinker and understands the meanings beneath appearances, one who tries first to see things as they are and then to photograph them that way. Honesty and truthfulness are important, because the credibility of the paper depends on displaying these qualities. The photographer must capture the significant meanings as they present themselves and express those meanings in the photographs. There is no formula for that—it comes from experience.

I try to give a realistic impression of the events or subjects as I see them. My first impressions are usually what I prefer to record, because after I look at something for a while, I no longer see it as I first did. I will develop a new impression, which may lack the spontaneity and insight of the first. My mind is trained, and when entering a room I automatically notice the source of light, how many windows there are and which is the best place to be in to take the pictures. It could be a press conference, a board meeting of some kind, or just an office. Instantly, you should know whether you need extra light or can go with the existing light. Many times when leaving a very important press conference, the reporter would ask me to describe the layout of the room. I would be able to tell him the number of windows, color of the room and approximately the size. A photojournalist sees more than any other person, because he is trained to observe and to anticipate events.

As I walk or drive, or even ride a bus, I watch the surroundings. I look at the design and lines (horizontal or vertical) of buildings and at how people walk and what they wear. These mental exercises are good training for my mind in thinking quickly during assignments.

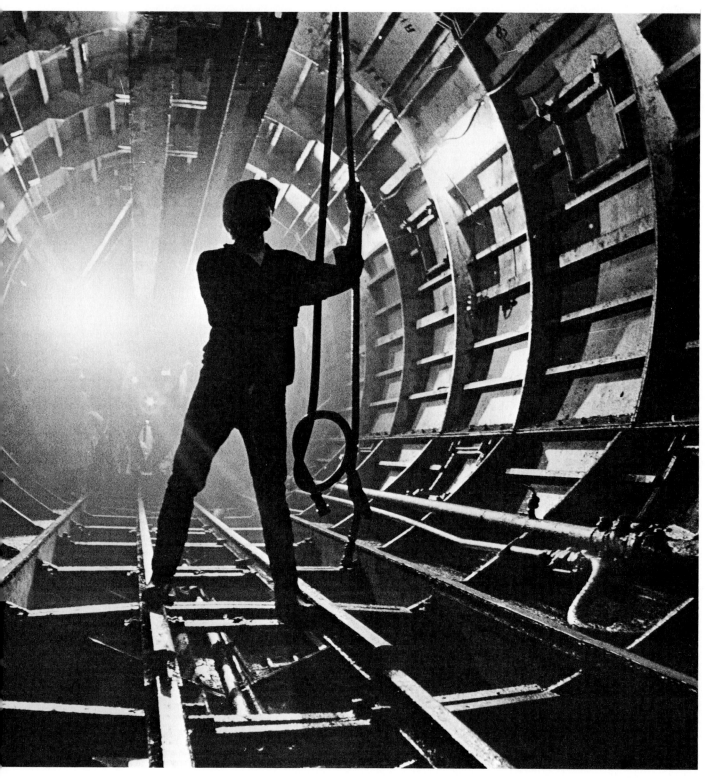

Excavation in a tunnel provided an interesting composition. I used a 15mm lens to include as much as possible of the area.

Types of Assignments

In this chapter I will talk about the news pictures, feature pictures, sports pictures, and photo stories that are routine for a photojournalist. The newspaper must have pictures on page one, women's section, feature section, sports section, and the back page, which is usually a photo story. Every photojournalist is expected to get at least two of these assignments every day. There is also the living section, with its interiors and exteriors of new and old homes. Although most photographers like to avoid these assignments, they had better be able to do them, because sooner or later they're going to get one if they are working on a metropolitan daily or even a weekly.

A photojournalist has to be concerned about how the picture will be used in the paper. Space between subjects is one of the major problems photographers face. They have to get photographs of people with the minimum of space between them. If the picture involves two people—for instance, at a presentation or a handshake (cliché shots)—there must be no lost space between them. The constant cry from editors echoes that old saying, "Get those heads close together." If two people are far apart, with over 50 percent lost space in the center, the chances are that the picture will never run in the paper. This is where the photojournalist has to be creative and find a way to compose the shot so that the picture is filled with content. Many newspapers today avoid the typical handshake pictures, and instead get a photograph of the awardee, or winner, doing something in his or her line of work. Many times, the photographer comes up with good suggestions and takes the person outside or moves in for a picture of either his wife, mother, or friend giving the awardee a hug or kiss. This is the human element that the editor likes. If, at times, it is impossible to get the person to go for a picture at a special place, get a good head shot of him or her to be on the safe side in the event the paper decides that the handshake didn't work. Always cover yourself with a backup shot. Remember that columns run up and down, not across, the page.

Equipment

The photojournalist is always asked which camera is the best to use on various assignments. There isn't one answer to that question. In most newspaper and magazine photo departments one will invariably find, for example, the 8×10 view, the 4×5, and the 35mm cameras for studio shots, which might be still life, clothes, models, fashions, food, interviews, or routine head shots. The wise photojournalist had better be able to operate all of the cameras. For food pictures, some editors require that pictures be taken with the 8×10; some don't care about the camera the photographer uses, providing the final result is what they want. I use them all. To me it's important to pick the right camera for the assignment. If I feel that the best result would be with the 8×10 for a special food illustration, where I can correct for distortion, I will choose the 8×10 or the 4×5 for the illustration.

To narrow it down, the 35mm cameras have now become standard equipment in most photo department operations. I'm not saying that if you use the 35mm camera you will automatically produce good pictures. The need for know-how still remains. Your

(opposite) A child in Tunisia, busy with her afternoon chore. The traditional life style, in contrast to Western ways, is very evident here.

interpretation and approach to the subject will have a lot to do with your success or failure. Every photographer thinks a little differently while making a picture. Select the camera of your choice because you feel competent with that equipment and also know that the camera can produce a satisfactory end result. What counts is the photograph you deliver to your editor.

A photojournalist should master all cameras and techniques, not just the 35mm camera. Make every effort to keep up with day-to-day advancements in camera technology. The minimum demanded of a photojournalist is craftsmanship and good thinking. I do not want to suggest that you should become overinvolved in technical matters, but you should keep abreast of all technical developments. I would like to say here that you can produce a photograph that is technically perfect and yet it can fail in creativity and composition. The editor may tell you to hang it on your wall. So we always come back to good thinking; creating a photograph with good content, impact, and excellent composition is the key to being a successful photojournalist.

How and What to Shoot

The more we learn about photography, the greater becomes our respect for it. Before pressing the shutter, the truly good photographer knows that the thought, imagination, and human feeling called upon will make the picture a proud example of craftsmanship. Many of us previsualize the shot in terms of subject matter, camera position, and light source. We do this in a matter of seconds, just before clicking the shutter. Carry out your impulses and make every attempt to translate your ideas on film. When you have a good idea for a picture and want to discuss it with someone, tell the picture editor about it. Don't make the mistake of asking other photographers what they think about the idea, because they may inject some of their own thoughts and completely destroy your original idea of the picture.

Everyone likes candid pictures. I certainly do. There are times, however, when working for a daily newspaper, that you have no choice but to pose the person or persons for the picture that is needed. This will take ingenuity to improve what often might be a dull subject. You have to make a sincere effort to obtain the candid look but must be realistic at the same time. If you are sent out to get a picture of several specific people and are told to keep it down to a two-column shot with both of them in the one picture, you have to make every effort to get that shot. When you arrive at the place you might discover that your subjects are scattered all over the room. You'll have to round them together and pose them for a tight shot. It could be for feature story, and a candid picture just can't be done because they may be doing absolutely nothing but just sitting there. It is here that you have to use your keen eye, imagination, and creativity to come up with something good. You can't go back without the pictures and tell the editor that they were not sitting together and that you couldn't get the shot. You may get away with that excuse sometimes. Editors know the importance of good candids; they like to use them when they can. But the good editor also knows when an experienced photojournalist has to pose a picture. These kinds of pictures do not satisfy either

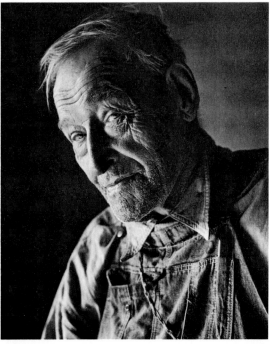

A routine assignment to photograph Fred Hasse, whose barn had burned down, became an illustration of the pathos of his situation. (**below**) The background graphically explains his plight, as well as contributes to the composition of the photo. (**right**) Taken indoors with an 85mm lens and using light from a window, this head shot is an insightful portrait.

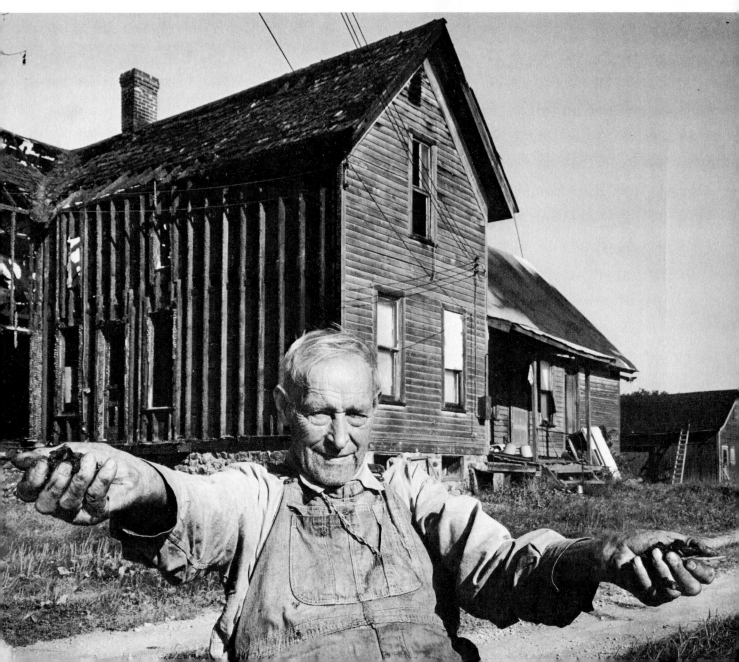

the photographer or the editor. They serve as subject identification. It is in this type of situation that the photojournalist should try to produce an interesting picture, not one that is merely acceptable. It is also here that you separate the thinkers from the nonthinkers.

Today's photojournalist is an important person within the newspaper organization—a visual reporter, an artist with a camera, and a recorder of historical events. Imaginative photojournalism has a hard, competitive job to do right now. The still picture must be better than ever, so that newspapers and magazines can be made better than ever. Pictures move on television, and that is an advantage newspapers must overcome just by being better, by crowding the impact and drama of the news into the still picture.

Darkroom Technique and Editing

Producing a good-quality print is as important as taking the picture. The shot is usually taken with the highest degree of skill possible in the situation. Using the camera, you can manipulate light only in a crude way, by letting more or less of it through the lens. You cannot hold back, dodge corners of the frame, or expose a dim corner, as is possible in the darkroom. When shooting the picture you can use all of the technical approaches possible to obtain the best evenly exposed negative. Now, that same amount of care has to be taken in the darkroom when making the final print. This is where the printing ability of the photographer enters into the process. I know many photojournalists who have not spent an apprenticeship in a darkroom, who see picture taking only in terms of cameras, and lenses. Believe me, good-quality prints are very important in order to ensure satisfactory reproductions in the paper. The print is the end product and should contain all the elements of technique and perfection of the photojournalist. If you don't know how to make good-quality prints, get in there and learn.

Many editors feel that when a photojournalist is given the right kind of equipment and the proper training, the results should be uniform. This is not the case, obviously. Photography is not only a craft, it is also high art. Even when photographers are given the same kind of equipment there will be different results because the thinking and the approach to the subject vary with each individual photographer.

Once the story is recorded on film, the next step is the lab work and selection. If I do a photo story, I prefer to make contact sheets to use for selection, time permitting. There are times when deadlines are near and selections must by made just by viewing the negatives through a loupe and notching the best shots. If your paper has a lab person to do the inside work, fine, but you or the picture editor should make the final selection.

The best way to start viewing a set of contact sheets is at arm's length. You can immediately tell some of your best shots, then move in with a magnifier to select good sharp negatives. After your prime selections, go over the entire set again. You may have missed a good shot. Now that you have taken the pictures, it is time for picture making in the darkroom. If the picture needs cropping, use a red marking pencil on the contact sheet as a guide for the printer. Cropping the picture is as important as shooting it. At

times you are limited when taking a picture and have to do the best you can under the circumstances. Perhaps you cannot fill the frame, or you see the picture as horizontal and have to make it vertical. Cropping gives you some flexibility.

There are times when a photojournalist does not like to make contacts, but they are demanded by the picture editor. Contacts give some indication as to whether the photographer is a clean or a sloppy shooter, and how versatile he or she is within the subject matter. From contacts the editor can evaluate the photographer's work. This is the best way to pick out the best pictures from the lot and permit the editor to judge quality, sharpness, and content all in one step. It also shows how the pictures should be cropped. The contact sheet is especially important in selecting the best frame in action shots. Since the entire roll of film is laid out on the contact sheet, it shows the good and the bad shots, the embarrassing moments such as out-of-focus and general run-of-the-mill shots that anyone could take, pictures with no imagination.

Naturally, there is a talent to reading contact sheets. I know of superb photographers who refuse to make contacts but can look at a developed roll of film and instantly know the best shots just by viewing the negatives through a magnifier. That is fine when you're on deadline, but it is a shameful waste because the best pictures could be lost forever in some frame that was overlooked.

Backlighting results in a silhouette effect. Choose a pleasing outline and expose for the sky. I used a 180mm lens, so that I could stay far enough away not to disturb the birds, and an exposure of 1/250 sec. at **f**/8 on Tri-X film.

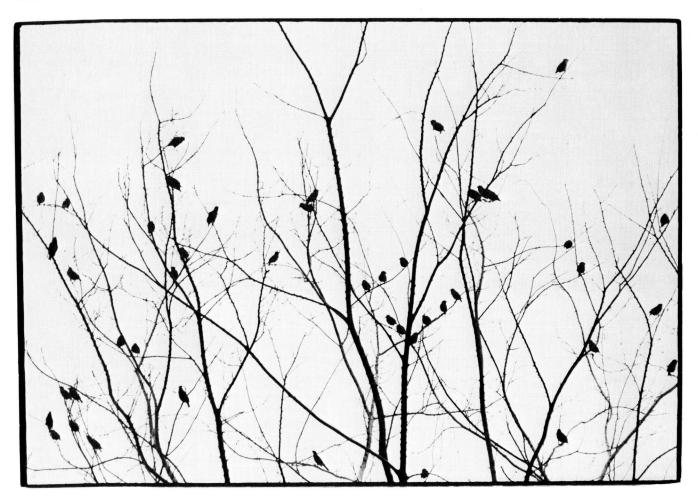

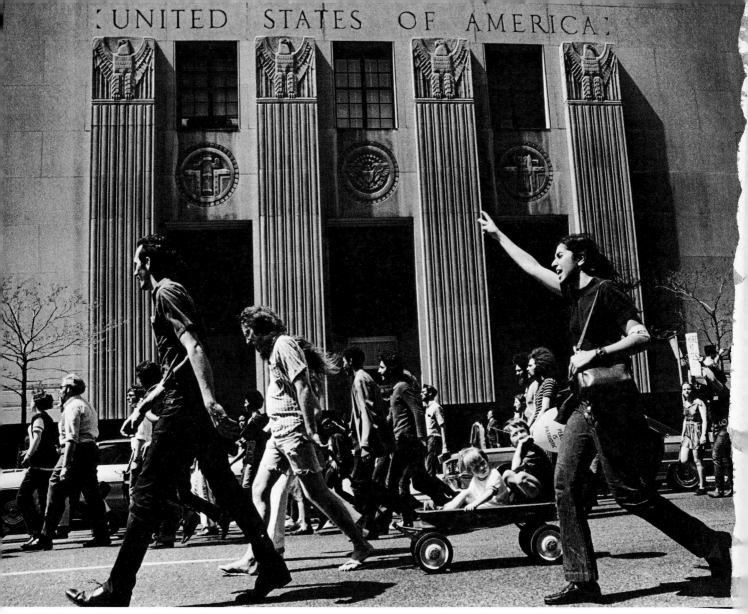

Protestors against the Vietnam War marching around the Federal Building in Detroit. I used a 15mm lens and shot with the camera at street level, tilted up slightly. Focus was preset at 15 feet.

COVERING THE NEWS

The Presidents

As a photojournalist, I consider presidential assignments the paragon of all photo assignments. They are usually given to a photographer with experience and know-how, because there can't be any slip-ups in this kind of coverage. Competition is always present, for every news medium covers the president's visit. The photographer must be on top of the situation at all times during this special assignment. He must be ready to capture on film every precious moment, and be ready for any emergency that may happen without advance warning.

Preparation

Before you have access to photograph a president, you must have Secret Service clearance. This means submitting name, social security number, place of birth, and date of birth at least five days before the president's visit. Photo coverage of a president is restricted to the press. Freelancers have a difficult time getting clearance unless they are temporarily employed by a magazine or newspaper for specific coverage. Then the company has to make the request for the photographer on company stationery.

The Secret Service issues directives over the wire services to both AP and UPI, detailing when and where to pick up the working press credentials. They are given out to the individual photographers after positive identification. The credentials are for designated areas. The Secret Service usually tries to grant credentials for the area that is requested, but we have to be satisfied with what we get. There is always a pool set up by the Secret Service that will allow us in a special area close to the president. They choose the photographers who are going to be in a "photo pool," a group of five or eight photographers. Sometimes they try to accommodate all of the photographers for close-up pictures of the president. They will escort about four photographers at a time in front, for about three minutes, thereby permitting them to get some photos at close range. We must obey the rules set up by them. When they say "that's it," they mean it. We must move, with no chance for just "one more."

We also must be there at least one hour before the president's arrival. This gives the Secret Service time to check the camera equipment and direct us to the place we are assigned. The area is then sealed off and we have to stay there until the president leaves. There are special privileges given to certain publications for a photographer to travel with the president during his visit. This order usually comes from the president himself.

A Personal View

Of the eight presidents I've photographed, I've known five on a personal basis: John F. Kennedy, Richard Nixon, Lyndon Johnson, Gerald Ford, and Jimmy Carter. Many of my photographs were personally requested by them. This honor was obtained not because I am a newspaper photographer, but because honesty, dedi-

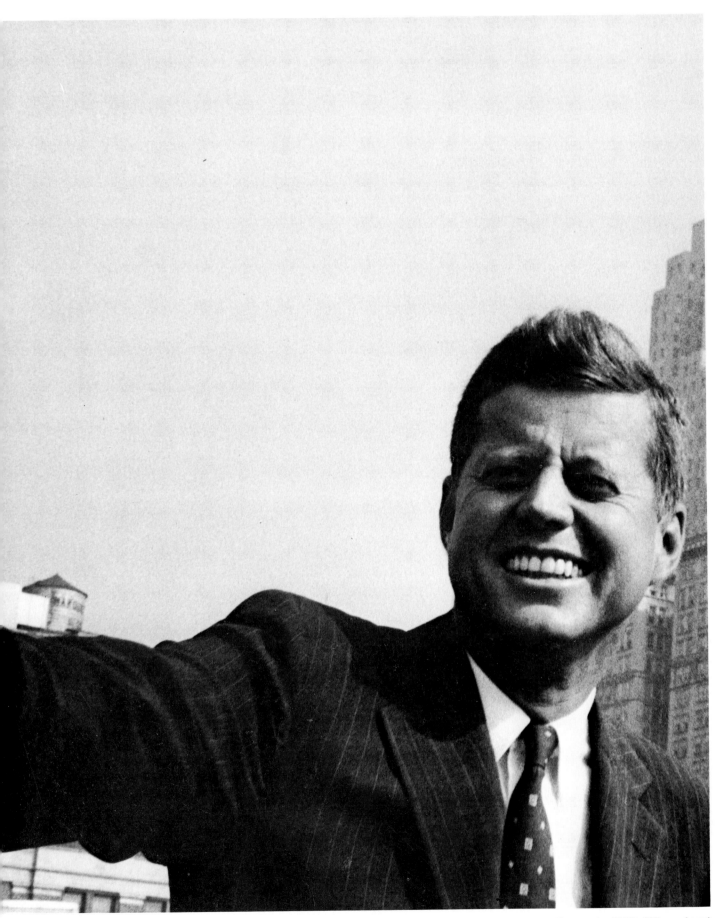

President John Kennedy on a visit to Detroit in 1962. (35mm lens)

cation, thoughtfulness, sensitivity, creativity, and great admiration for them went into every photograph that I have taken of the presidents. I have always had a gentle approach, with a warm sense of values. Regardless of the party affiliation, I've had respect toward the office of the president. I have always approached the president with the firm feeling that he was "my" president, and what a great privilege it was for me to be able to contribute a photographic record for posterity. I have had a positive approach, never negative toward them.

I am very proud to show you some of my favorite photographs of the presidents . . . from Truman to Reagan, with a brief comment on each.

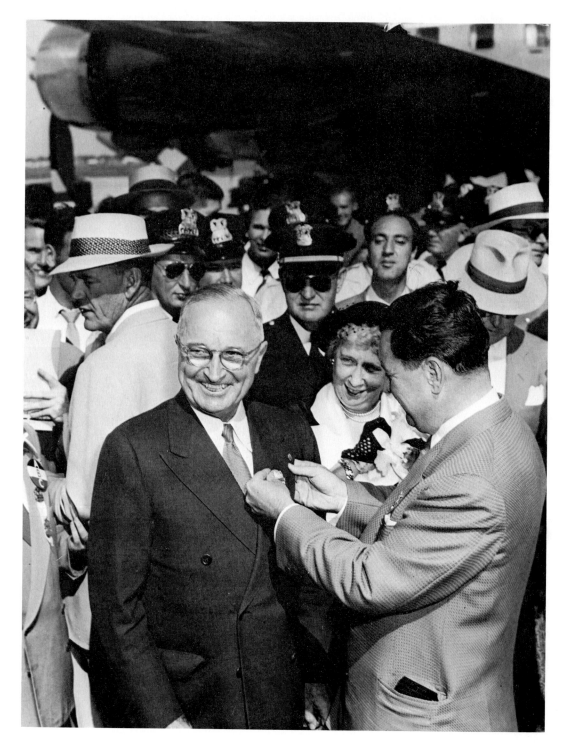

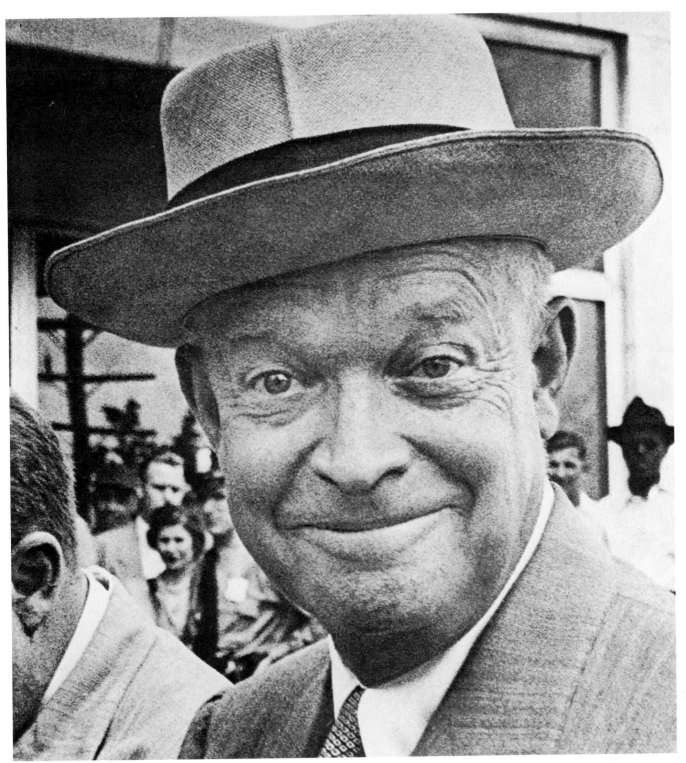

A rare view of President Eisenhower wearing a hat. The graininess of the print enhances the effect and emphasizes his genial expression. I used a Nikon SP camera with 50mm lens and Tri-X film.

(**opposite**) President Harry S Truman arriving at the 1952 Democratic National Convention in Chicago. This photograph was taken with a 4 × 5 Speed Graphic camera with normal (50mm) lens in available light.

President Dwight D. Eisenhower campaigning in Detroit in 1956. I was in a vehicle in front of the President's car, going at the same speed. This was my first venture into panoramic photography. I used a Panon 120 camera, which has eight pictures on one roll of 120 film.

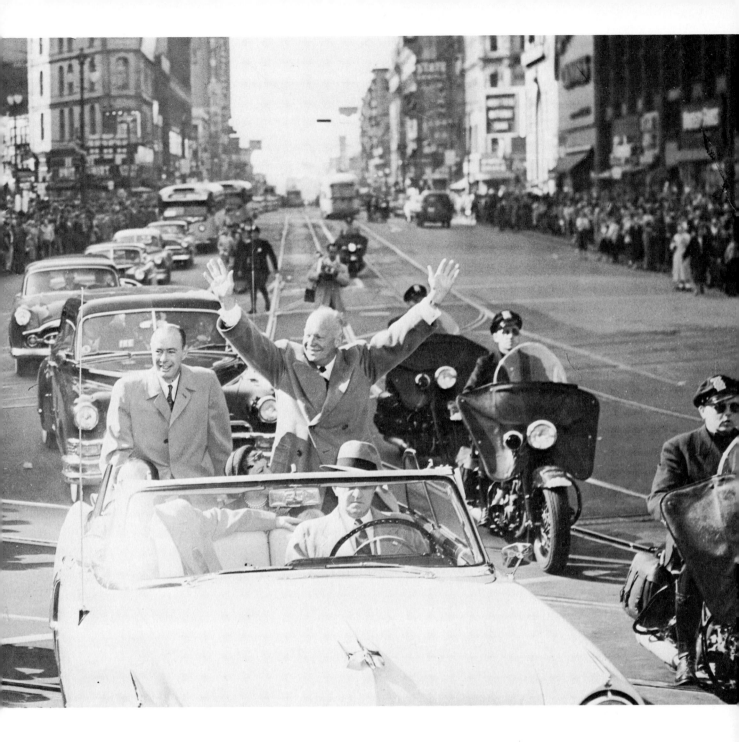

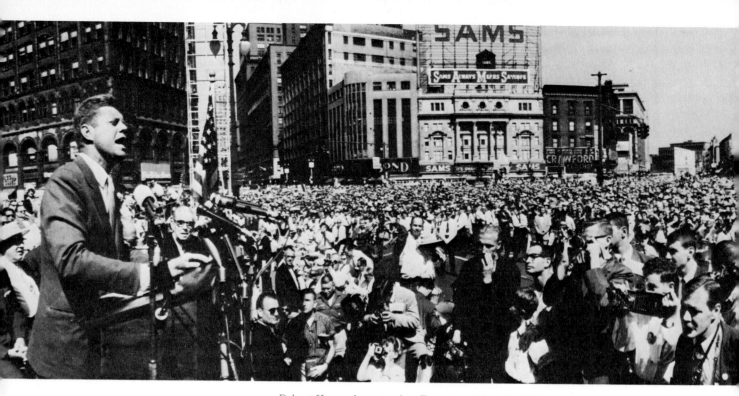

Robert Kennedy arrived in Detroit on May 15, 1968 to campaign for the presidency. Eight years earlier, John Kennedy had been in the same place doing the same thing. Recognizing this parallel, I wanted to try to express it visually—in a composite photo. I printed a picture taken of JFK speaking in the Square so that I would have a clear idea of one half of the composite photograph. I had used the Widelux camera, which covers an angle of 140 degrees. For the shot of RFK, I used the same camera at the same elevation. I then fused the two pictures in one print. As you can see, the seam in the center is almost invisible.

The **Free Press** ran this photograph after Robert Kennedy's assassination two weeks later. It covered 16 columns across two pages, the largest photo ever published in the paper. The parallel I had illustrated took on tragic significance. There was tremendous reader response, and as a public service the paper printed fifty thousand copies, 15 × 6 inches on high-quality paper, and distributed them for a nominal fee of 35 cents.

(**opposite**) President Kennedy with his proud and happy mother, Rose. The Kennedys have always been known as a close family. (85mm lens)

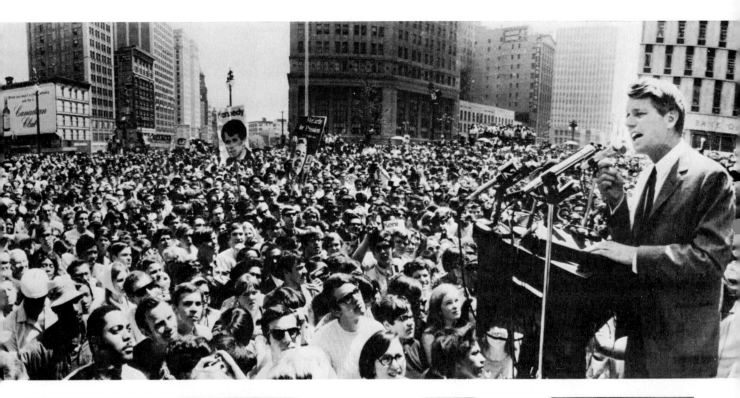

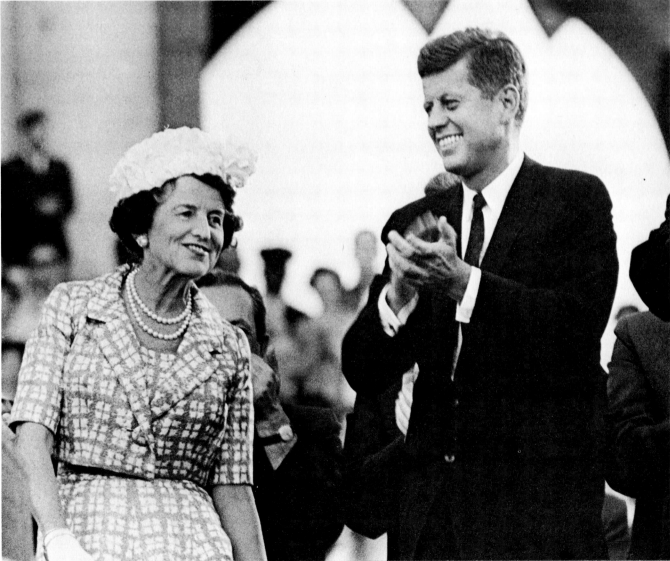

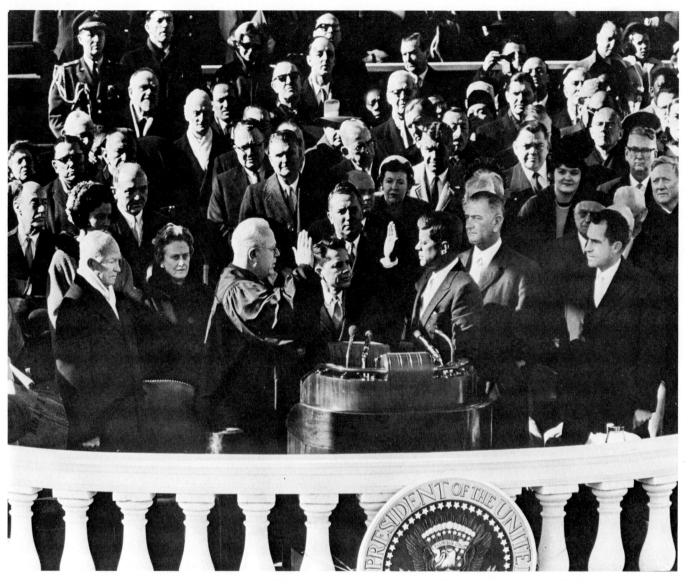

John F. Kennedy taking the oath of office from Chief Justice Earl Warren on January 20, 1961. This picture is prized because it includes four men who are or would be president: outgoing President Eisenhower; incoming President Kennedy; Lyndon Johnson, incoming vice-president who would be the thirty-sixth president; and outgoing vice-president Richard Nixon, who would be the thirty-seventh president.

President and Mrs. Johnson and Vice-President Humphrey applaud a group of marchers from Texas after the President's inauguration on January 20, 1965. The presidential seal overlooks all and is an important element of composition in this photograph. I used a 180mm lens from street level, shooting up at the reviewing stand. A polarizing filter helped to eliminate reflections from the plate glass in front of the stand.

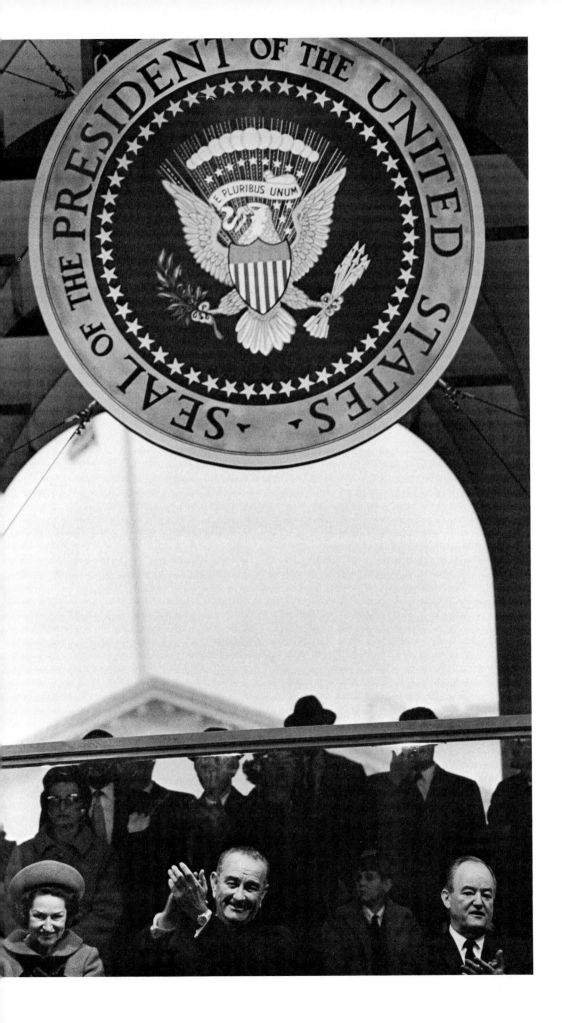

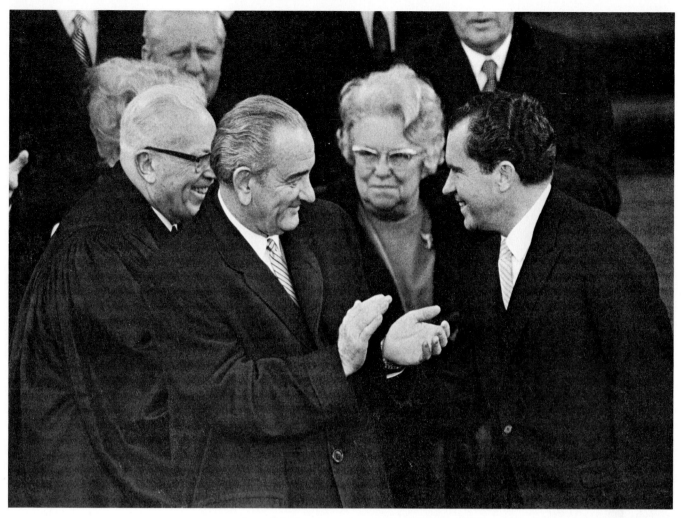

I caught a happy moment after President Richard Nixon took the oath of office, as he was being congratulated by outgoing President Johnson and Chief Justice Warren. I was quite a distance away and therefore used a 400mm lens.

(**opposite**) President and Mrs. Ford arriving in Michigan on a rainy afternoon. I caught them debarking from the plane, called "Spirit of '76," and included the plane's name as an element in the picture.

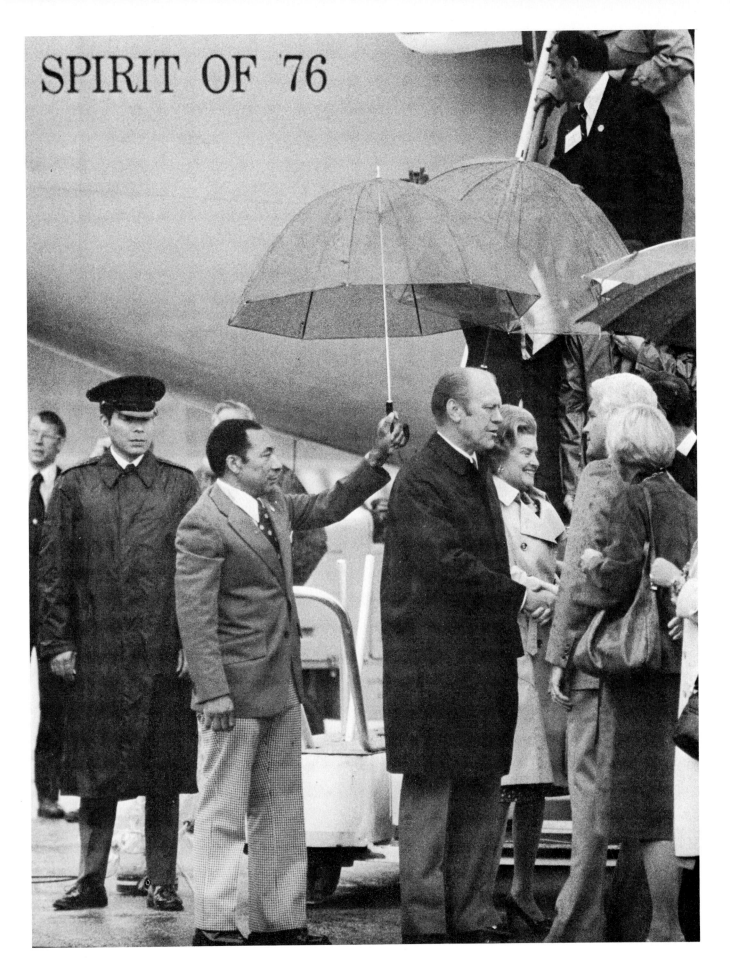

SPIRIT OF '76

Taken after President Jimmy Carter's inauguration, this photo expressed the feeling of the day—hands reaching out and the President, the only element in focus, returning the handclasps.

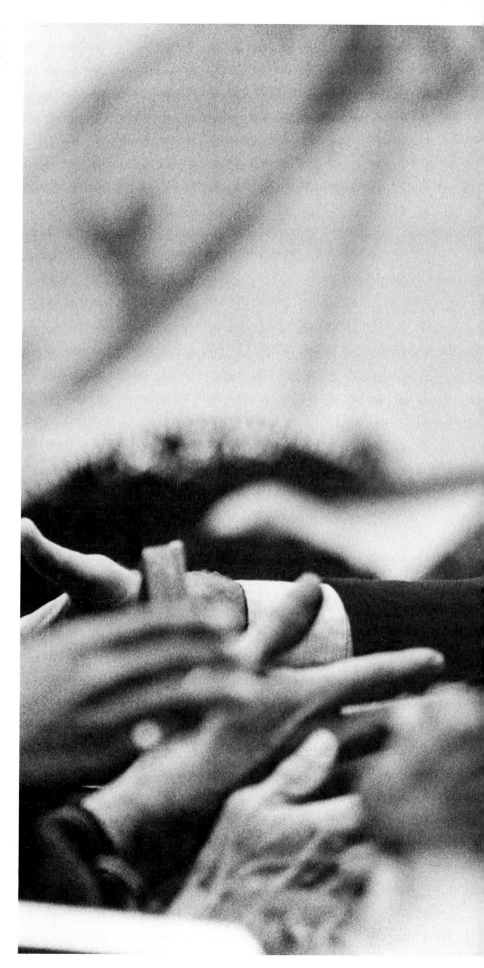

30

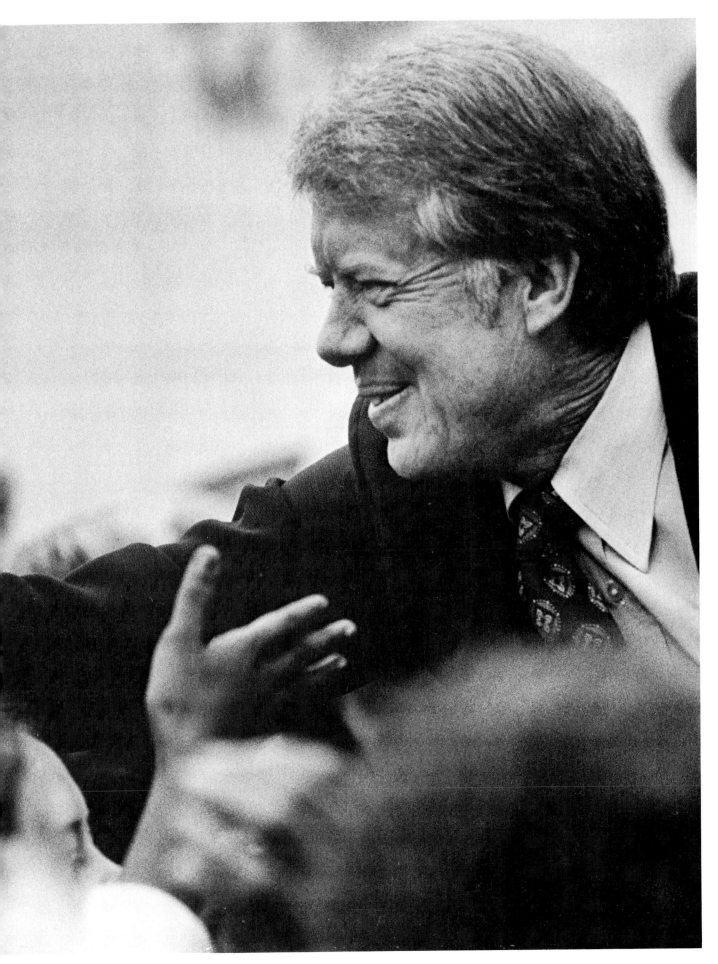

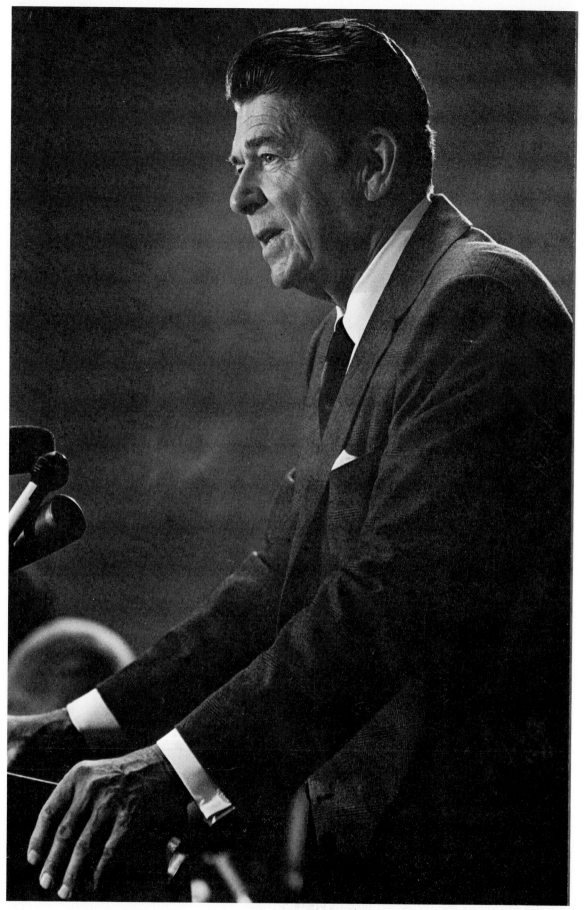

The fortieth President of the United States, Ronald Reagan.

Busing

ASSIGNMENT: Call from city desk at 4:00 A.M. to cover breaking story of buses burned in Pontiac.

I am sure we are all aware of the busing story that spread throughout the country. The courts ordered the school buses to transport students from one school to another to integrate the schools. In Pontiac, Michigan, it became a serious problem. Twelve school buses were burned in the school parking lot late one evening. Early the following morning I was assigned to cover the story.

I arrived at the school parking lot and quickly started to take pictures of the burned buses before the police could stop me. Most of the damage was in the interior of the buses—all the seats were burned right down to the metal. Crowds began to gather in front of the parking lot, blocking the entrance. In the meantime school personnel were attempting to drive out the buses that weren't burned.

I worked my way into the picket line, where families walked around the entrance with their children. I slipped on my 35mm lens to capture the entire scene as the buses tried to make their way through the picketers. Mothers with children in their arms stood in front of the buses, hoping that this would stop them from continuing. The women became very emotional, with tears trickling from their eyes, as some of the buses got through the picket line. Some of the women ran out into the street waving the American flag in front of the buses as they made their way down the street. The street was cleared by the local police, who made some arrests.

Covering Conflicts

Your approach in situations like this is very important. You must remain neutral and uninvolved if you want to get good news pictures on both sides. You need the confidence of both the picketers and the police. You start by keeping your mouth shut and taking pictures as you see them happen. If you start talking to one group you may lose the other's confidence. This would severely hurt your photo coverage.

There are going to be times during this kind of turmoil when you will be challenged. I was. I identified myself in a friendly manner and explained to both police and picketers, separately, that I was a photojournalist from the *Free Press* and wanted to do a fair photo-reporting job. I gained the respect of both sides. Being honest and truthful has always worked for me. I didn't take a negative attitude toward any of them. Some picketers yelled at me when I took their pictures, but I waved and smiled. Returning the yell with gestures is asking for trouble.

Even though I had two cameras around my neck and a camera bag over my right shoulder, I managed to write down whatever information I could get. You don't need names of people in an overall shot, just the location. If you zero in on someone, make an effort to

One of the leaders of the protest began to scream as police took away her colleagues. Media people gathered around to record the happening. I held the camera way above my head to get this shot.

get the name. You don't need any model releases because it is a breaking news story happening in a public area.

A caption pad and pencil are important items to carry in your camera case. ID's are important because a news picture is not complete without proper identification, which must be accurate.

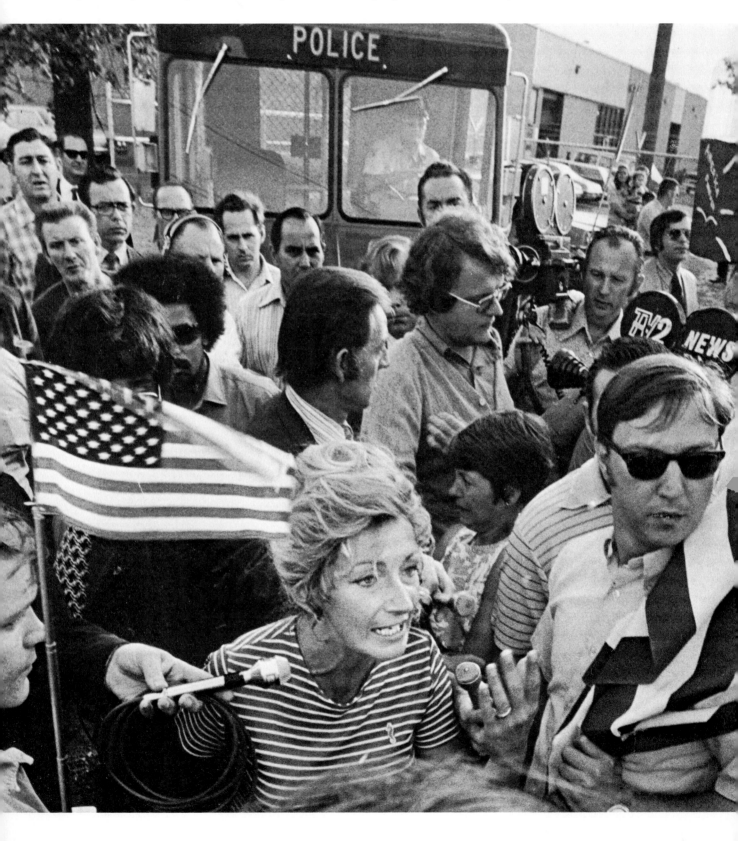

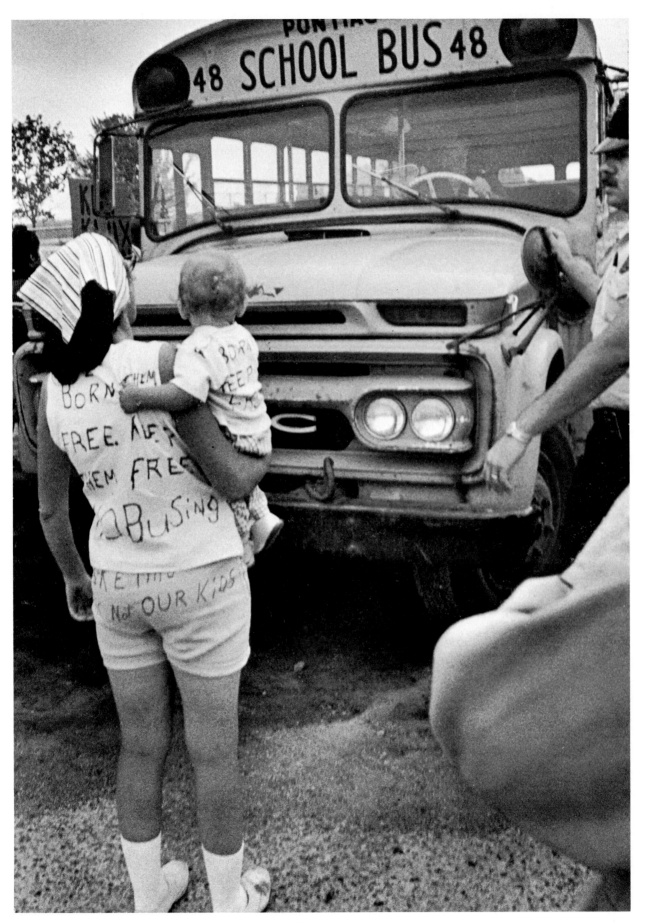

A woman holding her child tried to prevent the bus from leaving the parking lot. This shot is informative and expressive of the situation.

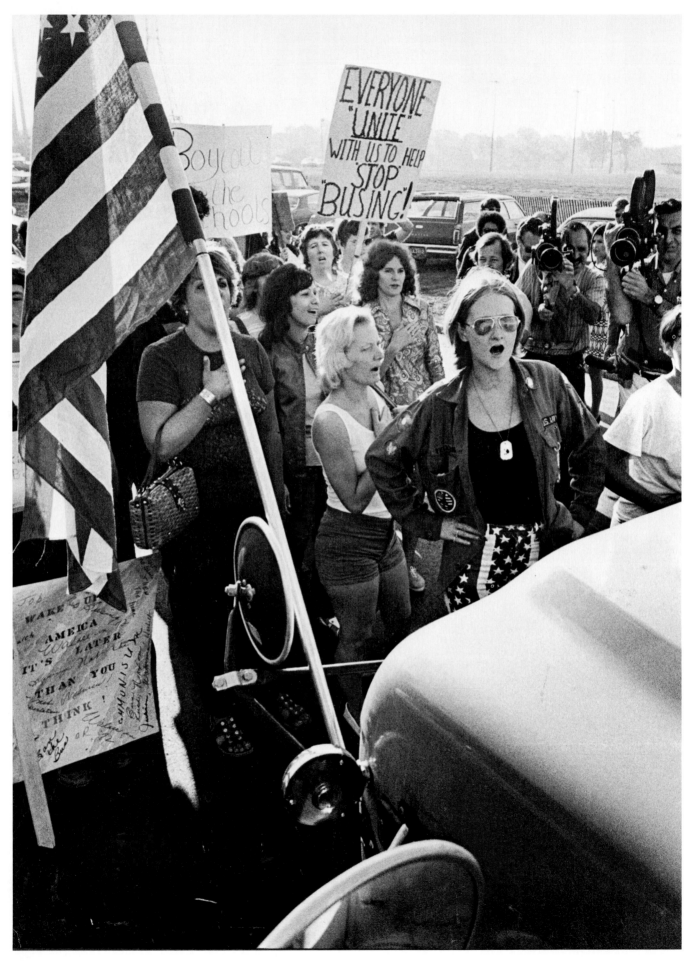

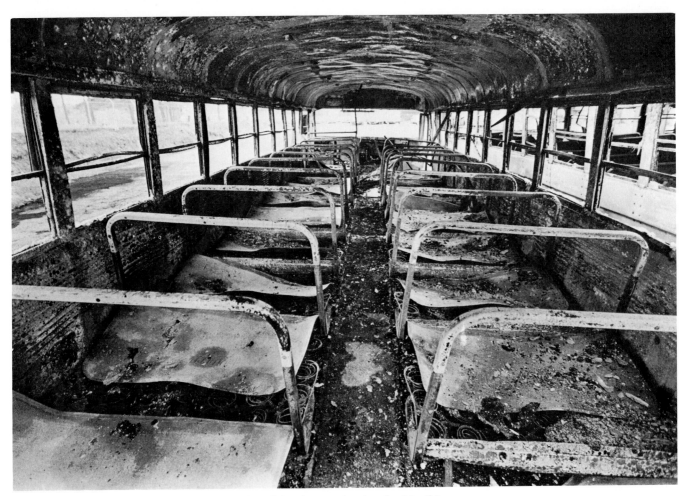

(**above**) The interior of a burned bus, symbolic of the destruction involved in this emotional issue.

(**opposite**) The protestors sang "God Bless America" each day as buses left the parking lot. Note the cameramen on the right—missing a good shot.

The Riot of 1967

ASSIGNMENT: Fast-breaking news story. Editor called me at home to hurry to the scene.

The Detroit riot that started on July 23, 1967, was the worst riot in the history of America. It started on a Sunday morning and lasted almost a week, with rioting, fire bombing, sniping, and looting. It left the city with 44 dead, miles of smoldering ruins, and damage estimated at more than $300 million, with thousands of people injured and more than 3,500 arrested.

On the morning of July 23, the city editor called me at home to tell me that the city was on fire, and that a riot had broken out on 12th Street. He said that it was pretty bad and that I was to hurry down to the paper.

Preparation

I had to wear the right kind of clothes, something durable as well as dark, so as not to make myself conspicuous to snipers or rioters. In the trunk of my car was a helmet with the word *Press* painted across the front and protective goggles. I also had to be selective of camera equipment and not burden myself with a lot of unnecessary gear. For the first day I made the decision to take only two Nikon F's: one with a 35mm lens, and the other with an 85–200mm zoom lens with a motor drive. I had a very small camera case that swung over my shoulder, about 3 inches wide by 8 inches long, enough for 10 rolls of film. That was it—very mobile, enabling me to move fast if necessary.

On the Scene

The riot was getting worse, and the National Guard was immediately called. They began to mobilize at the Central High School grounds, where the command post had been set up. I immediately went there to see if I could get a lift with the National Guard into the riot area. The commanding officer told me to hop into one of the army trucks right away if I wanted to go. There was a caravan of about ten trucks going in, and I had to choose the right truck for my purposes. I decided to ride in the second one, because this would give me the chance on the way there to get some shots of the truck in front of me as it approached the riot area.

When the lead army truck arrived at the burning riot scene, the soldiers began to get off. That gave me a good opportunity to get a picture of them as they jumped off of the truck with the riot scene in the background. Before I jumped off, I slipped down the plastic protective shield over my eyes, to protect them from flying debris and any objects that might be thrown. I then started to walk along the side of the street with the National Guardsmen. They were looking for snipers and rioters throwing bottles and rocks from second-story windows as we walked by. As a soldier looked up toward the window from which bottles were being thrown, I took one of my best pictures of the riot. The fear on his face, with the burning

buildings in back, tells it all. This picture ran eight columns on the back page.

I continued to walk along with the National Guardsmen. My helmet with the word *Press* really did help. The rioters didn't throw anything at me—some even asked to have their picture taken. I walked in back of the soldiers, so that I could shoot from behind them toward the crowd lined up on the sidewalk. They cornered a rioter who had a knife in his back pocket. He didn't want to surrender, and both the police and the National Guardsmen were involved before he was subdued and arrested. I walked about three miles to the other end of the riot area, where a temporary command post had been set up by the Detroit Police, shooting all the way.

It was getting close to our first-edition deadline time, and I needed a fast ride back to the *Free Press*. No cabs were permitted on the streets. I ran into my friend the Fire Commissioner, Tom Engott, and told him that I had to get back to the paper. He said that he was going back to fire headquarters and would give me a lift. We went back with a blazing siren.

National Guard troops enter the riot area. I took this photo standing on top of the cab of the following truck. I used a 35mm lens to encompass a large area of background.

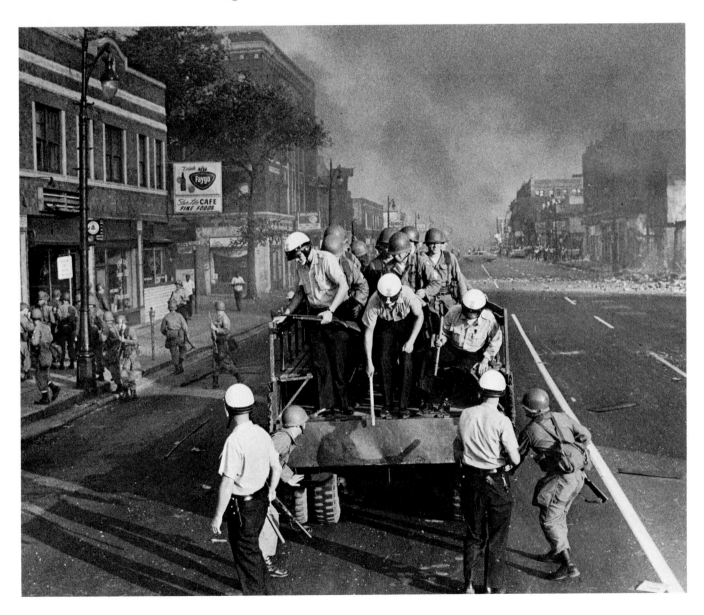

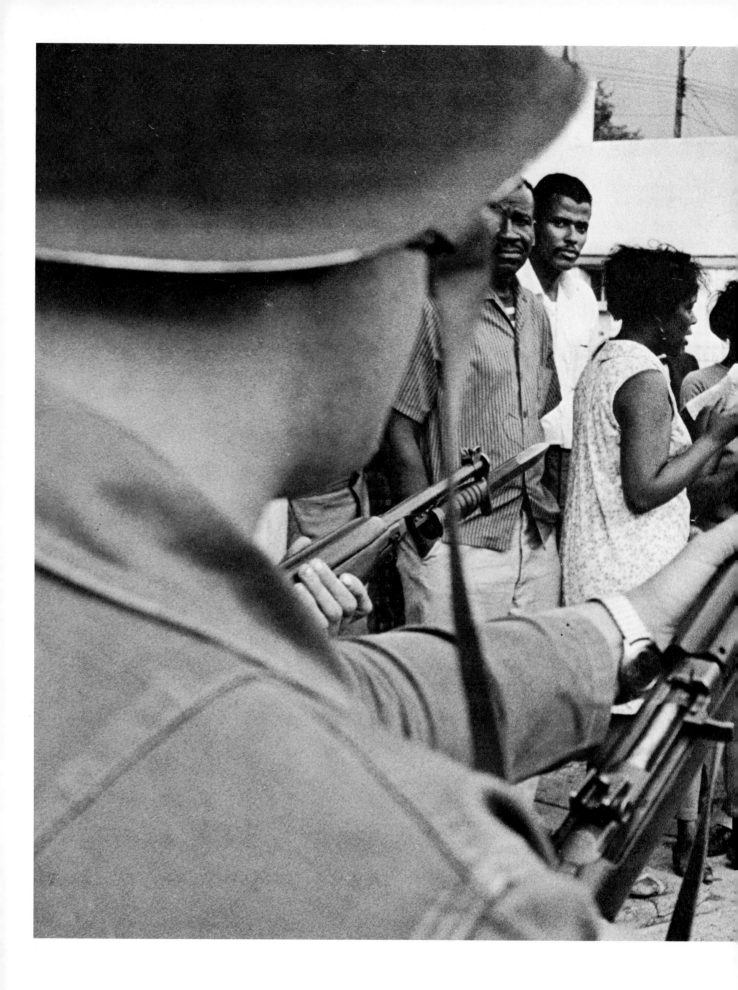

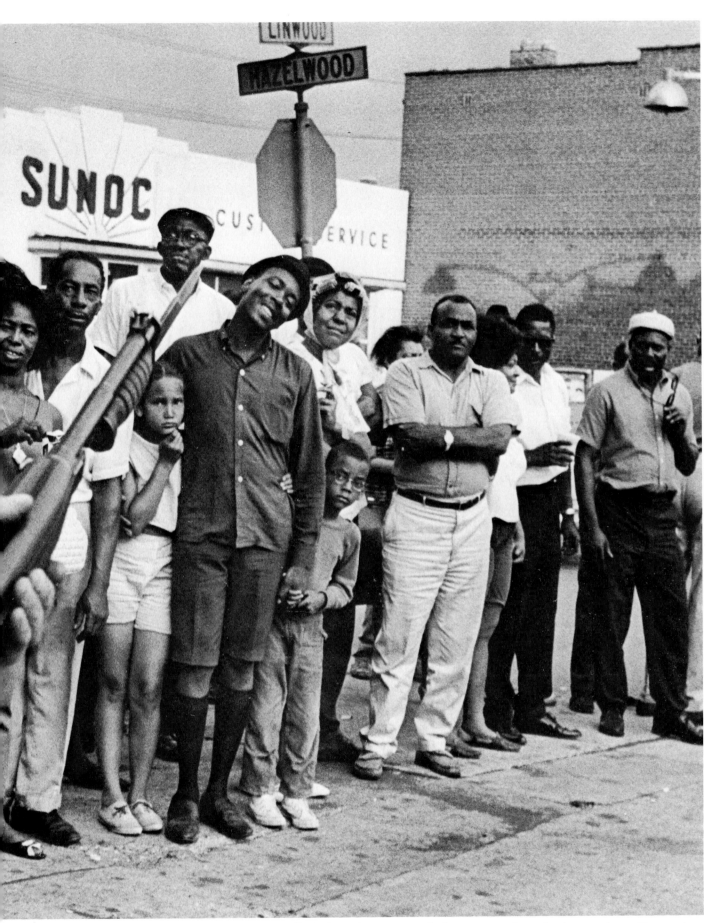

I walked along the streets with the troops and caught the reactions of bystanders to the soldiers' presence. The reactions varied from surprise to anger, with all shades in between.

41

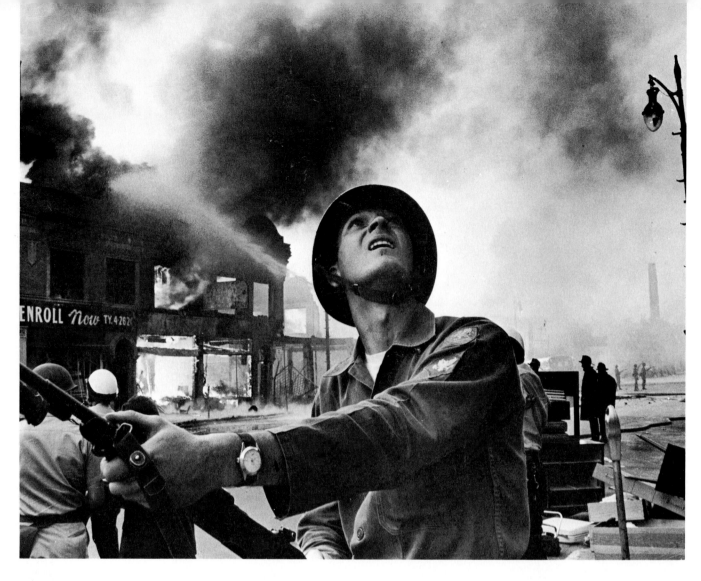

Bottles and rocks were being thrown from rooftops and windows. As I edged along the buildings to avoid flying debris, I captured this young National Guardsman's look and stance, so expressive of the event's tension and fear. This became my lead photograph for the story. It was published internationally, used as a backdrop on television newscasts, and **The New York Times** ran it eight columns.

U.S. Army tanks were used to patrol the streets.

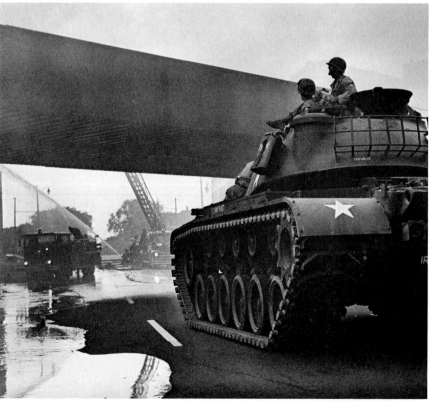

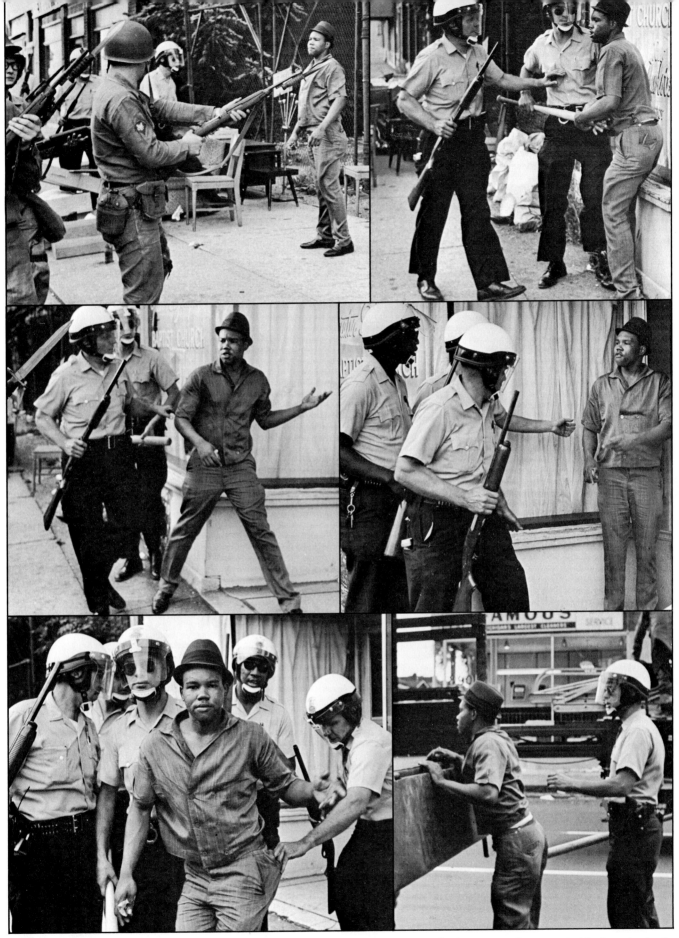

This series of six photographs records the arrest of a suspected looter who had a knife in his back pocket. I was in the right place at the right time. (Nikon F camera with motor drive)

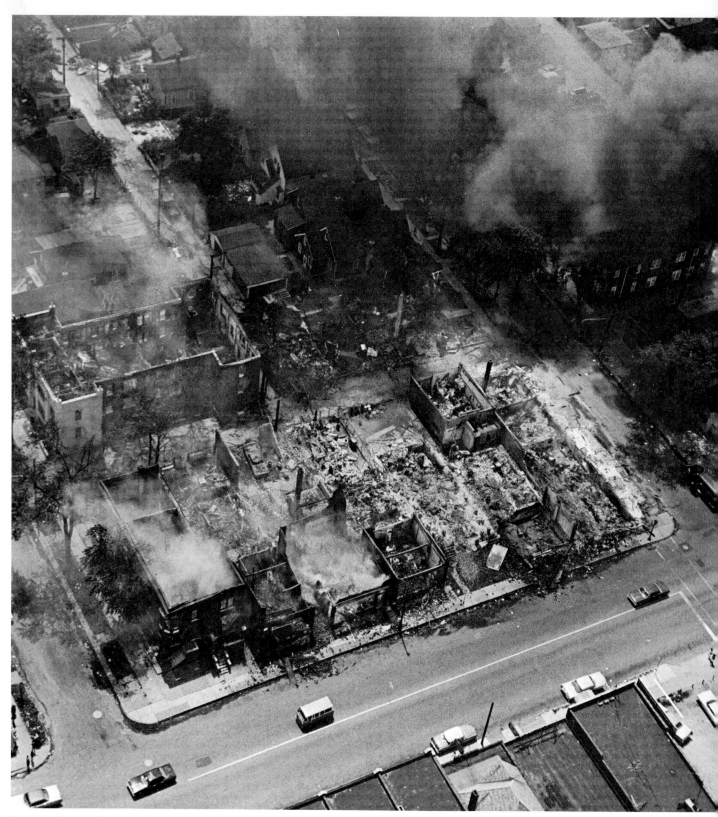

An aerial view of the devastation, from a helicopter taken on the third day of the riot. The altitude was 800 feet. I used a 35mm lens and fast (1/1000 sec.) shutter speed, because of the vibration in the helicopter.

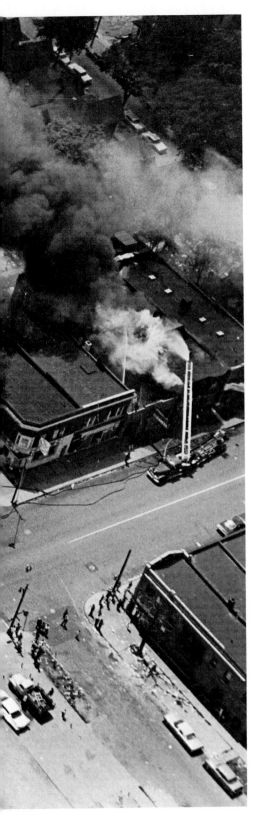

Aerial Shots

On the second day I decided to take some aerial shots of the rioting scene. The helicopter pilot whom we usually hire for aerials was skeptical of taking me up. He realized that there was some danger of being shot at while flying over the scene. But he told me that if I was game, he would go too. We were to make only one pass over the area, because that would lessen the danger. During a second time around it would be more likely for someone to take a pot shot at us. I had my motor-driven Nikon F with 35mm lens, shutter speed set at 1/1000 sec. The best altitude for the shots would be between 800 and 1,000 feet, flying parallel to 12th Street where most of the fires were taking place. I was able to shoot only one roll of 36-exposure film in the one pass over the area.

Wearing the dark clothes and the helmet with a plastic eye shield was a great asset in not getting hurt. Walking alone would probably have been a dangerous thing to do. After the second day, we went out in pairs; either two photographers, or a photographer and a reporter together. The *Free Press* ran four full pages of photos every day. I shot about 30 rolls of film during the five days of rioting. It was a big relief when it ended. During those five days it seemed as though we were in a war zone, with curfews, sounds of gunfire, and fire sirens going on day and night.

The *Free Press* won the Pulitzer prize for its coverage of the riot and I was very pleased to have been a member of this team.

Five-Alarm Factory Blaze

Fires are inherently dramatic enough to produce acceptable pictures most of the time. Composition is the key to getting a new approach, something different from the cliché shot. Upon arriving at the scene of the fire, the first thing to get is an overall shot for the record. Unfortunately, some photographers shoot the same scene, duplicating shot after shot. What I did at this fire, after taking the overall shot, was to look for something different from what I had already taken. I spotted some firemen pulling a water hose and quickly went to their other side so that the sunlight would be falling on their faces on a three-quarter angle. I wanted to frame the firemen pulling the water hose with the burning factory in the background. I waited for the precise moment to record this action shot.

Quick thinking on my part, and using the right camera and lens, resulted in this dramatic picture. If I hadn't searched for something different from the ordinary, this scene would not have been photographed. As the saying goes, "you don't miss anything you don't see, and neither do the editors."

This picture was taken with a Nikon F2 and the 35mm lens.

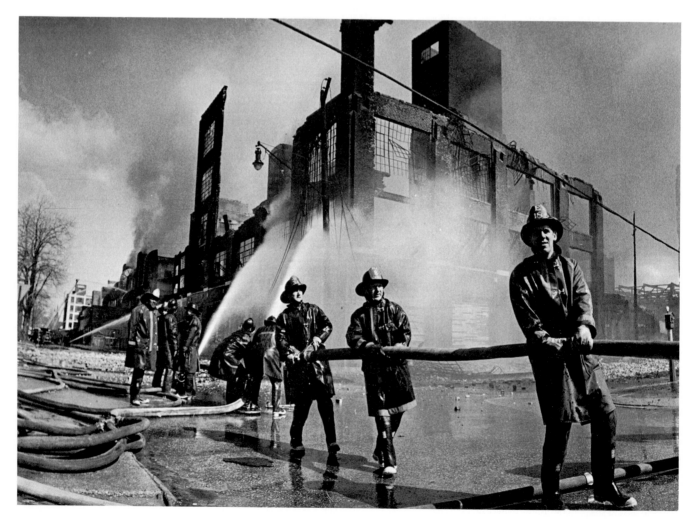

Out of the Charred Remains

ASSIGNMENT: Rush to scene of big fire.

By the time we got the call on this five-alarm fire, the church had completely burned to the ground. I hurried to the scene, but when I got there the fire was almost out and the firemen were rescuing some of the objects. I had the 35mm lens on my camera, and after taking a few exterior shots I went inside the church. The roof had completely collapsed. I noticed a group of firemen at the altar who were taking down the cross. Immediately I slipped on my fisheye lens, because I wanted to capture the entire scene. The only way out was where I was standing, so I waited for them. It was a touching moment to see these brave firemen gently carrying the cross out of the ruins.

Since the fisheye lens captures an angle of 180 degrees horizontal and vertical, I had to wait until the firemen came almost up to me. I had to hold the camera with my arms stretched out, or else I would include my own feet in the picture. The fisheye captured the entire scene: the firemen carrying the cross over the pews, the collapsed ceiling, and the walls that remained on the sides. The photo ran eight columns on the back page. Exposure was 1/125 sec. at *f*/11 on Tri-X film and developed in D-76.

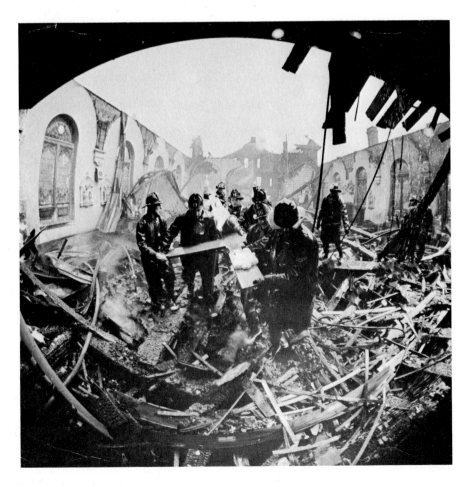

The fisheye lens, covering an angle of 180 degrees, can help to create a special effect. I used available light for this photograph, exposing for 1/125 sec. at **f**/11 on Tri-X film, which I developed in D-76, my standard, reliable developer.

Ted Kennedy and George McGovern

ASSIGNMENT: Cover campaign speeches, with emphasis on Kennedy and McGovern, in Kennedy Square at 11:00 A.M.

This is probably one of my best campaign pictures. When Senator George McGovern ran for the presidency of the United States, Senator Ted Kennedy came to Detroit to campaign for him. Kennedy spoke in front of Labor leaders and dignitaries while Senator McGovern sat on a chair to his left. Most of the press photographers were using telephoto lenses for close-up shots of Kennedy.

I positioned myself on McGovern's left side to get him in the foreground and Kennedy on the rostrum. I did get several shots of Kennedy and McGovern seated, but I waited for that very moment, for I had a feeling Kennedy would point to McGovern sometime during his speech. It happened for a brief second, and I was ready to get that shot. The picture tells it all—it needs no explanation.

"That's my man for president," Kennedy shouted. This is tailor-made caption material.

The picture was taken with the Nikon F2 and the 35mm lens on Tri-X film and developed in D-76. The picture ran eight columns on the back page.

Senator Ted Kennedy endorses presidential candidate George McGovern. A picture can make a statement without words if you capture the moment.

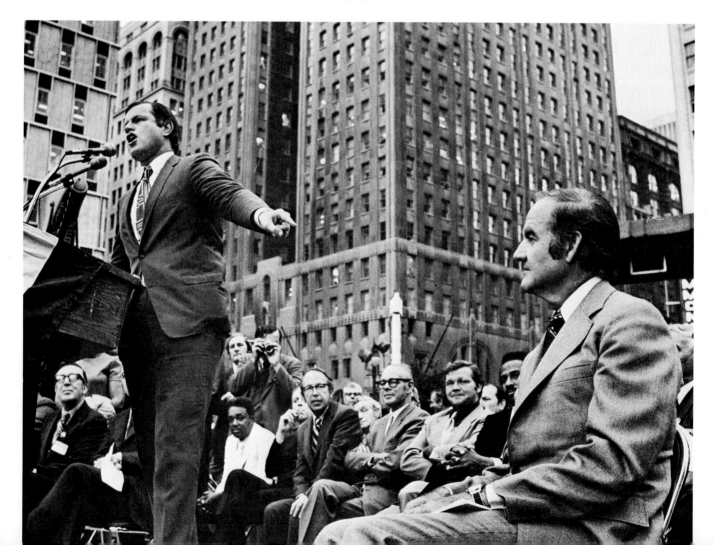

Pope John XXIII

ASSIGNMENT: Original idea for a personal portrait of Pope John XXIII.

One of my greatest accomplishments as a photojournalist was my exclusive audience with Pope John XXIII. I was the first journalist to have a private audience with him. The entire text and photographs were published the world over, including *Newsweek, Time,* and *Life* magazines.

I wanted to appear casual, with not much photographic equipment, and not looking like a man from Mars with all kinds of camera gear around my neck and shoulder. I took my two Nikon SP's with three lenses: the 35mm, 50mm, and 85mm lenses. I decided that I would take my chances and use the existing light, and take as many pictures in that short period as I possibly could. I loaded both of my cameras with Tri-X film, 36-exposure rolls, and put four additional rolls in my pocket along with two rolls of High Speed Ektachrome, in case I had an opportunity to take some color photos. I knew that I had to be as unobtrusive as possible.

I followed the Pope's private secretary, Monsignor Capovilla, into the Pope's private study. I had been told not to engage the Pope in conversation, so I knelt and kissed his ring, and without a word began taking pictures. I took about ten pictures in complete silence. In a quizzical manner, Pope John turned to Louis Capovilla and said in Italian, "When is this photographer going to start taking pictures?" I understood Italian and what the Pope had said. Monsignor Capovilla gestured that he wanted me to explain to the Holy Father what I was doing. I quickly held up the two cameras I was using and explained in Italian that I was taking pictures in the normal room lighting and that with a combination of fast lenses and fast film, I could depend on the existing light in the room.

The Pope's face brightened with a warm smile. "I like pictures like that," he said. Several times the Pope expressed his delight at the pictures that needed no blazing lights, and I thanked the instinct that had prompted my decision.

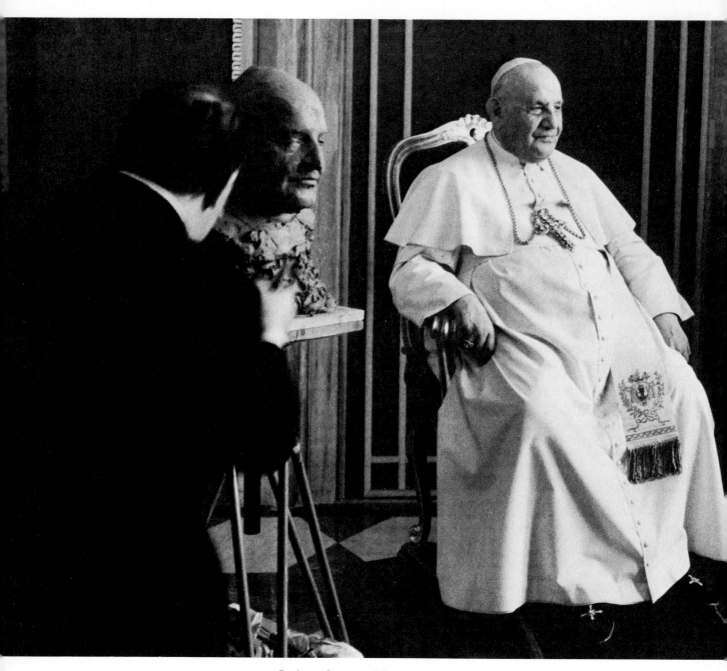

Sculptor Giacomo Manzu working on his masterpiece, the likeness of Pope John XXIII. This was the first time that photographs had been permitted while a Pope posed for an artist. Pope John was seated on a throne placed near the window light.

Pope Paul VI

I was privileged to be invited to photograph the three audiences the Pope held every Wednesday. I was the only photographer given this privilege, other than the official Vatican photographer, Felici. During this time that I would spend with the pope I would try to capture, in candid photographs, the man's warmth and concern for people. Too often these human aspects have been obscured because the Pope gives a first impression of dignified reserve. But this is only a superficial impression. I wanted my photographs to show him in a relaxed mood.

I wanted to be sure that I would be as unobtrusive as possible during my visit with him as I followed him around during the three audiences he would hold. I decided not to use a flash but to depend on the existing light. Next, I had to carry the smallest amount of camera equipment. My choice was to take my two Nikon F2's with no motor drives, and three lenses, the 35mm, 85mm, and 15mm. For film I would use Tri-X Pan for black-and-white shots, and if time permitted I had some High Speed Ektachrome for color shots.

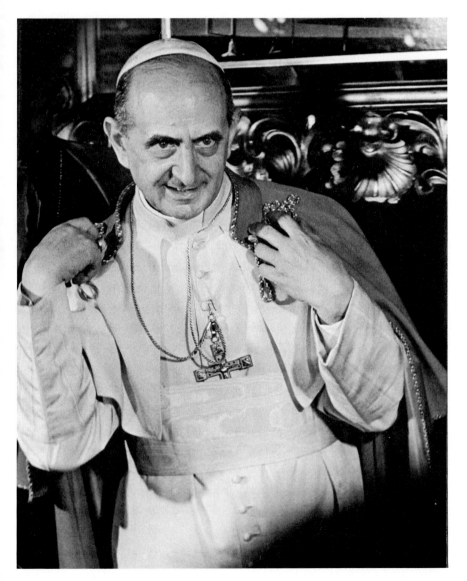

Pope Paul VI preparing for an audience. Because I wanted to be unobtrusive, I utilized available light and carried only two cameras and three lenses.

The Inauguration of President-Elect Ronald Reagan

ASSIGNMENT: Cover the inauguration ceremony, sending film back same day for front page. Cover social/celebrity scene at night and return with film next day. Washington bureau has made hotel reservations. Make your own arrangements for credentials but leave me a memo of your plans.—Sandra White

After the Republican National Convention nominated Ronald Reagan as the Republican candidate for the presidency of the United States, the paper assigned me to cover the event on January 20, 1981. I was to make all the necessary arrangements myself because I had covered the last seven inaugurations and knew the procedures for all the advance work that had to be done. As the first step, I wrote on *Free Press* stationery to Maurice J. Johnson, Superintendent of the United States Senate, Press Photographers' Gallery, to place my name on the list for still photographers to cover the inauguration.

Special Arrangements

Several weeks later I received a letter from Maurice Johnson, whom I've known for over twenty years, explaining that the Joint Congressional Committee on the Inaugural had not appropriated funds for construction of a press stand for still photographers as had been done in the past. Because of his untiring efforts in fighting for a place for the photographers, a solution had been worked out. A photographers' stand would be built above the CBS Television Network booths, providing the photographers covering the inaugural ceremonies at the Capitol shared the construction costs. The size of the stands would be determined by the number of people requesting accreditation. The cost per photographer for a single space would be anywhere from $400 to $1600, depending on the number of photographers seeking space.

A deadline date was set for those who were willing to share the cost. After all the requests were in, we would be advised of the cost per photographer. Payment was to be made in advance. No provisions for roving photographers or areas to work from other than the photo stands were considered by the Inaugural Committee.

The *Free Press* decided to absorb the cost for the photo coverage. A second letter was mailed to Maurice Johnson agreeing to pay whatever amount the committee and CBS determined. Several weeks later I received word that my accreditation for the photo stand was approved and the cost would be $900 for a spot on the elevated stand. Secret Service clearance was necessary for all the media.

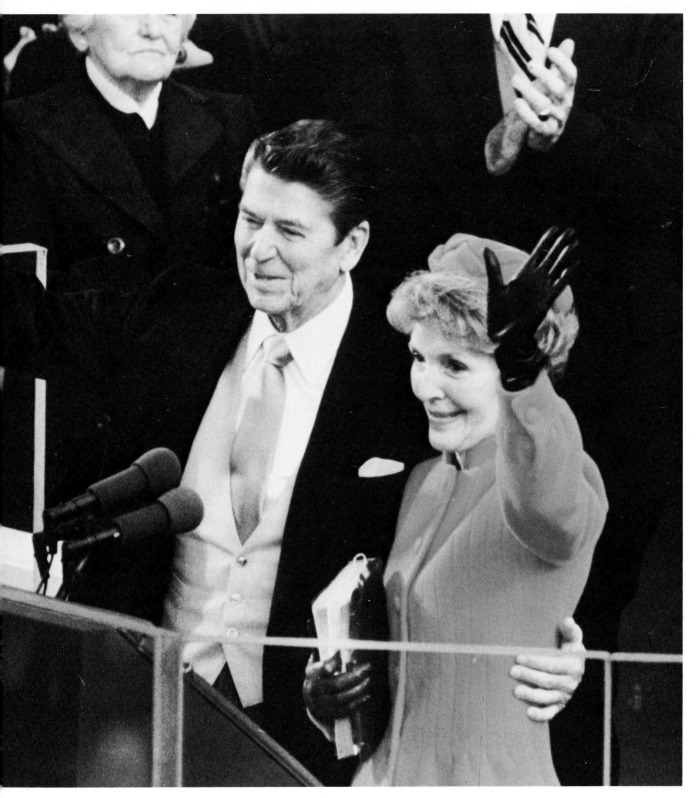

President Reagan and his First Lady, Nancy, waving to the crowd after his inauguration.

The Press Photographers' Gallery only handled accreditation for the swearing-in ceremony. All other activities, including the parade, Treasury and Lafayette Park press stands, balls, receptions, and concerts were handled exclusively by the Presidential Inaugural Committee–81. Those requests for accreditation had to be sent to Dixie Dodd, Room 1114, 2nd and T Streets, Washington, D.C. 20599. That deadline was December 31, 1980. None would be honored after that date. I immediately sent out a request to cover the Inaugural Ball at the Smithsonian Institution, because that was where the Michigan delegation would be.

In order to make plans and decide what equipment to take, I needed some technical information regarding the position of the elevated stand. I telephoned Maurice Johnson and asked him for the approximate construction of the photographers' stand. He said that the stand would be built over the CBS booths, which were on a 45-degree angle facing the swearing-in podium. In the past years the stand had been directly in the center. He told me that all the photographers who were accredited would be receiving a diagram showing the layout of the West Front and the limited positions for still photographic coverage. During our conversation I asked him if there would be any possibility of taking a picture directly from the center. He said that there was a center spindle tower but that no space was available on that stand except for the TV pool, AP, UPI, and an official inaugural photographer. He was considering putting a steel bar on the center stand that would give some space for remote-control-operated cameras. I told him I was interested and to put my name on the list for a remote-control camera.

Equipment

With all the paper work on credentials practically out of the way, the time came to plan what equipment to take. I knew that the elevated photographers' stand was to be 100 feet from the swearing-in podium. For a good tight shot of Reagan taking the oath I would need a 400mm lens. For an overall shot from the center stand [remote control], the 35mm lens in a vertical position would be fine. I would want a third camera around my neck with an 85–200mm zoom. These were the three lenses that I would be using on my three Nikon F3's during that precise moment of the taking-of-the-oath, which would last about 24 seconds. During that short period I would need: the overall shot, several tight shots of Reagan, and as many in-between shots as I could get. Before and after that would be no problem because I would have the luxury of shooting at will. This is the list of camera equipment I planned on taking to Washington:

Cameras: 3 Nikon F3's

Lenses: 15mm, 35mm, 85–200mm zoom, 180mm, and the 400mm.

Film: 30 rolls Kodacolor 400, 36-exposure
2 remote control cords
1 SB-11 Nikon strobe [for the F3]
1 Petersen vise/grip to hook camera to bar on Center Tower
1 roll of 1-inch black tape
4 shipping envelopes
1 sturdy tripod for the 400mm lens
1 monopod

Covering a presidential inauguration takes preparation and planning: hotel reservations; plans for a messenger, which I made with a friend, Vince Finnigan, a Washington-based photographer; airline schedules for film shipment, checked out in advance as to arrival times. All this information was typed and copies made for the graphics editor, city editor, and managing editor of the paper.

I decided to leave on January 17, early on Saturday morning. I carried my three Nikons, lenses, and film with me on the plane. The rest I checked through my luggage. It's not a good idea to check your camera gear through with your luggage because the rough treatment that luggage receives could damage the equipment. Film should always be carried on the plane because of the X-ray check.

On Friday, January 16, I was given the Inaugural plans from Clark Hoyt, editor in charge of the Inauguration. This was the detailed assignment.

Here's the inaugural plan: Shirley Eder, Tony Spina, Ken Fireman, and Remer Tyson will be covering the social/celebrity scene in Washington. Ken Fireman will report on Michigan folks. Shirley Eder will report on the inaugural balls and party activities. Remer Tyson will have the national scene and will team up with our reporter in Washington, Saul Friedman. Tony Spina will shoot color of the inauguration and immediately ship film back for arrival that same afternoon. We are planning a color shot on page one and several on the back page. Then from there go to the Inaugural Ball at the Smithsonian and team up with Shirley Eder for the Style Front for Thursday's paper. That film he will bring back with him Wednesday morning.

Preparation

Everything had to work with no hitches. The assignment sounded reasonable and I knew that the deadlines could be met. When I arrived at the hotel that morning I went directly to my room to call the messenger and finalize plans. As I entered my room there was an urgent message to immediately phone the Press Photographers' Gallery. I called even before unpacking my suitcase. Tom O'Halloran, photographer for *U.S. News & World Report*, answered the phone. He said he was helping Maurice Johnson because CBS was demanding that all photographers on the elevated stand must be insured for $1 million. All of the photographers who had credentials had to have this policy or they would not be permitted on the stand. I rushed over to Photographers' Gallery. Maurice showed me paragraph 6 in the contract, which required this insurance. I explained to him that all newspapers have insurance on their employees. He said that they wanted a certificate of insurance by Monday the 19th. Here it was Saturday. The business office at the *Free Press* is closed both Saturday and Sunday. Maurice Johnson explained that it wasn't his doing. CBS and the U.S. Government requested this insurance, and that was it. I quickly called our controller at the *Free Press*, Jerry Teagan. I told him of the problem regarding my insurance. I told Jerry that this was only for the time I would be on the photo stand in front of the Capitol. He said not to worry, that the *Free Press* has the insurance and he would see that a wire copy arrived on Monday morning.

What a day of frustration. I got back to the hotel late in the afternoon, annoyed at CBS for demanding this at such a late date. But these last-minute emergencies do happen, and you learn to cope. I unpacked my suitcase, checked my camera gear, and telephoned the photomessenger to meet me Sunday morning for a dry run to and from the airport.

The fastest and surest way to get film to the airport was by subway. It would be almost impossible to get a cab from the Capitol after the inauguration. Police stopped traffic for several miles within that area. It would be only a five-minute walk to the subway station and about 25 minutes to the airport. We had plenty of time to spare to meet the 3:30 P.M. flight to Detroit.

Ron Thompson of Nikon, Inc., was in Washington to help us hook up our remote-control cameras from the Center Tower. The Secret Service issued an order that all the cameras had to be in place by 4:00 P.M. Monday the 19th. After that nothing would be permitted on the Tower. Radio control cameras were not allowed. To be on the safe side, I purchased 200 feet of 15-gauge wire and attached the remote-control tripper to that, to operate the camera. There were to be about 12 cameras hooked up on the metal bar. On Monday afternoon I would meet with Ron Thompson and decide then the best way to make it work.

On Monday morning at the Capitol I picked up my credentials for the photo-inaugural stand. Positions were assigned. I had a spot in the front row alongside *The New York Times,* AP, and UPI. After checking out my position on the stand, I left to pick up my credentials from Dixie Dodd for the Ball.

Back at the hotel on the eve of the Inauguration, January 19th, I placed on the table the camera equipment that I planned to take with me. I checked over my two Nikon F3's, making sure that the batteries were working. My third Nikon was already in a fixed position on the Center Tower, protected with a cover furnished by Ron Thompson. He had permission to remove the covers from all the cameras early Tuesday morning. Next I placed the 400mm Nikon *f*-3.5 lens next to the cameras, then the zoom lens, the 15mm *f*-5.6, and the 180mm Nikkor *f*/2.8. I decided to take only 12 rolls of Kodacolor film. I figured I would use 4 to 8 rolls during the inauguration. I then called Bill Burke, who was going to be my messenger, to be at my hotel at 8:00 in the morning. With all this done, I went to dinner in the hotel.

Now my other concern was the weather. The weather report on the 11:00 P.M. news said that it would rain late in the afternoon, but during the inauguration the temperature would be 38–40 degrees with an overcast sky. I then called the desk and placed a wake-up call.

On Location

Everything started out well on Tuesday morning. I was awakened at the right time, had breakfast, but only half a cup of coffee. I didn't want to drink much liquid because once on that photostand I had to stay there for the entire event. My messenger arrived and we took off via the subway. It was a safe way to get to the Capitol, because traffic was beginning to be a mess, and no vehicles were allowed within a mile of the area.

We arrived at the Capitol by 9:00 A.M. I climbed the elevated photostand with my equipment, but Bill Burke had to wait at the bottom of the stand. First I set up my sturdy, portable Gitzo tripod, which has three extensions, with a center point that I can raise or lower for critical positioning. It's only 18 inches long when not in use. I mounted the camera with the 400mm lens on it. After that I attached my F3 motor drive onto the lens and loaded the camera with Kodacolor film. Next, I checked with Ron Thompson of Nikon to see if all was well with my camera on the Center Tower. He waved to me that everything was okay. My remote control for that camera was in place and ready to go. Around my neck I would wear a camera with the 85–200 zoom lens, for any in-between action I could get. My exposure was 1/500 sec. at f/5.6. Time was getting near. The diplomats and VIP's were all seated on the platform waiting for President-elect Reagan's arrival. I planned to shoot at least two rolls before the swearing-in activities began.

Later, on the Center Tower, I decided to use my 35mm lens to fill the frame, with the Capitol as a backdrop and Reagan clearly visible taking the oath of office. To me this was a historic picture because it was the first time ever that a President had held the inauguration on the West Front of the Capitol. Not knowing what the weather would be like during the swearing-in ceremony, I pondered the best way to get a good exposure. If I left the camera on automatic, the whiteness of the Capitol would certainly cause underexposure of the ceremony taking place. But I should leave the camera operation on automatic in case a severe change of weather took place. What to do in this situation? Well, this is what I did. I set the exposure dial at ASA 100 instead of 400. On automatic the white structure of the Capitol would activate for that exposure, since it comprised over two-thirds of the picture. Using Kodacolor 400 film, shooting it at ASA 100, means two stops' difference. That would give me a good exposure of Reagan taking the oath of office; if I had properly exposed for the Capitol, Reagan would be a silhouette. When I did this several of the other photographers followed the same procedure. The final results were perfect. White is white and so a difference of a couple of f-stops is hardly noticeable.

This would be my key picture. It would become of historical value in years to come, probably the only time we would see an inauguration taking place on the West Front.

See color photographs on pages 68–72.

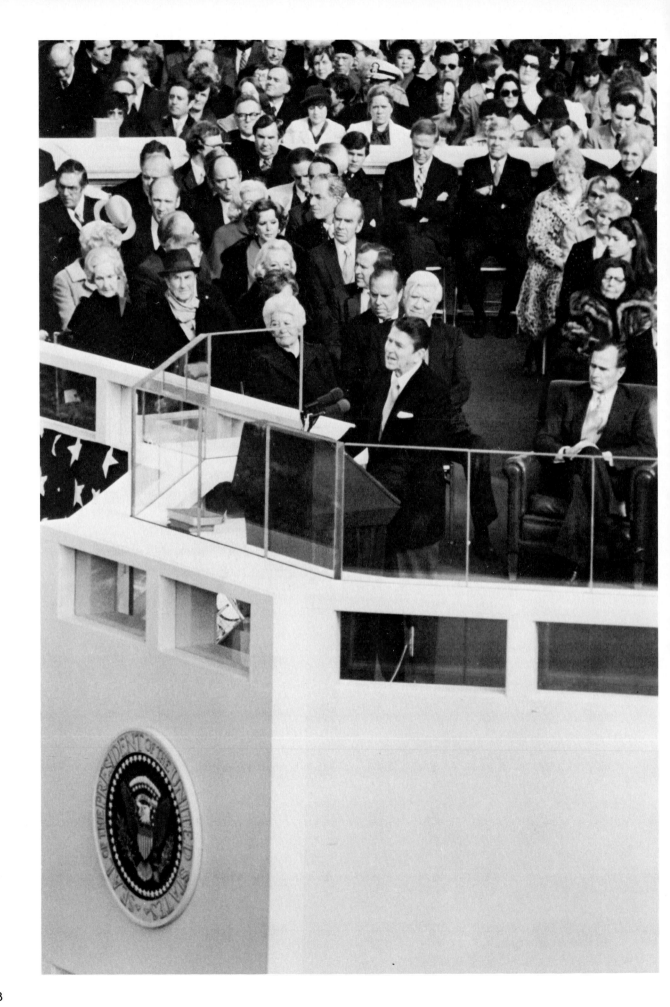

FEATURE PHOTOGRAPHS

When photographing sports events, you must have some knowledge of the sport. The photographer has to make arrangements in advance in order to get access or admission. For example, at baseball games, there are rules set up by the club and the umpire when you are given an admittance pass. Violation of any of those will mean a quick exit from the game. To be on the safe side, check with the officials to determine the where's and don'ts of the restricted areas.

There are different angles from which to shoot, so pick out the one that you think is best for you. Remember that you can't be in two places at one time. Try to prepare in advance the shot you think is best and plan to be at that place at the time when the high points of the action might occur. You have to make that choice, because if you don't you risk missing the shot.

Anticipation of the action—timing in getting the peak of the action on film—takes experience. You have to be able to capture that slide at home plate, the steal at third base, the error in left field, the fumble at a football game, the interception, the winning touchdown, and many other sports action pictures. The sports photographer knows that the paper requires him to come up with these shots. There will be no one there to tell him when to shoot or what to get. He alone has to produce.

There is no originality in sports photography. The action is there for all to see. You could apply a different approach in your style or technique in the composition of the photo that is based on your intelligence of the event. You can use an extreme low angle, pan the action—blurring the background—or get a sequence of the action with the motor drive. There are no retakes. If you miss, don't get discouraged, keep shooting and hope that another good opportunity will happen, and you'll be ready for that one.

I do not recommend using a tripod when covering sports. At most major events they are prohibited on the field because of the danger. If an athlete is running toward him, the photographer has to move fast in order to avoid a collision. If you need some support for the telephoto lens, a monopod is the equipment to use. Cameras are normally hand-held by the sports photographer when on assignment because he needs to be mobile. The majority of sports photographers use a 35mm SLR (single-lens-reflex) motor-driven camera. The best two all-around lenses for sports are the 180mm and the 300mm telephotos. To zero in closer on the action, some use the 400mm or the 500mm lens to isolate the action from the context. In order to be versatile, sports photographers use these long telephotos so they can come up with pictures that are different from the day-to-day routine shots. It's hard not to be repetitive.

Use of the wide-angle lens in covering sports is limited. You need a shorter lens than the telephotos for feature and pregame shots. I find the 35mm lens the best for this work.

There are certain precautions a sports photographer must take because there are some dangers in photographing sports. If you are at the sidelines during a football game, you have to constantly

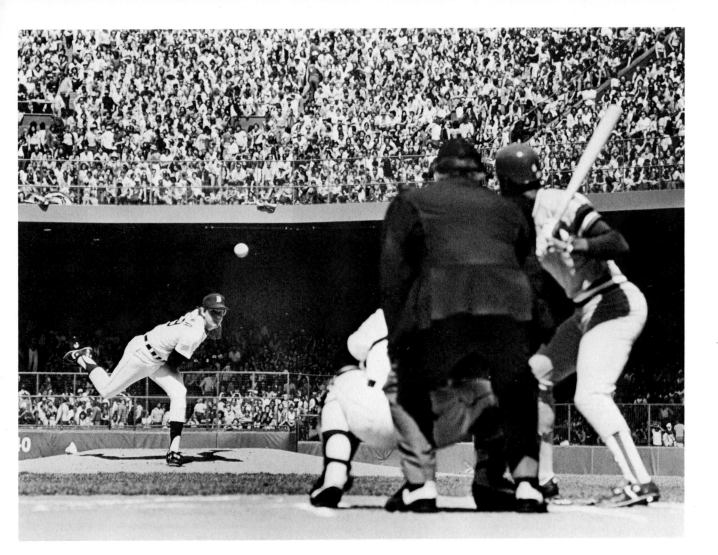

keep your eyes open for unforeseen action that may be coming in from the left side. Players are tackled with great speed, sending them crashing into the sideline—which is usually lined up with photographers. You have to be able to get out of the way fast, and I mean fast, to avoid being hit. At times it's very difficult to see them coming because your eye is glued to the viewfinder.

If you have an assignment to take pictures at the race track, you have to preplan the kind of picture you want to get. There is the usual cliché shot of the finish. Other possibilities could be the start of the race taken with a telephoto aimed toward the horses just after they leave the gate. To get this angle you have to be in the stands at the first turn, looking directly at the action at a 90-degree angle. The last turn is another good vantage point, when all the horses bunch up in the final stretch for the finish. If you plan to photograph the finish at ground level, wear dark clothes. Light clothing might distract the horse. Also, if you are at the finish line, stay in one place and don't move or jump up with excitement as the horses go by. If you do, it could lead to disaster.

Good sports action photos are not easy to take. You have to keep up with the game every moment and know what is going on in order to come up with a decisive, meaningful action shot. You have to be at the right spot with the right lens and be able to click the shutter at the right moment to record that great sports photograph.

Anticipating the action is especially important in sports photographs. First, determine the angle necessary for the shot you want, then wait for that "decisive moment."

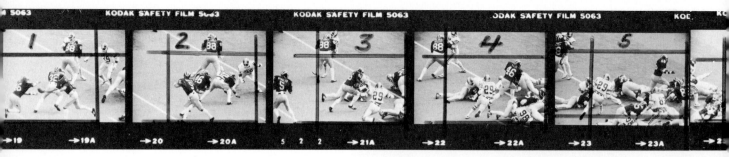

Decisive touchdowns are important in championship games. Seek out a good spot, whether it is along the sidelines or on the photo deck. First you must choose the proper lens. For sideline action I prefer the 180mm and the 300mm lenses. Shooting from the photo deck, depending on its size, I use anywhere from a 300mm to a 600mm lens.

In this sequence taken from the photo deck of the U. of M. stadium, I used the 600mm lens on the Nikon F3 camera. Anticipation of the play is important, and that comes from experience—knowing when to start in order to capture a complete play on film. I selected six photos from the series, as indicated from the contact sheet, illustrating the hand-off and run for the touchdown.

A system I use to avoid running out of film on key plays is as follows. I have two cameras. With the first I shoot about half a roll, then I switch over to the second camera and shoot up the entire roll. I quickly switch cameras and load the second camera between plays because there are about 15 exposures left in camera number one.

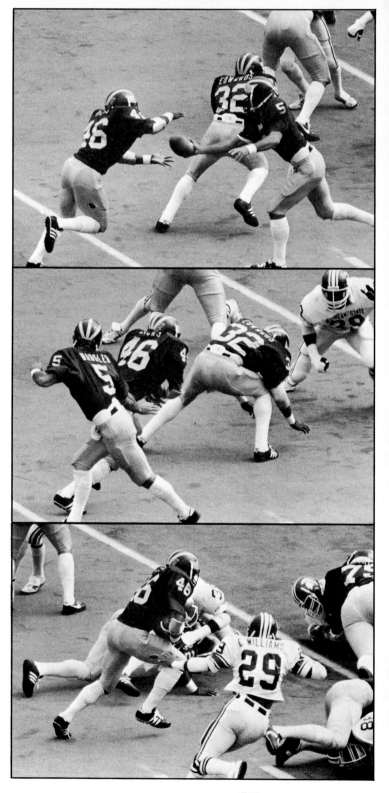

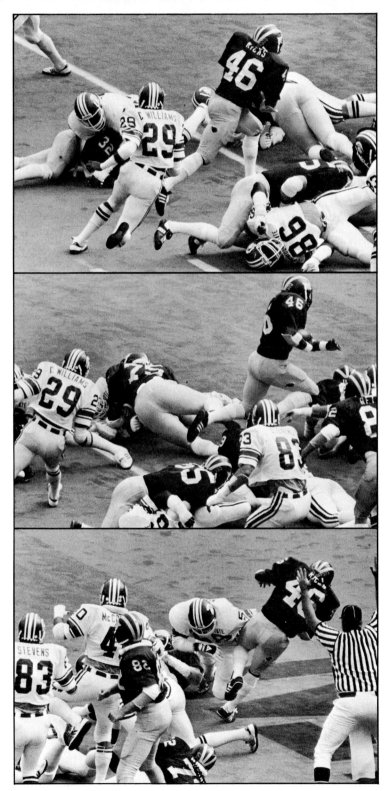

Nadia Comaneci

Nadia Comaneci won seven Olympic gold medals at age 14 in
1976. On March 15, 1981, she came to the Joe Louis Arena in De-
troit to display her outstanding talent. At 19 years of age she
weighed only 90 pounds. She is a world-class athlete and acts it.
She doesn't smile a lot or act like she's having a terrrific time.
Nadia is now studying at the University of Physical Education in
Bucharest.

Equipment and Preparation

I decided to use the 400mm Nikkor *f*/3.5 lens and the 180mm
f/2.8 lens, each on a Nikon F3 camera with motor drive. I also took
along my tripod. I didn't know which lens would be best for the
shots, because I didn't know how close I would be able to get. I went
to the arena about 45 minutes before the event to plan out my
shots. I first went to the show manager and asked him about the
routine, when Nadia would perform, and where in the arena. He
told me that if the event started as scheduled, she would be per-
forming at about 2:45 P.M. Just before intermission she was to per-
form on the beam, which would last 1 minute and 20 seconds. I
then asked him about the lighting. He said that the arena lights
would be the only lights used, and there would be no spotlights on
her.

The closest I could get to the beam was about 50 feet, good
enough for my 180mm lens. I then took a meter reading with my
Nikon F3 and set my speed at 1/125 sec. That was the fastest speed
I could get with my lens left wide open at *f*/2.8, using Kodacolor
400 film. I set the camera on the tripod in a vertical position. From
that spot the picture almost filled the 35mm frame.

Shooting

The moment came, and Nadia casually walked up to the beam
that was on the left end of the arena. She went directly to the cen-
ter of the beam, held her arms on the beam, and lifted herself up. I
had to be concerned with two major elements here. One was that I
had to follow focus because I was shooting wide open with no depth
of field to speak of. Next, I had to be sure to take every shot at the
peak of the action; otherwise I would get a blur because of the com-
paratively slow shutter speed. When shooting for the peak of the
action, the movement is frozen momentarily because the action
starts to reverse after the peak. At that precise moment is the time
to shoot. With a wide-open lens, I had to be sure to keep my focus
constantly on her as she moved on the beam.

I kept my left hand on the barrel of the lens to keep Nadia in
focus at all times. I held my right hand on the shutter release, en-
abling me to follow her every move with my camera. (Of course,

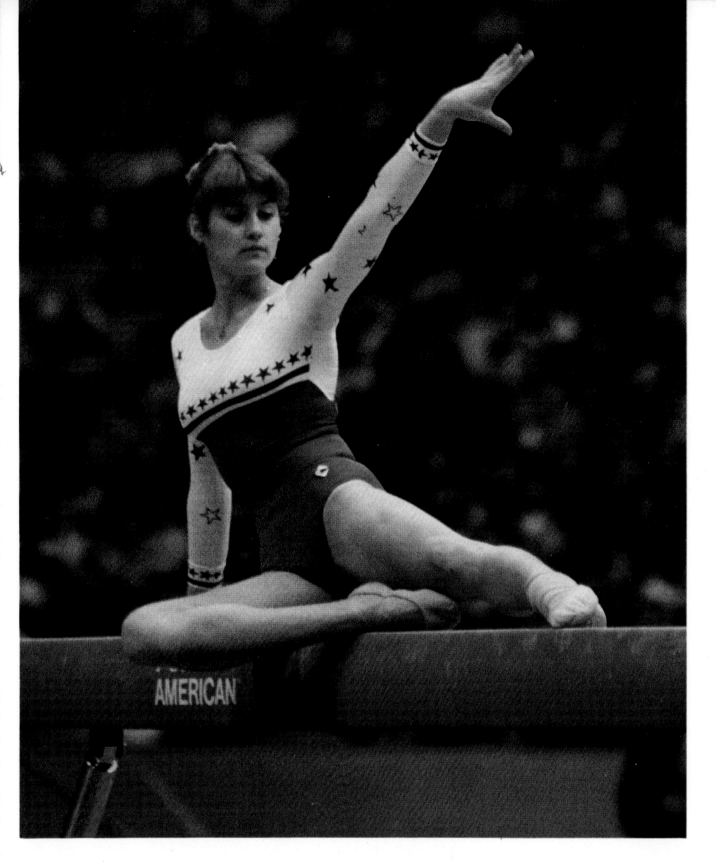

this is much easier to do when the camera is mounted on a tripod and you don't have to support it yourself.) I had the motor drive set at single-frame exposures rather than continuous so that I could choose the shots that I wanted. I took only 24 shots on the 36-exposure roll before she left the beam. I got back to the paper at 3:15 P.M., in time to develop and print a series of Nadia in color.

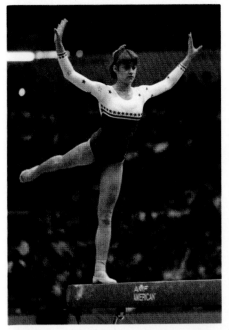
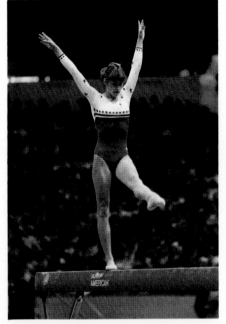
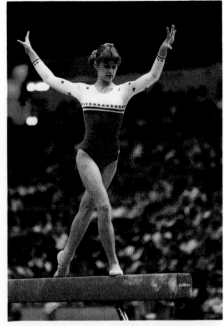

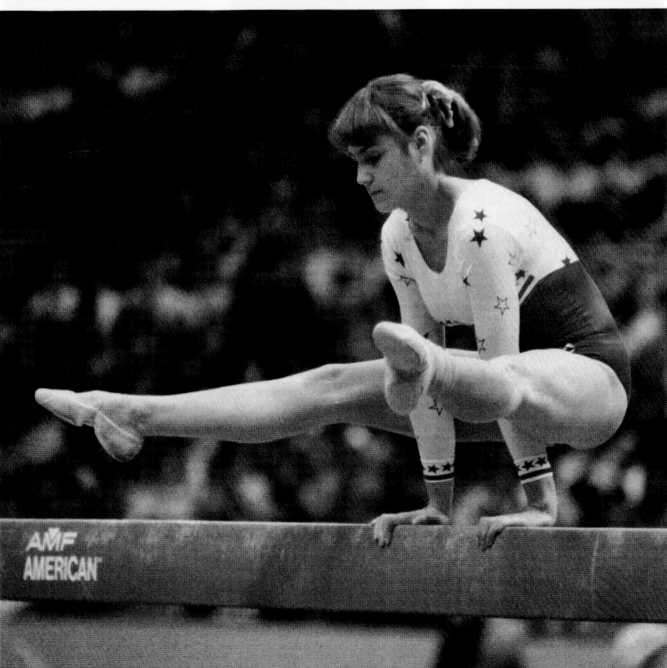

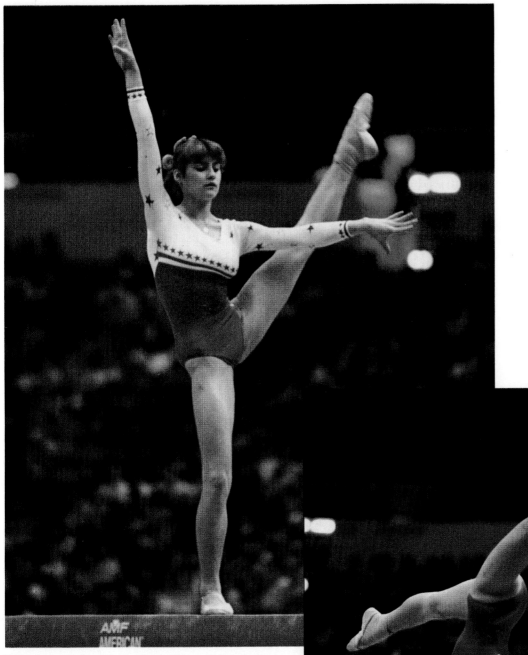

With the crowds of Detroit's Joe Louis Arena looking on, Comaneci displays her skills on the balance beam.

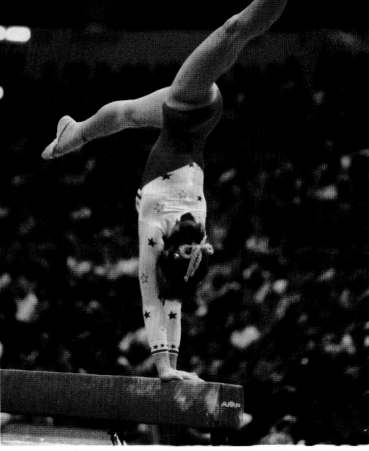

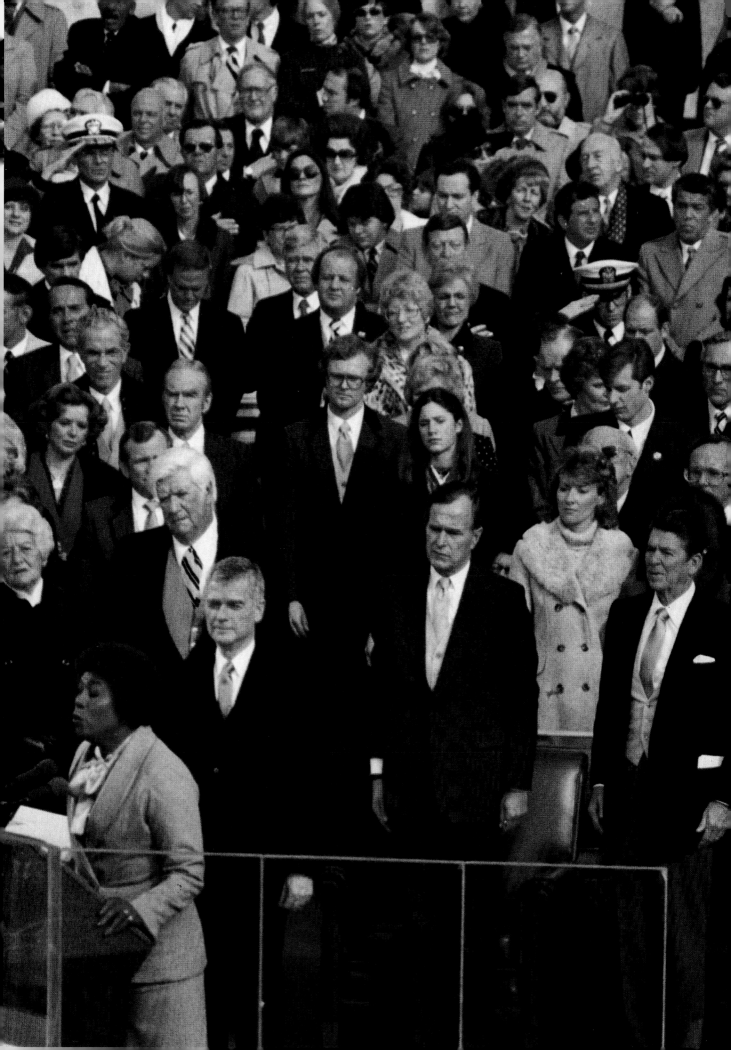

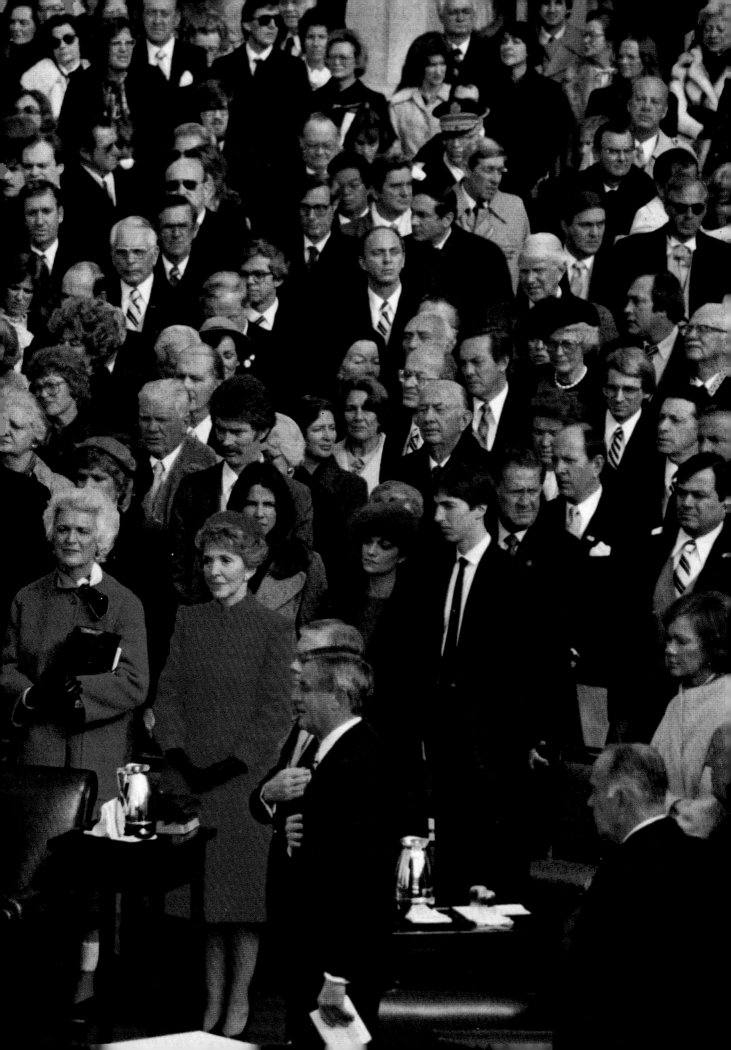

(right) Chief Justice Warren Burger administers the oath of office. I knew that I had about 30 seconds to record the historic swearing-in of the 40th President of the United States. I started with a vertical shot, using my zoom lens at the 85mm focal length.

(previous page) President-Elect Reagan chose Juanita Booker to sing the national anthem. I used the 85–200mm zoom about midway to fill in the area I wanted in the picture. Because I was in a fixed position on the elevated photo stand, the only way I could get a variety of angles was to use lenses with different focal lengths.

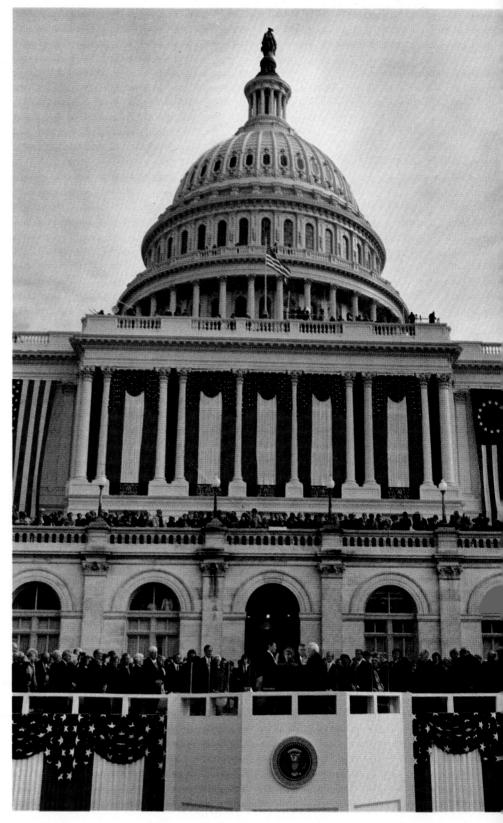

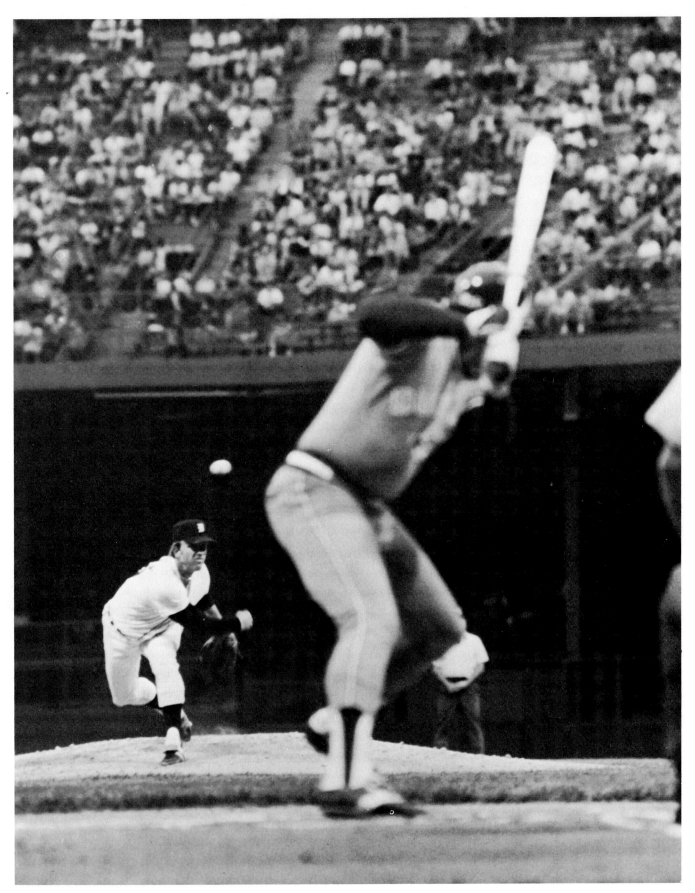

Detroit Tigers vs Toronto Blue Jays
April 15, 1982 Tiger pitcher Milt Wilcox hurls the first pitch opening the 1982 season for the Detroit Tigers. Photo was taken from behind home plate with the 180mm Nikkor lens at 1/1000 sec. at f/8 on Kodacolor 400 film with the Nikon F3 camera.

Opening Day of Baseball Season

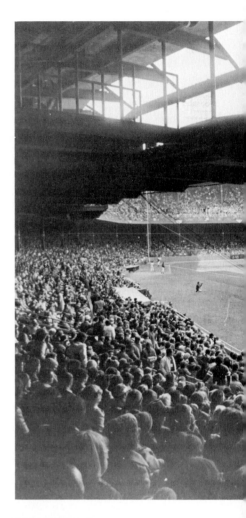

On opening day you must have an overall shot of the stadium, plus the dignitaries throwing out the first ball and the first pitch of the game. These are important because pictures will be run on front page, sports page, and back page. Sports will take the action shots and city side the feature material.

How do you cover all of these? Certainly it cannot all be done at the same moment. First I get the governor and mayor throwing the first ball out onto the field; the two managers shaking hands before the game starts; the first pitch. Then I stayed on the field to get some ground action, until the end of the third inning. By this time the crowd has practically filled the stadium. If you take the overall shot before the game starts, there will be a lot of empty seats, because of all the late-comers.

At the beginning of the fourth inning I went into the stands for a panoramic view setting the scene, a pictorial shot capturing all—players, crowd, and stadium. I used the Widelux 140-degree angle camera. The photo ran eight columns on the top of the back page. It was a good beginning shot.

The panoramic photo was the last picture before leaving. I had to leave by 3:00 P.M. in order to make the first edition. Another staff photographer stayed for the remainder of the game for action shots.

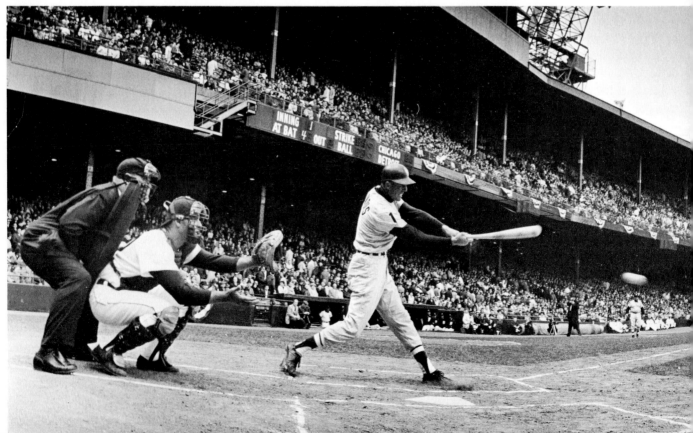

Using the Widelux camera makes it possible to include an area of 140 degrees. Here are an action shot and an overall shot of opening day baseball.

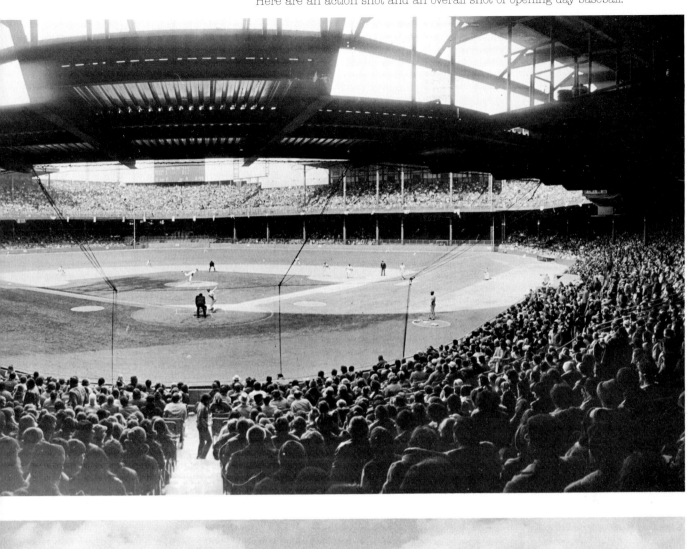

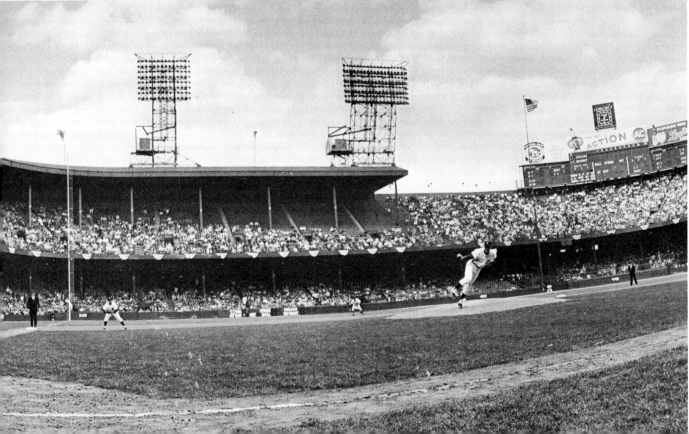

Mickey Mantle

ASSIGNMENT: Cover Mickey Mantle in action. Try for unusual head-on shot when he's at bat. Check with sports editor before going.

Mickey Mantle, of the New York Yankees, was about to break a record on home runs and hits. Before leaving for the game I met with the sports editor to see exactly what he was looking for in pictures on Mantle. He asked if I would try to show Mantle hitting in a different angle, something other than the usual pictures taken at home plate. He wanted a shot of Mantle in a swinging position, head-on if possible. I told him that I would see what I could do.

Shooting

I took the 1000mm lens, arriving at the ball park about one hour before the game to find a good and different spot to shoot from. The best place was out in center field, shooting from the grandstand. I set up my tripod and placed the lens right up against the screen. Shooting through the screen slowed down the speed of the lens about one *f*-stop. When the game started, I positioned myself so that I included the pitcher and Mantle at the plate. Depth of field was another problem. I had to increase my ASA to 1600 so that I could stop down a couple of extra *f*-stops and still maintain a shutter speed of 1/1000 sec. To focus, I waited for an opportune time when the pitcher walked to home plate to talk with the catcher or met halfway between the mound and home plate. There was my opportunity to focus. I focused about one-third the distance past the mound. This would leave me about two-thirds in focus behind, giving me just the depth of field I needed. Now, all I had to do was wait for the precise moment for Mantle to hit a home run. I had to be on him every time he came to the plate.

I waited with my Nikon, 1000mm lens, and motor drive every time he came up to bat. Using the motor drive didn't guarantee me peak action shots. There are times when you score with peak action by using the motor drive — if you're lucky. I can't afford that, I have to be exactly sure of the picture I'm taking.

Tips for Taking Action Shots

Remember, that action goes past you much faster than it seems, and it takes accurate timing to know just when to trip the shutter. If you snapped when you saw the batter hit the ball, you've only recorded his follow-through, and if you snapped when you heard the crack of the bat, you've taken a shot of him on the way to first base.

When I took this shot of Mickey Mantle at home plate, with my motor drive, I pressed the shutter as he started his swing. That gave me the peak action I wanted, but I kept on with the motor drive for the follow-through. This will not guarantee that the ball will be in every shot, but it will be a good action shot all of the time, with the batter in the peak of his swing.

Mickey Mantle trying to break the home-run record. Shooting from the grand-stand at center field, I used a 1000mm lens and preset the focus on a spot about one-third of the way from the pitcher's mound to home plate.

101 Miles Per Hour, Backwards

Doing a feature series means using your imagination to think of unusual coverage. I came up with the idea of getting a picture of the driver and the "roostertail" the boat leaves behind as it goes over 100 miles per hour in the river. *How* to do it was the problem. I went to the pit area where the drivers were testing their boats and talked with Roy Duby, driver of *Miss U.S.1.* I told him what I had in mind and asked for his thoughts on how it could be done. He had no idea . . . and didn't seem interested.

Refusing to be discouraged, I looked over his boat and noticed a space in front of the engine. I called Roy Duby over and asked him if it would be possible for me to stand in that spot during his trial runs. He gave me a strange look and said he would agree providing I was willing to take the risk—I would have to ride backwards in the boat. We agreed to do it the following day.

Word had spread by then, when I arrived all of the media had lined up along the shore to record what they thought would probably be my misadventure. Even my own paper sent a photographer.

Roy Duby loaned me a helmet and a lifejacket. After donning the lifejacket, I put my Nikon with the motor drive around my neck and climbed into the pit of the boat. I didn't want to be strapped down to anything in case of any emergency. I had to sit on the bow in order to clear the engine and windshield. I realized there was danger involved, but it had never been done before and I wanted to be the first to try.

Duby started his engine and we were ready to go. We agreed that if he thought I was in danger he would immediately shut off the engine. I also told him that if I was in trouble I would raise my left hand. Then he would stop the engine. Our signals were straight, and off we went. Here I was situated in front of a huge engine, holding my camera in my right hand and holding on for dear life with my left.

Duby started slowly down the course and increased his speed gradually until he got a "roostertail," at the same time keeping a close eye on me. When I saw the "roostertail" I started to shoot. My body absorbed most of the vibration and bounces of the boat. We made two rounds around the 3-mile course in the Detroit River. When Duby docked the boat he quickly came to see how I was. I told him that I was okay, just a little shaken from the bounces. "We were going one hundred and one miles per hour," he shouted.

I had taken about 30 shots, and half of them showed blur from the constant bounces. Believe me, it was not a smooth ride. The venture paid off, however. The picture series ran on page one of the sports section. Also, I was made a lifetime member of the 100 Mile Per Hour Club on Water — Backwards.

(**right**) A **Free Press** staff photographer took this picture of me as I sat in the pit area of the engine and prepared for my ride backwards. (**below**) My position in the boat enabled this unique shot of the "roostertail" effect because of the unusual angle of view.

Robert Frost

ASSIGNMENT: Get feature shot of Frost at U. of Detroit.

I was given an assignment to cover Robert Frost, who was making an appearance at the University of Detroit. When I arrived at the lecture hall, poet Frost was on stage, almost ready to speak. I quietly moved up front to find a good position. The light had been dimmed for the lecture. The rostrum in front of him was high, and from my angle on the floor looking up I could see only the top of his head. I moved around to the side for a better angle and climbed the five steps that led up to the stage for elevation. This was perfect, a good side view. I now had a profile with excellent rim lighting. I slipped the 180mm lens onto my camera to get a good-size image to fill the frame. I set my shutter speed at 1/125 sec. and the aperture at *f*/4. Then I waited for the right time to capture the moment on film when Robert Frost began to recite his poetry.

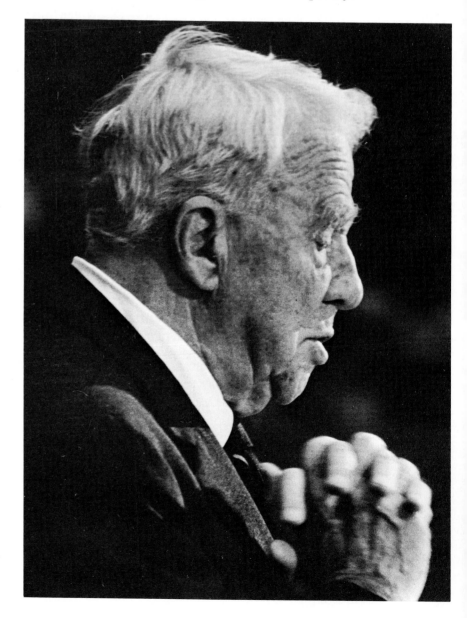

Poet Robert Frost during a lecture at the University of Detroit. I positioned myself so that rim lighting outlined his profile, creating a kind of halo effect.

Dr. Martin Luther King

ASSIGNMENT: Get several feature shots of Dr. King at Grosse Pointe War Memorial, 8:00 P.M. For final edition—need prints by 9:30 P.M.

When I arrived at the War Memorial, Dr. King and several other guests were seated at the usual speakers' table. I used my 85mm lens and Nikon camera for the photos, positioning myself along the side of the table for a profile shot. There was a moment of silence . . . and a great opportunity for a photo of Dr. King with his hands clasped in silent prayer. That was my shot. I knew I had captured a special view of Dr. King, one that showed both his strength and his gentleness.

I printed this one photo, which ran five columns on the front page. One month later Dr. Martin Luther King was assassinated. This was the last picture taken of him in Detroit. The photo ran again on page one with a black border. It was picked up by both wire services and transmitted throughout the world. Mrs. King requested a copy. Requests for reprints come in even now.

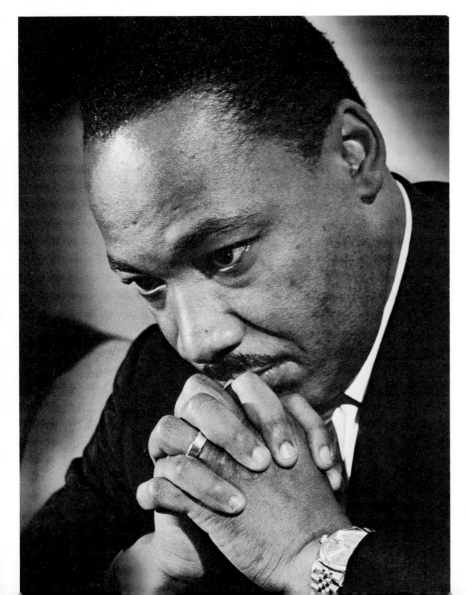

Dr. Martin Luther King preparing to speak. This portrait illustrates both the strength and the gentleness of the man.

81

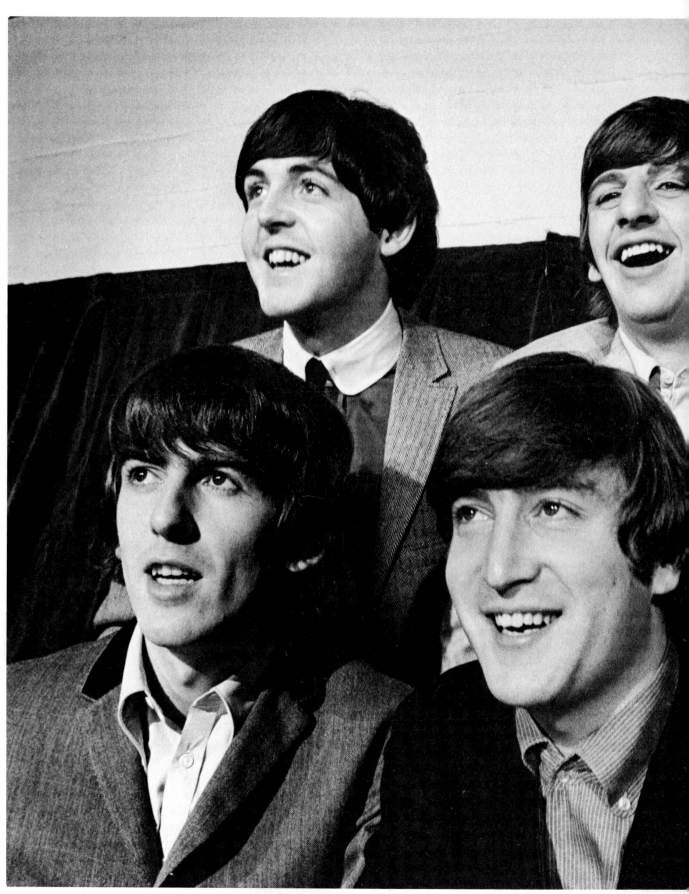

The Beatles: bottom, George Harrison and John Lennon; top, Paul McCartney and Ringo Starr. All four seemed quite at ease here in the dressing room before their first performance in Detroit's Olympia Stadium in 1964.

The Beatles

ASSIGNMENT: Cover the performance of the Beatles. Get group shot, performance shot, and crowd shot.

The Beatles were coming to town. They were the heroes for the generation of young people. They stormed America in 1964 and inspired a kind of hysteria called "Beatlemania." Over twelve thousand fans were present to greet them at Olympia Stadium for their first performance.

Preparation

I started by calling the public relations person at Olympia Stadium. I told him that I needed a picture of the group in the dressing room before they went out on stage. He couldn't guarantee the dressing-room shot but gave me clearance for the performance pictures. I met with Nick Londes, the general manager of Olympia, to see if I could get a shot in the dressing room. He said that there would be no problem because he was going to see them before they went out on stage and I could go in with him.

Shooting

About an hour before the performance, Nick and I went to the Beatles' dressing room. He asked them if they would pose for a picture before they changed into their performance clothes. They all were agreeable and laughed and joked with us. This was an exclusive shot because no other media people were permitted in the dressing room.

Then I went out front and found a good position to take shots of the group during the performance. When they came out on stage, there was total hysteria. Just think of twelve thousand fans screaming — some of them trying to throw themselves into the aisles in their eagerness to get close to the Beatles. It was pandemonium. The crowd was so loud that their noise drowned out the music. I did manage to get my shots of the Beatles performing on stage, although it was difficult because when two of the Beatles would be looking out the other two would either have their backs turned or their faces covered by the microphones.

After the performance shots I moved to the second level in preparation for capturing the crowd as the Beatles left the stage. I had discovered in advance the aisle the Beatles would have to take when exiting, so I waited there for my shot. They came, one at a time, escorted by police. I managed to get a shot of John Lennon as he waved to the shouting fans.

Equipment

I didn't carry much equipment with me—just my Nikon FTN with two lenses, 35mm and 180mm, and my strobe with an extension cord. In the dressing room I used my 35mm lens with the

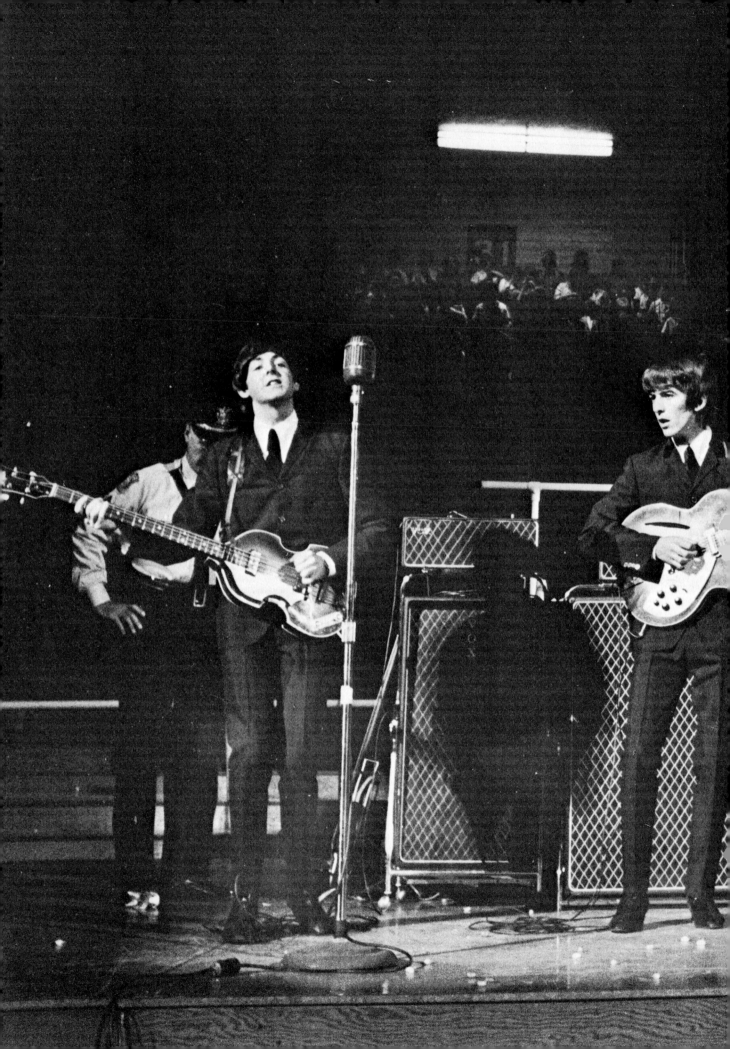

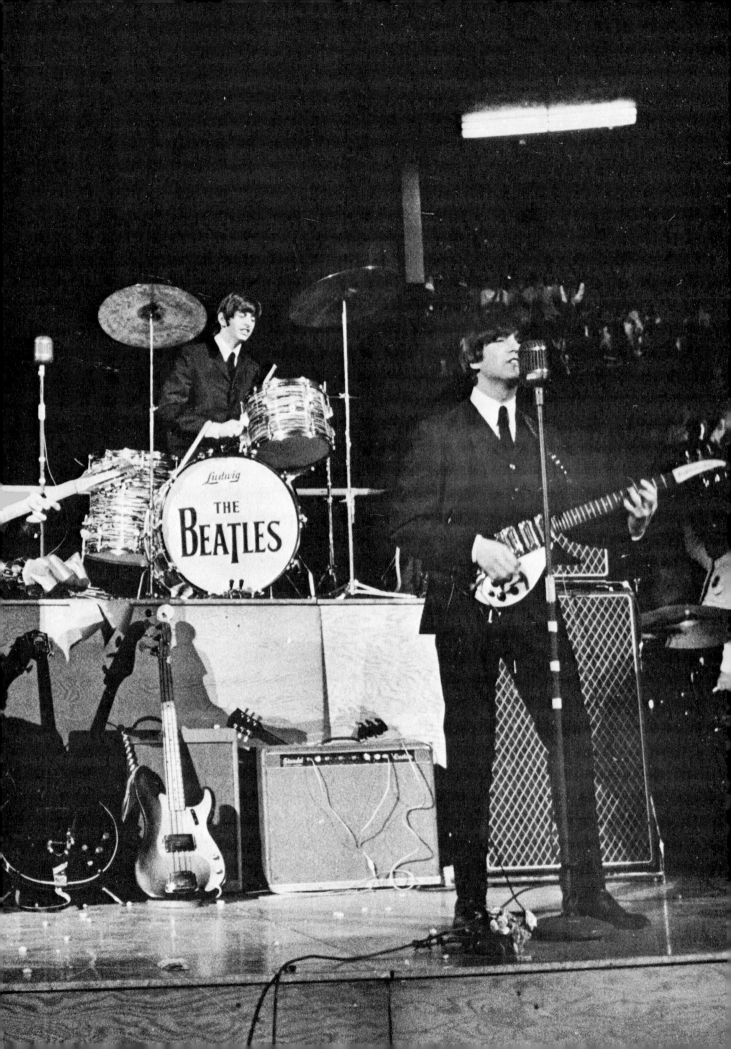

strobe off to my left to eliminate flat lighting. For the stage picture I took advantage of the stage lighting. I stood on a chair I borrowed from one of the fans, who were all standing and screaming, because I needed elevation for a good angle of the stage. The picture of the fans was taken with a strobe at 1/60 sec. at $f/8$.

Screaming fans try to reach the Beatles as they exit after their performance.

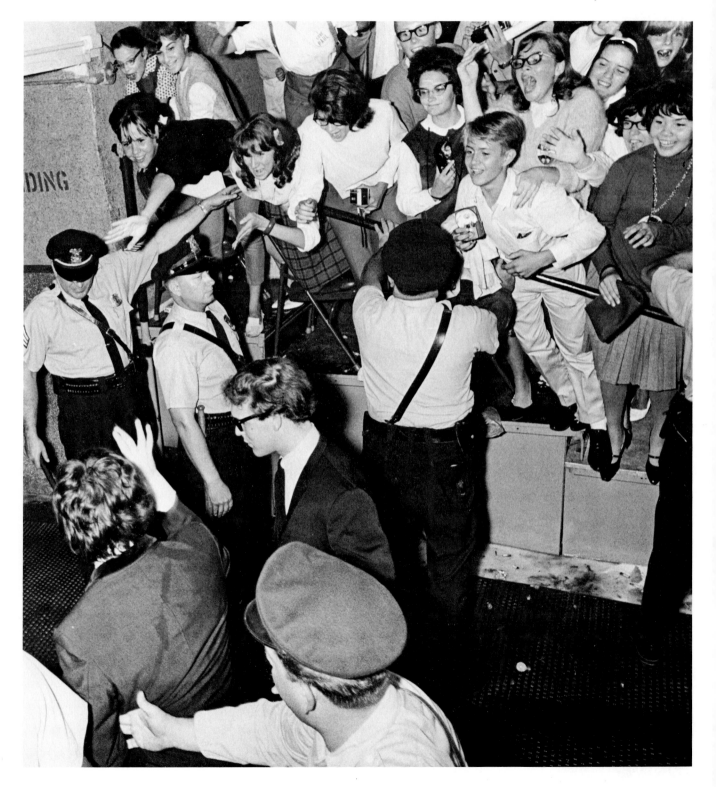

The Disappearance of Jimmy Hoffa

ASSIGNMENT: Get some candid shots of Jimmy Hoffa, to update our photo files. Since you know Hoffa, make your own arrangements. No hurry.

Because I personally knew Jimmy Hoffa, president of the Teamsters Union, I called him for an appointment at his home in Lake Orion. He was very busy, but I finally got him to agree to let me take some candid pictures. He told me that the best time would be early in the morning, at about 9:00 A.M. The appointment was set for July 30, 1975.

When I arrived at his home, two huge German police dogs were roaming the inside grounds. As I approached the gate the dogs started barking, so I waited there. In a few minutes, one of Hoffa's aides came to escort me inside. We walked into the house, where Mr. Hoffa was just finishing breakfast. He asked me where I wanted to take his picture, and I told him that I had noticed a picnic table in his yard and would prefer a picture of him outside his home for an informal look.

He took a last sip of coffee and said, "Let's go," and we went outside. I asked Mr. Hoffa if he would sit at the edge of the table, with one foot on the bench and his elbow on his knee. With my Nikon F2 and 85mm lens, I started to shoot. We talked while I was shooting, because this is the best way to get candid expressions and keep the subject relaxed and less aware of the camera. During our conversation, he told me that he didn't have much time because he had a luncheon engagement and he had to do a few errands for his wife, who was on vacation in Florida. I had been clicking away, so as not to waste time. For my final picture of him, I used my 35mm lens for a full-length shot. I had exposed two rolls of film. These were the last pictures taken of Jimmy Hoffa, and I was the last journalist to speak to him.

On the following morning while driving to work, I heard on the news broadcast that Jimmy Hoffa was missing. The initial reports were that he might have gone on a short business trip without informing his family. When I arrived at the *Free Press*, I immediately went to the city editor to get further details. I told him that I had just taken pictures of Hoffa at his home. I also told him that the disappearance was strange, because Jimmy Hoffa had told me that he had a luncheon meeting that afternoon and didn't mention any plans for going out of town. The city editor said that he'd keep me informed of any developments. In the meantime, I printed up a complete set of the pictures.

Jimmy Hoffa disappeared on July 30, the same day I took his pictures. We ran a picture of Hoffa on the front page on July 31, mentioning that the picture was taken on the morning of Hoffa's disappearance.

After the picture ran in the paper, the FBI came rushing to the paper to talk with me. The clothes Hoffa was wearing were the

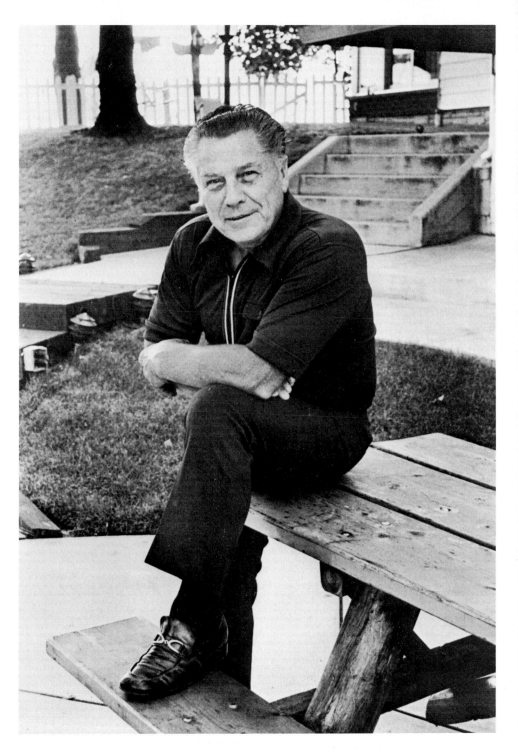

These are candid shots of Jimmy Hoffa taken for the paper's photo files. Little did I know when I took them that Hoffa would disappear later that day. The photos became important in the government investigation of the disappearance.

same clothes he was last seen in, according to his aide at his home, the FBI had said. They asked for a full set of pictures and also asked me what Hoffa said while I was photographing him.

The story now had become national news, and *Newsweek* magazine contacted me right away. They wanted some color shots. I had shot only black and white. I told them that I had color taken of Jimmy Hoffa at an earlier date, but they were only interested in the last photos that I had taken, and they wanted a complete set. Five days had passed by, and Hoffa was still missing, so my pictures became more and more valuable. *Newsweek* ran one in "duo-tone" on the cover and several inside.

Jimmy Hoffa is still missing as of this date.

Jousuf Karsh

> **ASSIGNMENT:** Need a mug shot of Jousuf Karsh for page three.

When my good friend and great portrait photographer Jousuf Karsh came to Detroit with his exhibit of portraits, I was assigned to get a mug shot of him. But I wanted more than just a head shot, I wanted an environmental portrait. I called him at his hotel and made an appointment to meet at the Detroit Institute of Arts, where his exhibit was showing.

Preparation

I was going to use my 35mm Nikon F2 camera. For lighting, I planned to use my Vivitar strobe off the camera, with an extension if the existing light was bad. After talking with Karsh, I asked him which was his most famous portrait on exhibit. He pointed to Winston Churchill. I asked him to stand about eight feet from that portrait. I wanted to use my 85mm lens for the shot. There was a strong spotlight falling on the right side of his face, which created a lighting problem for me. I had to use my strobe in order to balance the light on his face. This was done instantly, without his knowledge. Because he is bald, I aimed my strobe down toward his chest so that the main source of light would not fall on top of his head. I also wanted to make sure that I would get a small highlight in each of his eyes. I then composed my picture with Karsh in the foreground and the portrait of Churchill in the background. The existing light exposure was a 1/30 sec. at *f*/5.6. I balanced the strobe to equalize the existing light so that it would not go dark. I knew that Karsh was observing my movements, but our approaches are different. I am a photojournalist and have to work fast to meet deadlines in my work, and he is a portrait photographer, accustomed to working at his own pace. Karsh works with 4×5 and 8×10 cameras. My picture session lasted no more than five minutes. The picture appeared on the front page of our second section. Karsh, after seeing the picture in the paper, requested several copies.

Tips for Taking Portraits

Here are a few hints for shooting portraits. First of all, you must combine reality with flattery. You need good lighting if the existing light is poor. Selection of the lens is important. The 85mm lens was my choice because it allowed me to keep a reasonable distance, yet still get a head shot. Never use a wide-angle lens: the distortion is too obvious in a portrait. The acceptable direction of the light to be placed is one-quarter lighting, with a shadow on the side of the person's face.

If a man is bald, shoot from a low position, using no hair light or back light, and try to blend the top of his head with the background tone. For a person with a long nose, try to have him or her face the camera. Lower the main light and the camera position, and have the person look up. For a heavyset person, use low-key lighting and have him or her wear dark clothes in order to blend in

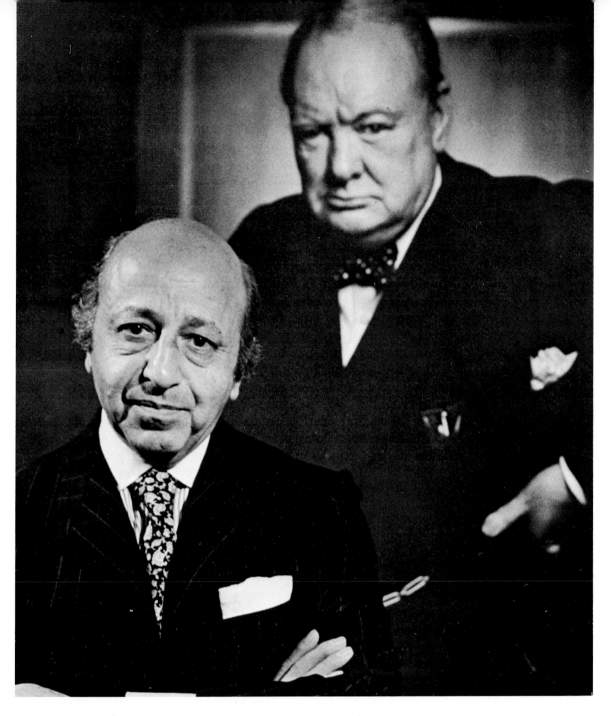

with the background. Double-chin problems are easy: just raise the main light, with the camera in a high position, at least six inches above the eyes, with the light casting a deep shadow under the person's chin.

Recognizing the faults of your subjects will come automatically with practice. (Make sure, if they have any, not to mention them while taking the picture.) Try to flatter your subject if you can, and try not to be frustrated. Be pleasant and show the person you care about the results.

Teenagers are a different story, they need the opposite of flattery. Make them laugh by saying that you hope they don't break the camera when you take their picture, or some such nonsense. This kind of humor turns them on and will make them relax more so that the end result, in most instances, will be a natural photograph.

An "environmental" shot of portrait photographer Jousuf Karsh, which includes his best-known portrait of Winston Churchill. A spotlight illuminated Karsh's right side, so I had to balance it with a strobe, taking care to angle the strobe correctly to equalize the light.

Frank Sinatra

Because of deadline requirements , I couldn't stay at the concert any longer than one-half hour. If it started late I could stay, with no time to spare, until 8:45 P.M. The ticket designated a seat up front which meant I had to shoot straight up at the stage. The position was terrible, so I moved back into the stands, which are elevated. I asked the head usher if I could shoot from the aisle. He said it would be fine, providing I didn't block the spectators' view, and that I must make room for people to pass.

The 180mm lens was perfect from this position. The angle was a good straight shot of Sinatra on the stage.

The performance started right on time and I took some candid shots of him singing. My best shot was when he lifted the microphone off the stand and held the cord in his left hand. The exposure was a 1/250 sec. at $f/4$. Instead of getting a solid black background from this angle, I was able to include some images of the crowd.

I left the stadium at 8:30 P.M. and had the print on the picture editor's desk by 9:20 P.M. This shot ran six columns on the back page.

Frank Sinatra performing at Olympia Stadium. I shot from the stands with a 180mm lens using available light.

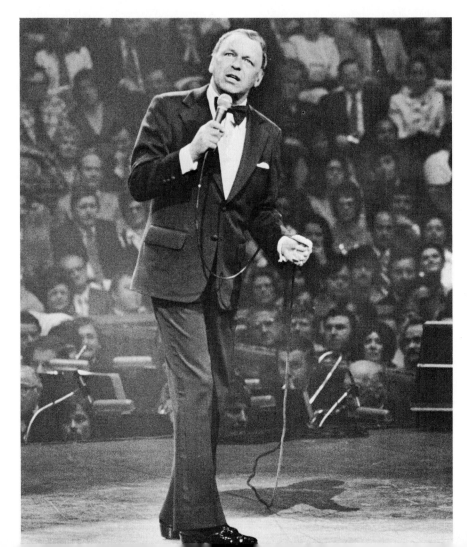

Lee A. Iacocca

ASSIGNMENT: Private interview with Iacocca, Chrysler World Headquarters, 10:00 A.M.

This portrait of Lee Iacocca, Chairman of the Board of Chrysler Corporation, was made during an interview with our newspaper on how he managed to get Chrysler Corporation out of debt and put it back into good financial shape.

One can't always count on good existing light when going on such assignments, so I always take along a strobe unit with a long extension cord. In this case I was right. The light in his office was all overhead, casting deep shadows in his eyes. I had to set up the strobe. I casually set the bare-bulb strobe on my light stand in one corner, and plugged in my 20-foot synch cord. I like to work from behind the interviewing reporter and move around to various positions. I chose the 180mm f/2.8 lens, which allowed me to keep a good distance away and still get a head shot. I shot at eye level, keeping my subject in the viewfinder and waiting for that shot that would tell it all. Midway during the interview, he lit his favorite cigar, and when he exhaled, that was my shot.

The light was placed at a distance of 15 feet.

Lee Iacocca of Chrysler Corporation during a private interview.

93

Divining Rod

ASSIGNMENT: Need photo to illustrate a story on the water shortage for Sunday section.

We had a tremendous water shortage in our area, and the *Free Press* was planning a story for the Sunday section. I remembered having read that in the old days a man with a divining rod was often used to find water. I suggested the idea and the editor agreed that it would be a good shot for the story.

A friend of mine knew of a farmer who knew such a person. I headed for the country and was taken to the farm of the diviner. He agreed to pose for a picture. I told him I wanted the real thing—the actual procedure he used when he went on his venture to locate water underground. He was a professional "dowser," or water finder. He said he was able to locate water underground by the use of a forked hazel twig which, by twisting in his hands, led him to the place where a well could be drilled. Like the "homing instinct" of certain birds and animals, the dowser's ability lies beneath the level of conscious perception; and the forked twig acts as a tool to interpret and direct the power. Because of the mystery that exists, he is also known as a "water witch."

The picture I had in mind had to be dramatic. To capture the mood, I posed the dowser in a position so that I could put my flash on the ground, aiming it directly up to his face and casting shadows upward. With a long extension cord hooked to my camera, I shot up toward the sky.

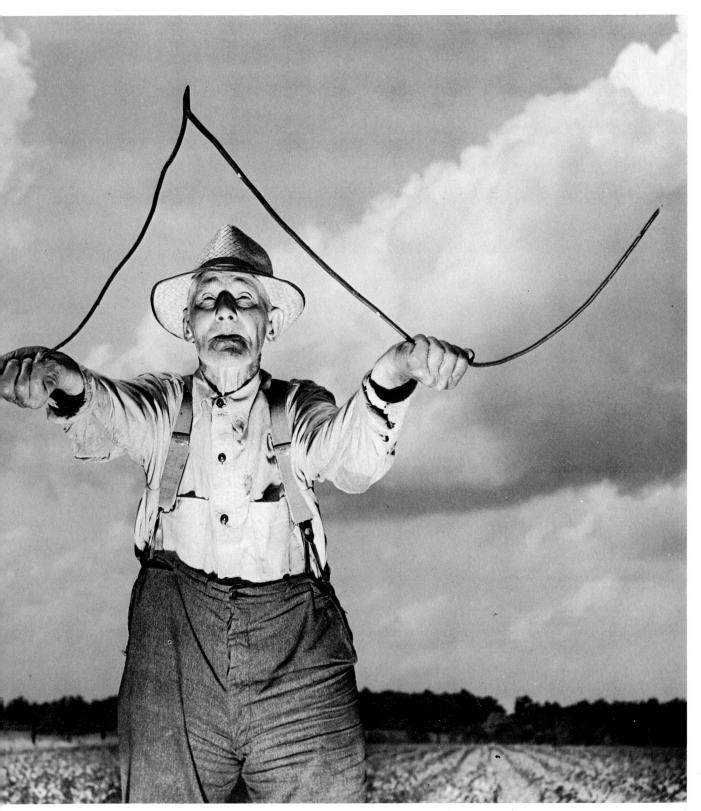

A divining rod being used to locate water. The shadows cast by my flash created a dramatic photograph in keeping with the mystery of the subject.

Russia

Russia announced that thirty masterpieces of art from the Hermitage in Leningrad would tour the United States. Detroit was one of the four cities chosen to exhibit this great collection of art, at the Detroit Institute of Arts. An idea came to me for a series of photographs illustrating Russian culture, to run in the paper during the exhibition. I typed out a memo to the managing editor, explaining in detail a series of pictures to be taken in Moscow and Leningrad to be published during the exhibition.

The managing editor seemed interested in the idea and called me to his office to elaborate. I told him that I had several good ideas on picture possibilities, such as the people, their culture, candids, and ending with a series of photos of the Hermitage, origin of the art collection. He liked the idea, providing that I could get permission from the Soviet government to take pictures in the Hermitage and the two cities.

Preliminary Arrangements

I wrote to the Russian Embassy in Washington, explaining that we intended to run a series of pictures during the Hermitage exhibition in Detroit. A couple of weeks later, the embassy answered that there would be no problem for me to take pictures in Moscow and Leningrad. All I needed was a visa and a letter explaining my purpose for visiting Russia, being a journalist. I immediately applied for a visa, enclosing a cover letter and a biography of myself.

It took about three weeks to get my visa from the embassy. I checked with our travel agent for transportation. I would fly to New York and from there board the Russian plane Aeroflot, flying to Moscow via London. I was given eight days to do the photo story, four days in Moscow and four in Leningrad.

I didn't want to take a lot of camera equipment with me, because I was afraid they would get suspicious if I carried all of that around. I took only two Nikon F2's and three lenses—the 15mm, 35mm, and the 180mm—a pocket-sized electronic flash with an extension cord for off-camera shots, 30 rolls of Tri-X, 36-exposure film, and 10 rolls of Ektachrome ASA 400 daylight color film. I was told before I left that the majority of my shots would be used in black-and-white, but I took along color film just in case a color shot could be used during this series.

Never having been to Russia, I checked with some journalists from the Associated Press who had visited there. I heard all kinds of stories: don't exchange money on the black market or sell clothing, especially blue jeans; if I were caught exchanging money or selling clothing, my chances of returning to the United States would be slim for at least some time; also, that my every move would be watched and that my hotel room would be bugged. Well, I had no fear because I knew that my approach and attitude would

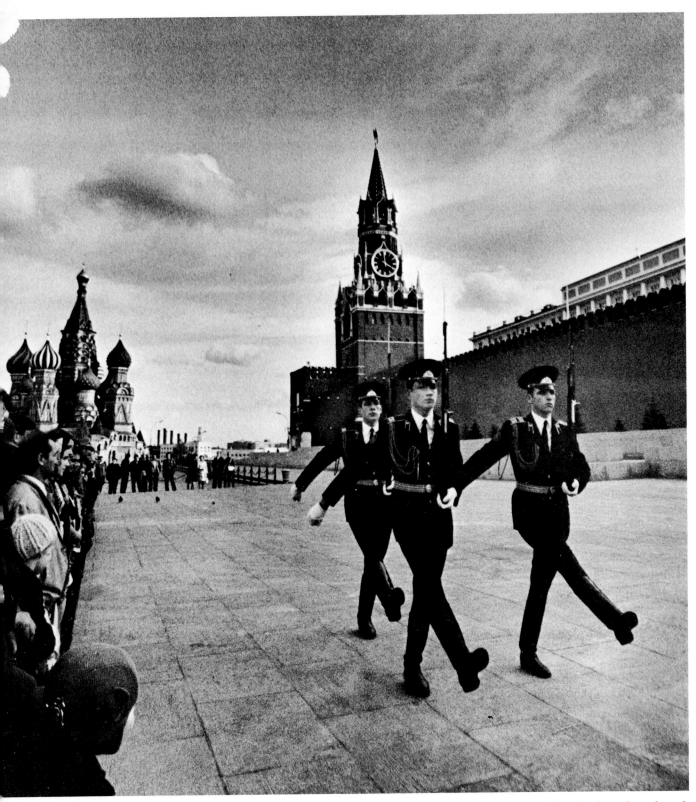

Changing of the Guard in Red Square. A crowd of several hundred people gathered to watch the impressive sight, and I happened to be at the right spot to get the goose-stepping soldiers and the surroundings. (15mm lens)

be sincere and that I would be trying to do an honest photo reporting job. I was really looking forward to my trip.

During my flight to Russia I had plenty of time to plan my schedule. I would only have about three days of actual shooting time in each city. My first day in Moscow I would do a series at Red Square and go to Gum's department store. The second day, photograph the subway, and the third day, take people shots. This was just a basic plan, easily changed if any better ideas came while I was there. In Leningrad I would spend time taking pictures at the Hermitage. In a total of six days' shooting time I knew I wouldn't do much sitting around.

Shooting

During my time in Moscow I went first to Red Square, which was a beautiful sight, with St. Basil's Cathedral and Lenin's Tomb. I spent the three days just as I had planned, walking around and photographing people and scenes that would convey a sense of everyday life in Russia.

In Leningrad I spent an entire day at the Hermitage and the rest of my time there walking around shooting street scenes. It was a very pleasant time. All of the officials I met were helpful and I had no feeling of being watched or suspected. At the airport in Leningrad I declared all of the exposed but undeveloped film and the officials were very cooperative.

A group of schoolchildren visiting the Hermitage. The window light provided backlighting, and I exposed for the faces of the children.

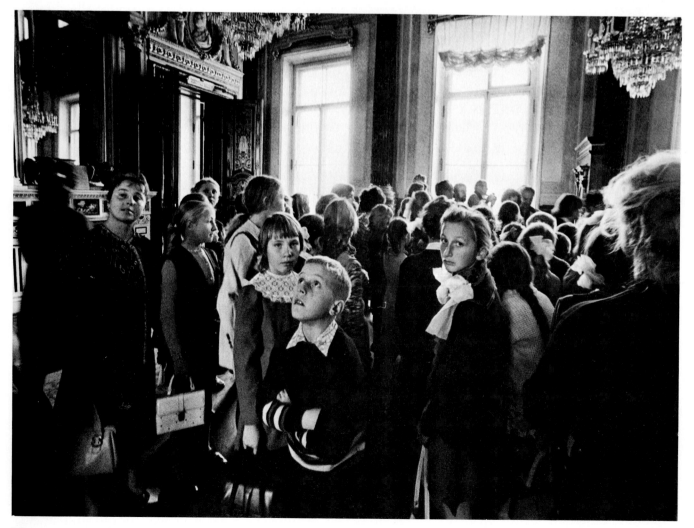

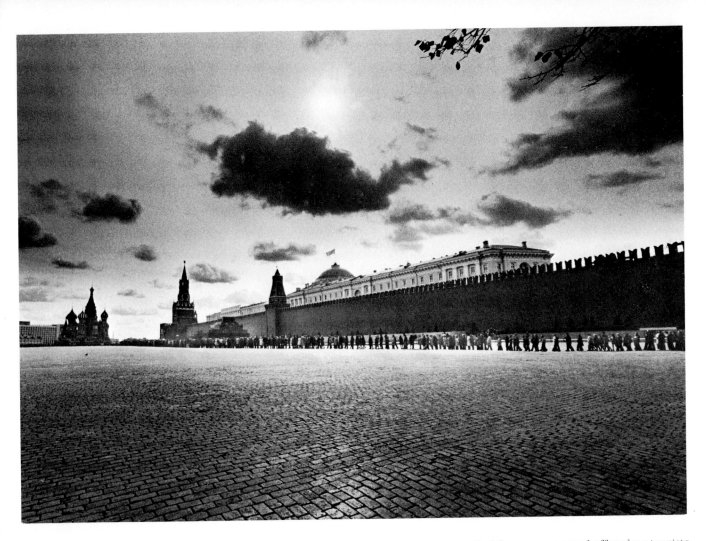

Editing

Upon my arrival back at the paper I reported to the managing editor and told him what pictures I had. I developed all of my black-and-white film in D-76 for 7 minutes, made contacts of the 22 rolls, and separated and marked those taken in Moscow and Leningrad. I printed up a set of 8 × 10's, about 20 of Moscow, 15 of the Hermitage, and 20 of Leningrad, to give them an idea of the content of the picture story I had. They were really pleased with the pictures and suggested that I take them to the Detroit Institute of Arts for them to take a look. Bob Rodgers, the public relations director of the Art Institute, was impressed and suggested that it would be a good idea if about 40 of the photos could be exhibited, in conjunction with the Hermitage traveling exhibit.

The *Free Press* ran three separate stories. The first was a series on Moscow; the second a series on Leningrad, and the third on the Hermitage: all positive photo stories with text that I wrote. These appeared in the paper a week before the Hermitage exhibit opened at the Art Institute.

When the director of the Hermitage traveling exhibit saw the photos displayed at the Art Institute, he asked if the pictures could accompany the Hermitage exhibit on the rest of the tour. I was honored and pleased by his request and agreed to lend him the photos. From Detroit they went to the Los Angeles County Museum and from there to Washington, D.C. and New York.

Red Square was roped off and no tourists were permitted while Russian people visited Lenin's Tomb. At this angle the towers, people, wall, and church stood out. If I had taken the picture head-on at a 90-degree angle, all the elements would have blended together. Composition helps to communicate the photographer's vision to the viewer, and here it gives perspective and a feeling of the scene. A yellow filter on the 15mm lens brought out detail in the sky.

Man in Manhole

A good photojournalist always looks for interesting enterprise shots. As I was driving down Grand River Avenue, I saw a man peer out of a manhole. My first impression when I saw this was of a head on the street. I quickly pulled over to the curb and asked the man if I could take a shot of him. He didn't mind. I took my camera with the 35mm lens and put it right down on the street for a low-angle shot. I couldn't lie down on the street because it was wet from a slight shower, so I removed the prism from my Nikon F2, which makes it much easier to see the image in the viewfinder. From this angle it looked as though the man's head were lying on the street.

The photo ran six columns on the back page and I'm sure the desk had fun writing the caption.

This scene caught my eye as I was driving down the street. Enterprise shots such as this are always welcome at a newspaper.

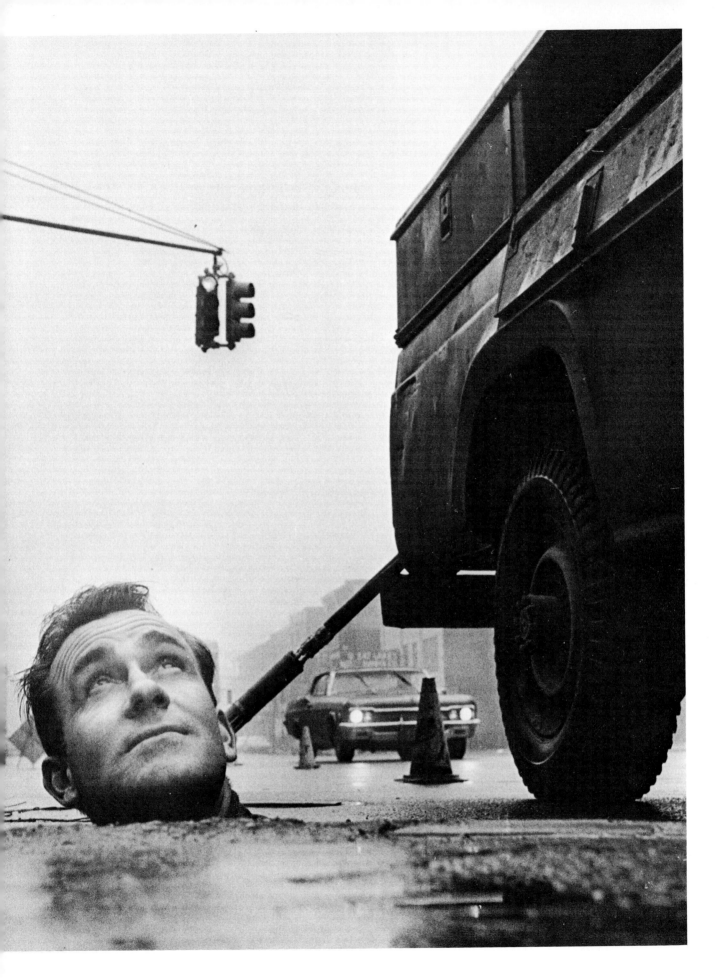

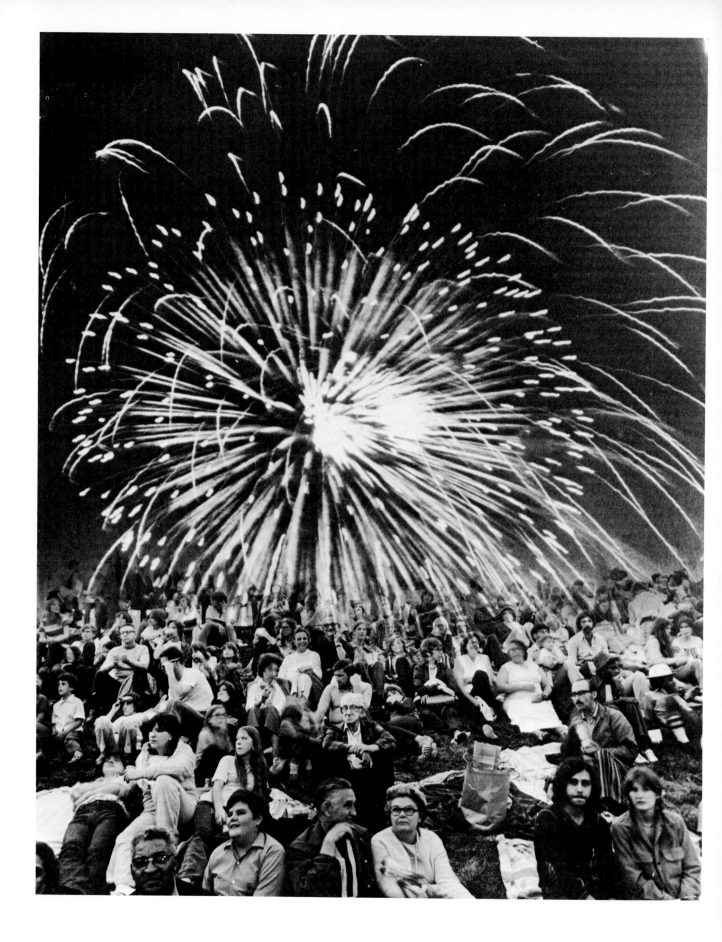

The Fireworks

ASSIGNMENT: Fireworks display, Hart Plaza, 9:30 P.M.

The International Freedom Festival is celebrated in Detroit during the week of July 4. On the eve of the fourth, thousands of people enjoy the huge fireworks display held over the Detroit River. Many sit along Hart Plaza to watch. Each year I try to come up with a different picture. This year I decided to try a double exposure.

When I got to Hart Plaza, I looked for the proper angle for a shot of the crowd. I put my Nikon camera with 35mm lens on the tripod. I wanted to get a picture of the crowd looking up at the display. I filled only the bottom part of the frame with the crowd. The exposure was ⅛ sec., using the existing light in the plaza.

I then used my double-exposure lever for the fireworks shot. I turned my camera around toward the sky and made sure that the fireworks would fill only the top portion of the frame. When the fireworks started I aimed the camera in the right direction and set the exposure on time so that I could get five or six bursts on that same exposure. I had to change my 35mm lens to the 85mm lens for a closer view of the fireworks. I stopped the lens down to $f/5.6$, with focus set at infinity. During the fireworks exposure, I kept the lens covered with the cap and carefully moved it away for about one second when the bursts were at their peak, then quickly covered the lens and waited for the next burst.

After this shot, I took the camera off the time exposure and took a few shots of the fireworks for some additional pictures just in case more than one picture was needed. The paper used the double-exposure photo six columns on the back page.

(opposite) Fourth of July fireworks. First I photographed the crowd watching the display, being careful to fill only the bottom of the frame. I used a 35mm lens with the camera on a tripod. I then switched to an 85mm lens and repositioned the camera so that the fireworks would fill the top of the frame. I shot several bursts of fireworks to get this effect.

Tunisia

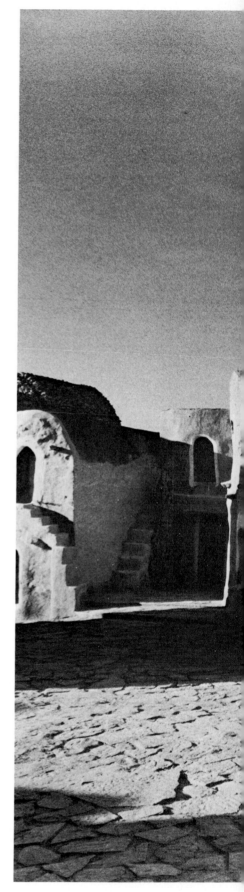

After completing my assignment in Israel, I had a few extra days, and so I made plans to stop in Tunisia on my return trip. I checked with the American Embassy before making final plans. They told me that no visa was required, just an up-to-date health card.

I arrived at the Tunis Airport and took a cab to the hotel. I introduced myself to the assistant manager, explaining my need for a reliable driver for a few days and asking how much it would cost. He told me that he would arrange for a driver who understood English and that I would have to arrange the price with the driver. A few hours later I met the driver and we settled for $40 a day. I told him that I had only a day and a half. After looking over a map, we decided to drive along the Sahal region, which is the Arab name for the seacoast. This region comprises about one-third of the country's population of almost five million. This route would take me through two other large cities, Sfax and Gabes, besides the city of Tunis. I wanted to capture on film the feel of the traditional life style, which offers an interesting contrast with our Western ways.

I took only two of my Nikons and four lenses: the 24mm, 35mm, 85mm, and 180mm. With one camera around my neck and the other over my right shoulder, I walked the narrow streets. I never raised my camera to my eye. I shot from the hip so the people wouldn't be aware of my taking pictures. I set my 35mm lens at $f/11$ if the light was bright or $f/8$ in overcast weather. My shutter speed was set at 1/500 sec. and my focus preset at 10 feet. At this setting I had a good area of sharpness, from about 6 feet to almost infinity when stopped down to $f/11$. This was a good working depth of field: I could pick my shots of the subjects within that area and not worry about focusing for every shot.

One of the interesting places I ended up in was the Berber Village and the ancient village of Ksar Haddada. A *ksar* is not exactly a village but rather a group of small arched structures of mud and stone, often two stories high. From a distance they look like a mass of boulders.

These are some of my photos from my one-and-a-half-day venture.

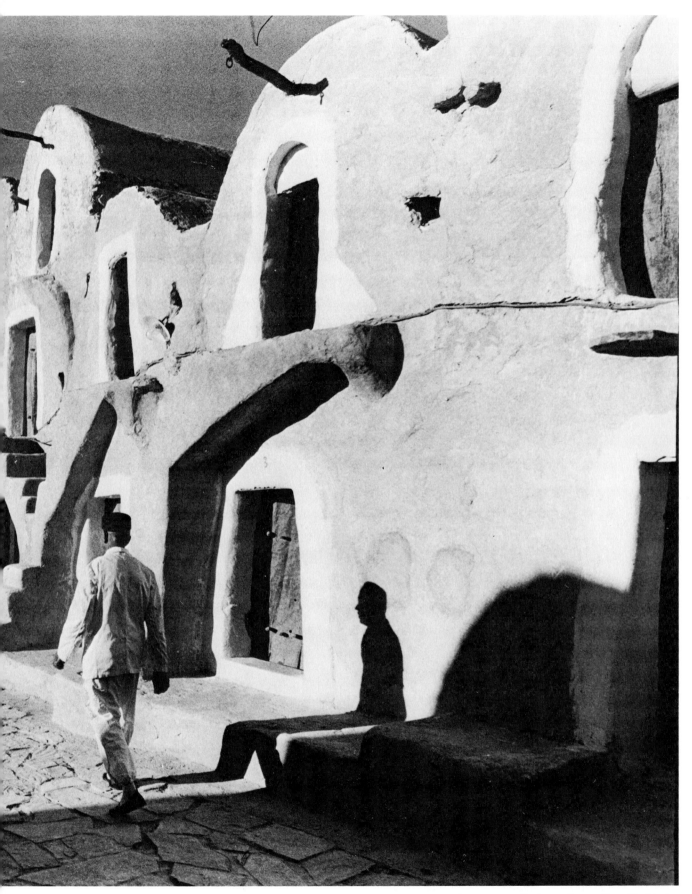

A hotel in the ancient Berber village, Ksar Haddada.

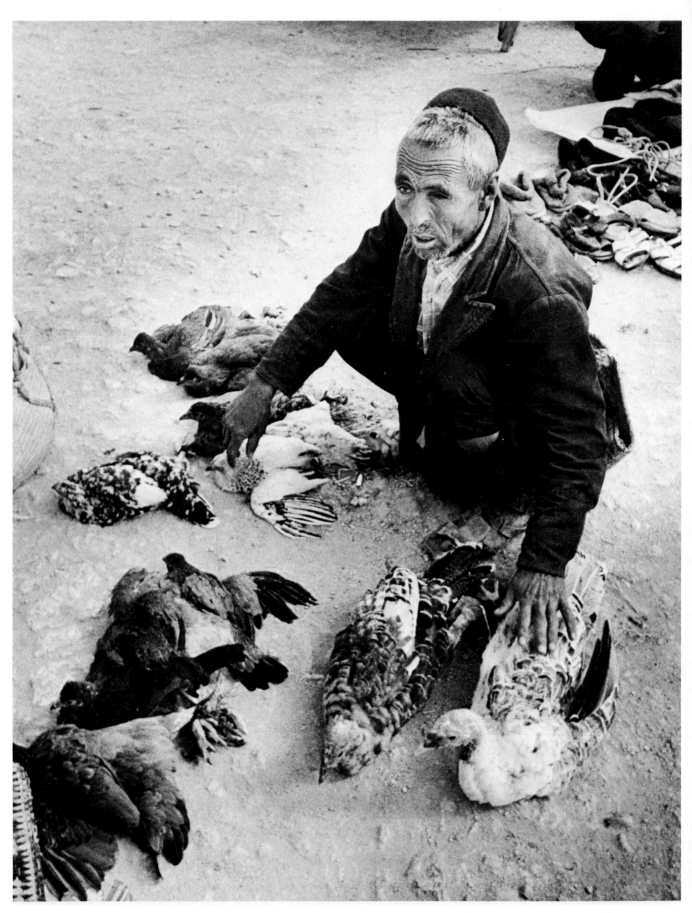

These photographs show the traditional life style still pertaining in Tunisia, as opposed to our modern Western ways.

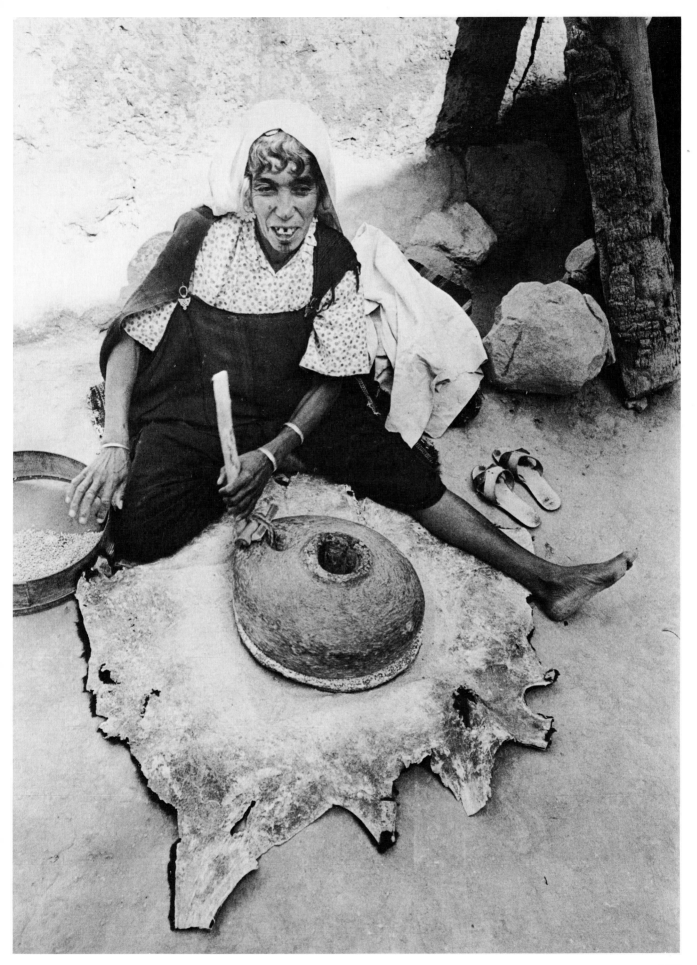

That Ring Around the Moon

ASSIGNMENT: Try for color shot of ring around the moon. Sighting called in by many readers.

The phone rang at 1:00 one morning. I had a feeling it would be the *Free Press*. Who else would call at that time? It was the night city editor on the phone: "We've received over a hundred calls regarding a ring around the moon. Check it out and get a picture if it's possible."

I got out of bed and went out in the cold morning to take a look. I live out in the country, so I could see the sky clearly with no street lights to glare out my view. There it was—a huge ring circling over half the night sky. I had taken pictures of similar rings around the sun, but I had never seen one around the moon. I quickly went back into the house to set up my camera equipment for the shot.

I wanted to shoot this in color, so I loaded my Nikon F3 with Kodacolor 400 film. Since the ring was so huge, I chose the 15mm lens to include the entire view. I mounted my camera on a sturdy tripod and headed outside. It was cold: about 12 degrees above zero. I knew that I would have to take all my shots before going back inside. The camera and lens steam up if they're cold when you enter a warm place.

I placed the tripod on the driveway and aimed the camera straight up toward the sky. It was pitch dark, making it easy for me to look through the viewfinder. I made sure that the driveway lights were shut off. I carried a flashlight to check my shutter and the aperture. In order to look through the viewfinder I had to sit on the cold blacktop.

Shooting

Now I had to figure out the exposure. Taking pictures of a full moon is equal to daylight exposures. The huge ring was about twenty times weaker in brilliance. If I exposed for the moon, the ring would be underexposed. And if I exposed for the ring, the moon would be overexposed. Obviously the ring around the moon was the important element to capture, so I exposed for the ring. The 15mm lens would make the moon very small anyway, and by overexposure I would get a glare that would add to the drama of this phenomenon in the sky.

I started with an exposure of 1 sec., setting the focus at infinity and the aperture at $f/5.6$. In order to avoid camera movement when I pressed the shutter, I set the camera on delay-action, which automatically trips the shutter after 15 seconds.

I bracketed my shots, ranging from 1 to 5 sec. with a few at ⅛ sec. and ½ sec. My best exposure turned out to be the first shot taken at 1 sec.

This huge ring covered an area of 46 degrees radius from the center of the moon. When you look directly up into the sky, it is 90 degrees radius, so this ring did cover just about half of the sky. The 15mm wide-angle lens was my only choice in order to capture the entire scene. I discovered later that the halo phenomenon is caused by ice crystals formed from cirrus clouds. The ring is visible because of refraction from the moon's light.

See color photograph on page 114.

Henry Ford II

ASSIGNMENT: Environmental portrait of Henry Ford II for lead story on front page of feature section.

Ford Motor Company's seventy-fifth anniversary was approaching, and the *Free Press* wanted to run a color cover of Henry Ford. It's not a simple matter to set up a photo of Ford's Chairman of the Board. I have known Mr. Ford for the past 30 years, so I telephoned Ted Mecke, vice-president in charge of public relations, and told him that I wanted to take an environmental portrait of Mr. Ford. Ford agreed and told Mecke to make the necessary arrangements, but he arranged the session for 8:00 A.M., since he was an early riser. The cars were set up at the Visitor's Center in Greenfield Village.

I arrived on location at about 7:15 A.M. to help line up the cars at the angle best for the picture. I wanted Ford to be in the center, with cars on both sides and in back of him. I needed some fill light, so I set up my bare-bulb strobe unit. I also needed a ladder for a little elevation.

Henry Ford arrived exactly at 8:00 A.M. and walked directly toward me with a smile and asked, "Where do you want me to stand?" We talked for a few minutes and I explained to him exactly the photo I wanted to take.

I had predetermined the exposure and was all set to shoot with no time to waste. I took 12 to 15 shots and was through in about 5 minutes.

Before Ford arrived on the scene, I took an overall reading of the existing light in the hall. The reading was 1/30 sec. at *f*/5.6. I needed depth of field and an aperture of *f*/8 would be perfect, so I set up my bare-bulb strobe unit at eight feet, giving me an exposure of *f*/8 at 1/15 sec. This would balance my strobe with the existing light, thus preventing the background from going dark. I used the 35mm *f*/1.4 lens on my Nikon F3, loaded with High Speed Ektachrome daylight film. The small amount of green in the background is from the fluorescent lighting in the room.

See color photograph on page 126.

Democratic National Convention, 1980

ASSIGNMENT: Get overall coverage of event.

The 1980 Democratic National Convention was held in New York City's Madison Square Garden. Requests for credentials were made at the same time as we made them for the Republican Convention, but for only one photographer—me.

I made my hotel reservations when we first started to plan the photo coverage—one year in advance of the convention. The Democratic headquarters for the convention was the New York Statler Hotel, right across the street from Madison Square Garden. There I would pick up all my credentials and information pertaining to the convention. Candidates began arriving a few days before the start of the convention and making appearances and speeches at various hotels, creating huge traffic jams and making it very difficult to get around.

How do you start? What do you do first when you arrive in the Big Apple? I know that writers are concerned about the four "W's"—what, when, where, and why. As a photojournalist, I added a fifth word, "how." The first thing I did was to go to the Democratic National Headquarters in the lobby of the Statler. I sought two important items—a schedule of events and a telephone directory and guide printed by the New York Telephone Company for press use. For me, this telephone directory was one of the most important booklets I've used. It listed all the important convention phone numbers pertaining to all the functions, plus every phone number for all state delegations in alphabetical order, directly to the chairperson of each delegation, along with the numbers of the hotels in which they were staying. It also included a foldout map with all the important places circled and directions on how to get there. This pamphlet had a soft cover and was small, 4 × 8 inches, making it easy to carry either in my pocket or camera bag. It was a valuable piece of information.

The schedule gave me all the data I needed on how to plan my photo coverage. During convention time, getting around in New York is rough. Cabs are hard to find. Some are reluctant to take you to Madison Square Garden because of the tremendous traffic jams. Walking or taking the subway were the only other ways to get there. I overcame this problem by leaving for the Garden three hours before the convention started, and found no problem in getting a cab.

Getting started always seems the most difficult, but after that things begin to fall into place and become routine hard work. I found Madison Square Garden very difficult to get around. To be sure of my timing, I made several dry runs to check on how long it took me to get from one area to another and to the exit. If an exit were jammed, I had to know what would be the next best bet. You

have to take all these measures before the convention starts and have to be sure to know your way around. In order to be prepared, I arrived in New York three days before the convention started.

Before my departure for New York, I made arrangements with Hal Buell, head of AP's photo division, for daily special transmissions from Madison Square Garden to the *Free Press*. The AP had a huge photo set-up right off the convention floor. All I had to do was place my film in one of their envelopes and hand it to them for processing. All of their photographers were shooting at ASA 800, so I had to standardize and shoot likewise if I wanted my film to be processed quickly with no special handling. It would take about 15 minutes before I could edit and select my shots to be printed. After notching my film for the shots I wanted printed, I gave the film to the printer, who printed 4 shots in a little less than 20 minutes. While waiting for my prints I typed out my captions and alerted the *Free Press* that within 15 minutes AP would start transmitting 4 pictures. It would take 7 minutes for each transmission.

All black-and-white photos that were transmitted were of late news happenings. The daily color shots were shipped earlier via American Airlines "priority parcel" counter-to-counter shipment. After each color shipment I called the editor to inform him of what was coming and to have a person at the airport at the proper time to pick up the stuff.

Everything worked well during the four days. It was a busy time, but very satisfying professionally.

See color photographs on pages 122–123.

Futuristic Escalator

I'm always on the lookout for a good color shot—one of those "anytime" kind of shots that can be published when the news content is low. Our science reporter had told me about a fantastic, colorful escalator at the Detroit Science Center, and on one slow morning I decided to take a look.

When I arrived, I told the director that I wanted to get a color photo of the escalator, which was spectacular with moving colors. I loaded my Nikon F3 with High Speed Ektachrome 400 film. The 35mm lens was perfect for this picture. I asked one of the attendants to stand at the top of the escalator, with his arms stretched out on the rails. The radiant colors moved fairly fast down the tunnel-like escalator. My exposure was 1/30 sec. at $f/5.6$, giving me just the depth of field I needed. I bracketed the shots to be sure that I got the correct sequence of colors from the escalator's blinking lights. The colors continually changed. I took about a dozen shots. After processing, I selected this color shot. The picture editor liked it and ran it six columns on the back page.

Picture editors seem to like vertical shots. This may be because the columns run up and down on a page.

(**opposite**) Escalator at the Detroit Science Center. The blinking lights made the colors change continually, so I bracketed my shots to be sure I would get the best sequence of colors.

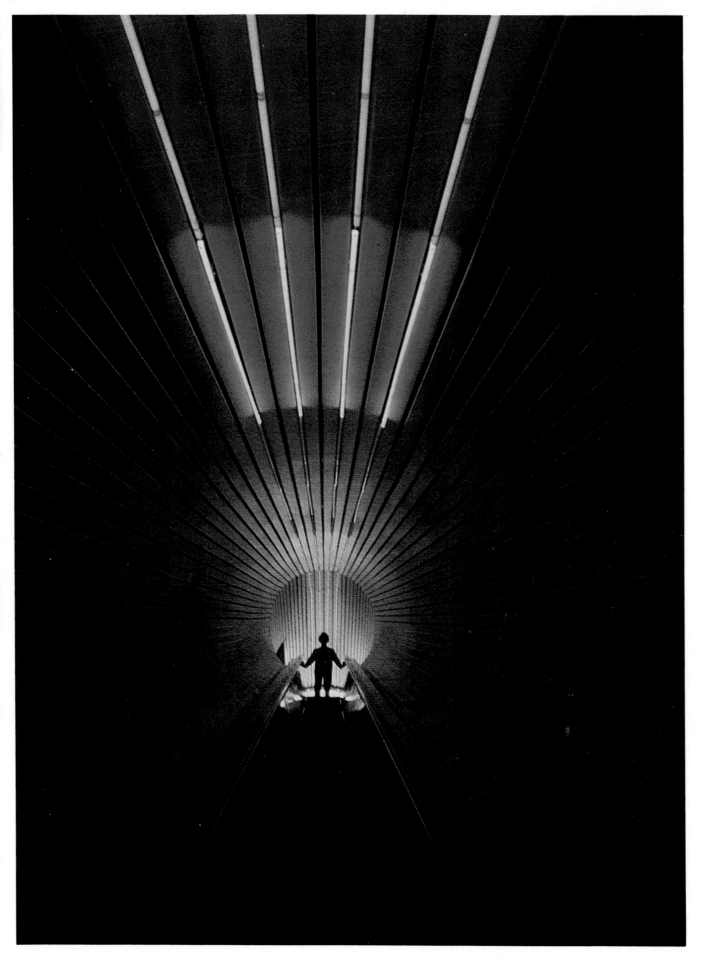

Colorful Fourth of July fireworks captured by exposing first for the structure, on the bottom half of the film, and then getting several bursts of fireworks on the top half.

Exposing for a full moon is the same as daylight exposure, but I wanted to get the ring, which was about twenty times weaker. Exposing for the ring meant that the moon would be overexposed, but that was the best choice in this situation.

The "Upper Room," or cenacle, on Mount Zion, which marks the site where Jesus and His disciples gathered for the Last Supper. In this shot I used my 24mm lens and existing light. There was some daylight, and artificial light of some sort was hidden behind cornices. Since there wasn't much color in the room I used daylight film, but also shot it in black and white. The color effect was more in keeping with its time. Having a figure in the room seemed appropriate, so I asked the person who was there to kneel in the center.

The Dome of the Rock courtyard temple, where Abraham bound Isaac, his son, for sacrifice. Tradition holds that Mohammed visited this site before his ascension to heaven. The rock sheltered by the golden dome is in the center of Mount Moriah, upon which the Bible says Solomon's Temple once stood.

In order to capture all these in one photo I had to consider three factors. First, the sun had to be about at a 45-degree angle to give me good separation between the archway and the dome. Notice how the shadows make all the cracks in the steps pop out and the detail in the dome and the archway. Next, composition: the right angle, capturing the dome through one of the arches. I needed some life in the photo, not very prominent, just some figures climbing the steps. My lens was stopped down to **f**/11 and my focus set at 15 feet. Everything would be needle sharp from 7 feet to infinity.

This is the mountain in Quamran where the Dead Sea Scrolls were found in 1947. The Scrolls were found in cave 4, which is the first cave on the left. This is the deepest spot on earth, 1300 feet below sea level.

The picture was taken around midday with scattered clouds. I waited until the sun appeared on the site alone, like a spotlight shining on the mountain. I positioned myself so the sun would be on a 45-degree angle, giving separation in the mountain slopes and caves plus pattern detail on the site. The picture was taken with the 24mm lens, as I stood at the edge of the cliff facing the caves.

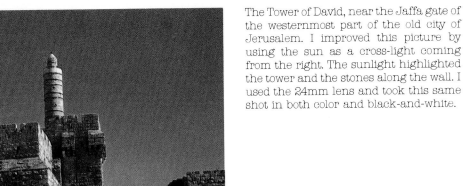

The Tower of David, near the Jaffa gate of the westernmost part of the old city of Jerusalem. I improved this picture by using the sun as a cross-light coming from the right. The sunlight highlighted the tower and the stones along the wall. I used the 24mm lens and took this same shot in both color and black-and-white.

The Western Wall, known as the "Wailing Wall," is the only surviving portion of the great retaining wall of the Temple court from the time of the first Jewish Temple. It is the most revered of Jewish places. I first wanted to get an overall view. Before climbing any of the buildings, I looked for the vantage point that would give me a view of the large square, the faithful, and the entire wall. There were steps on the right that would take me to the top. Once at the top I had to lie on a four-foot-thick wall to get the view you see here. I used the 24mm lens. The divider in the middle of the square separates the women and the men. After this opening shot I was free to get closeup candids of the faithful praying.

Jerusalem's Arab Market is an array of bustling stalls, filled with exotic scents and bickering merchants. Although in close proximity to the Wailing Wall, it provides a fascinating contrast to the solemn holiness of the photograph above.

117

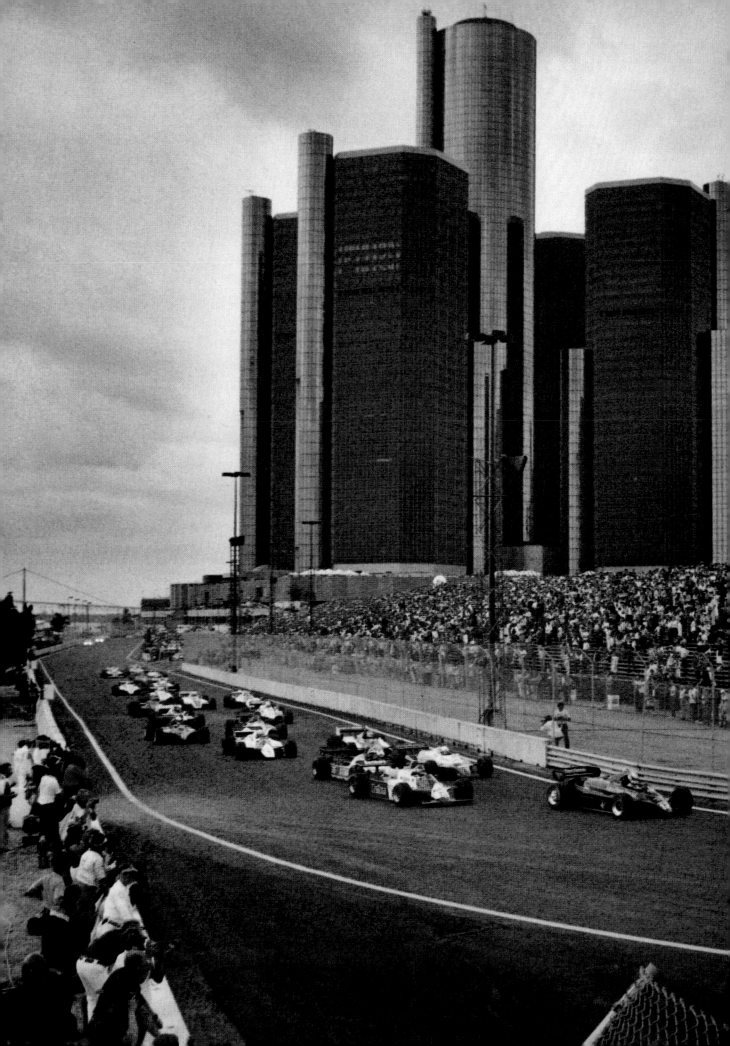

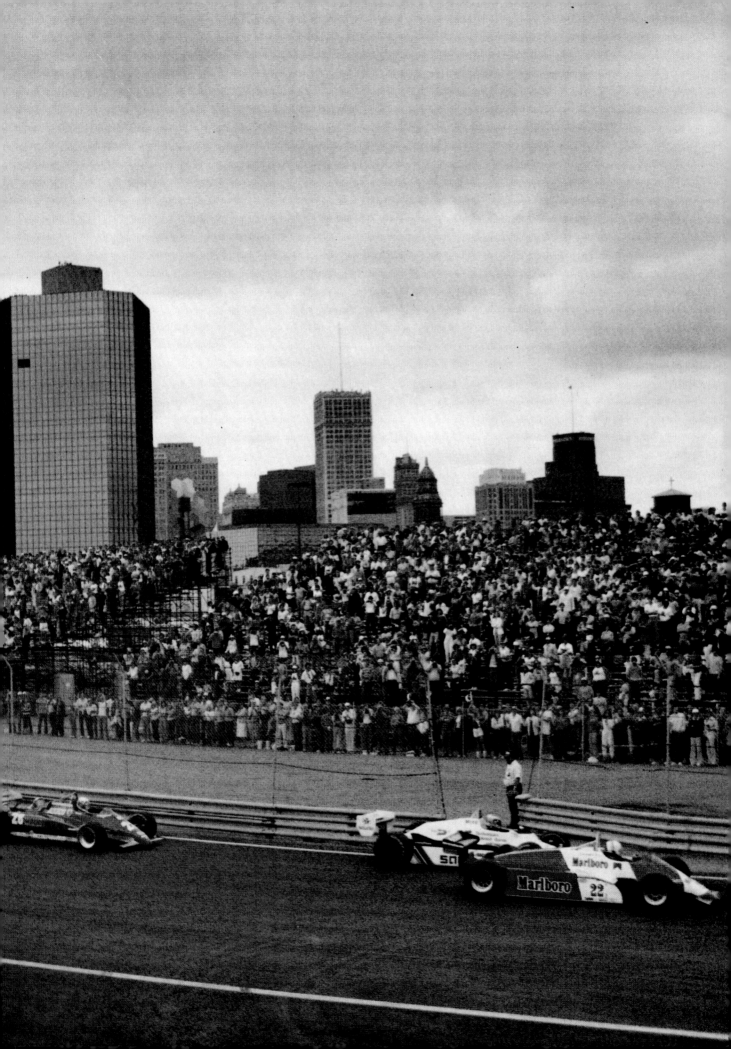

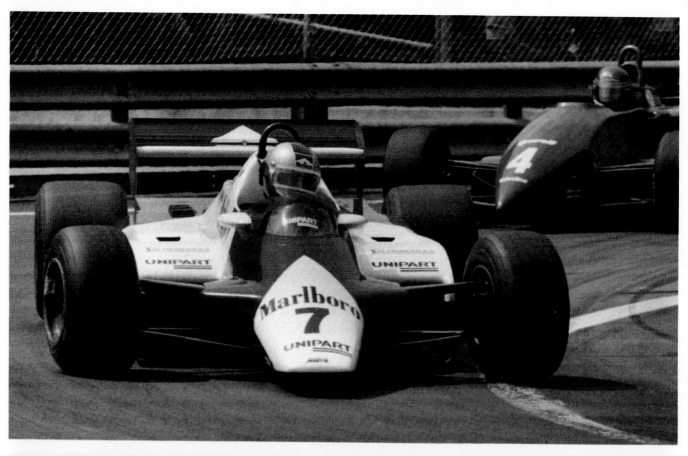

(**previous page**) The Formula One cars whizzing by moments after the start of the Grand Prix, with the Renaissance Center as a backdrop. This view captured the entire setting of the race. Exposure was 1/1000 sec. at **f**/5.6 on Kodacolor 400 film.

(**above**) Winner of the 1982 Detroit Grand Prix was John Watson in Marlboro 7, a McLaren MP4B. Watson earned 9 points and took the point lead for Formula One racing.

(**below**) The Marlboro Alfa Romeo with Bruno Giacomelli driving zooms by on the straightaway at 138 mph. In order to get this blur effect, I took the photo at a 90-degree angle with a shutter speed of 1/125 sec. I kept the racer in my viewfinder from my extreme right and panned the camera with a fast motion, keeping the car in the center of view. The most difficult part was to press the shutter at the precise moment when the car was at a 90-degree angle.

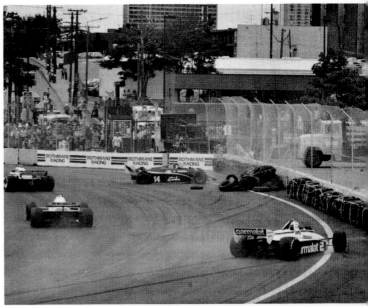

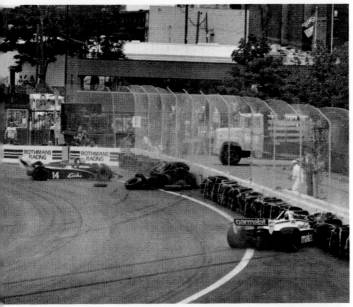

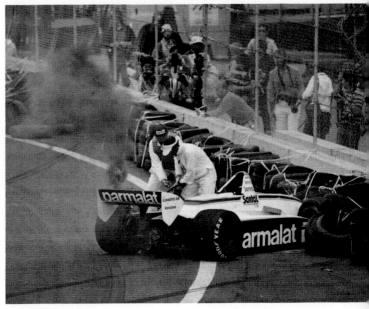

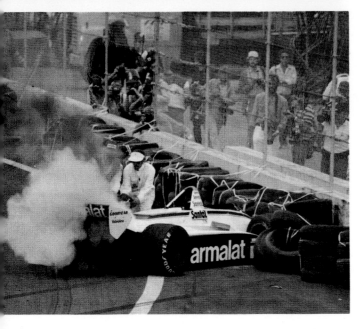

When the brakes froze in Parmalat 2, driver Riccardo Patrese caused car 14, driven by Roberto Guerrero, to skid into the embankment of tires at the first run. Parmalat then hit the wall, and caught fire immediately after the driver had jumped out. Track crews quickly put out the fire. A moment later it would have exploded.

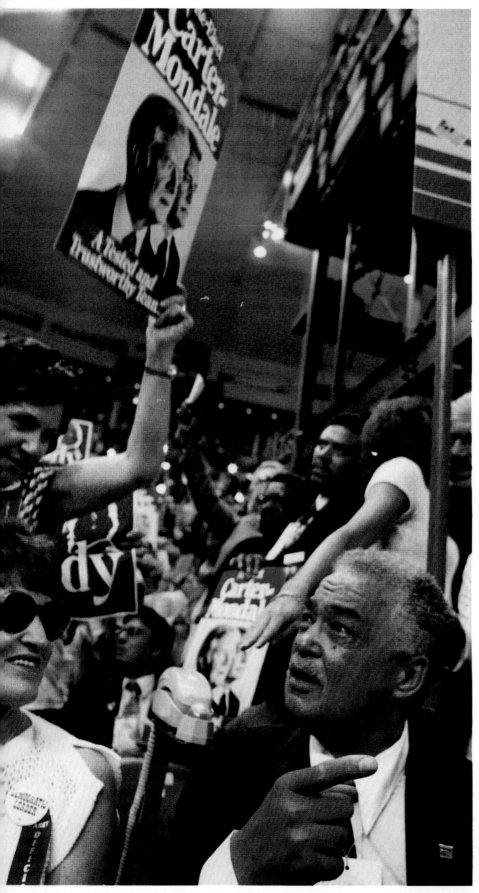

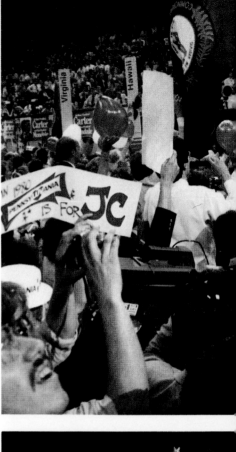

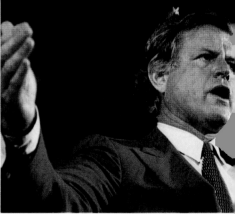

(above) Ted Kennedy made a historic speech from the platform, but lost out in the final roll call of the delegates. This photo was taken with the 180mm lens from the podium side stand position at 1/250 sec. at **f**/4.

(top) The climax, and the picture that tells the entire story of a convention. The center aisle was jammed, making it impossible to move. Once you got into a spot you had to stay there. The center aisle with the media scambling for pictures of President Carter on the podium was a rat race. Cameras were being held up high, photographers standing wherever they could find a place for their feet. It was pandemonium. I took this panoramic view with the Widelux camera, of President Carter and his grandaughter.

I worked my way to the front of the Michigan delegation, where Mayor Coleman Young of Detroit was putting on a strong drive for President Carter. Photo was taken with the 35mm lens as Mayor Young pointed and said, "That's my man for President."

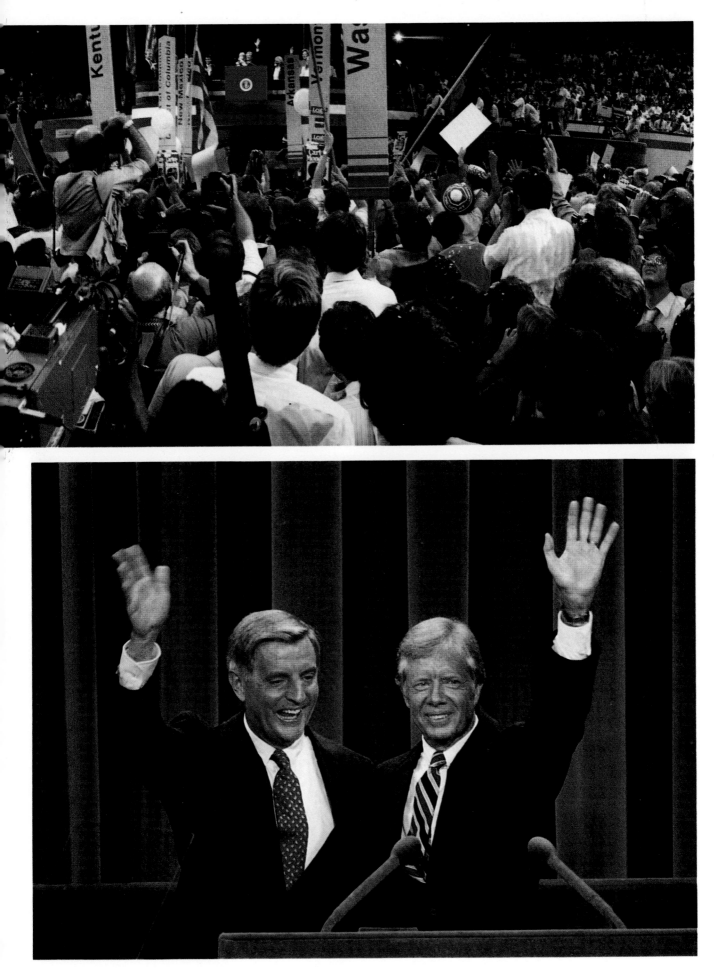

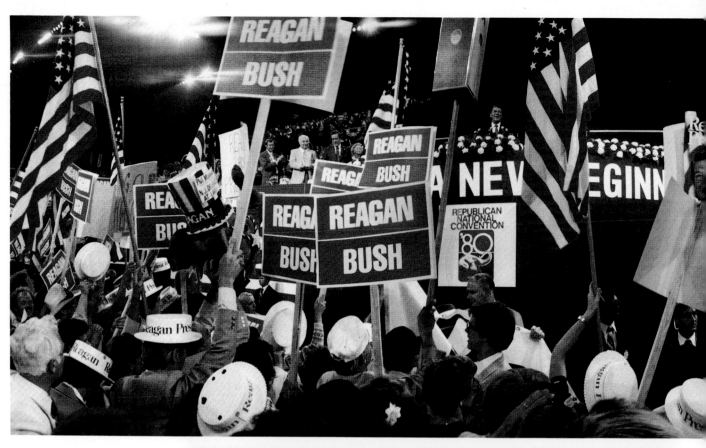

(above) I decided to use the Widelux camera to get a sweeping view of the convention scene. Because of the pandemonium I had to hold the camera above my head to get this shot. It was the lead photo, running eight columns across the front page.

(right) Nominees Ronald Reagan and George Bush on their way to "A New Beginning."

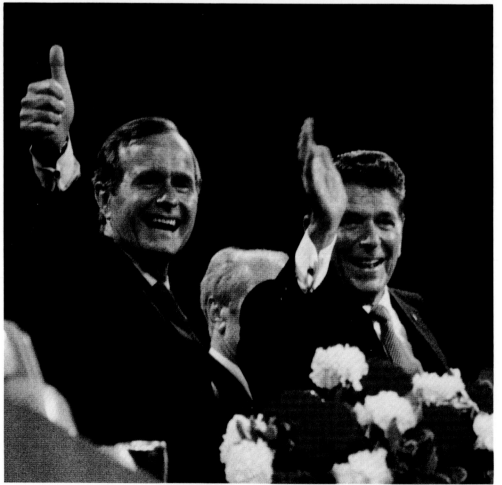

(top) My 180mm lens gave a good shot of Henry Kissinger and his wife seated in the VIP area, which was on the perimeter of the arena on the second level.

(bottom) Ronald Reagan's acceptance speech prompted enthusiastic demonstrations of support, and I had positioned myself to get a clear view of the rostrum.

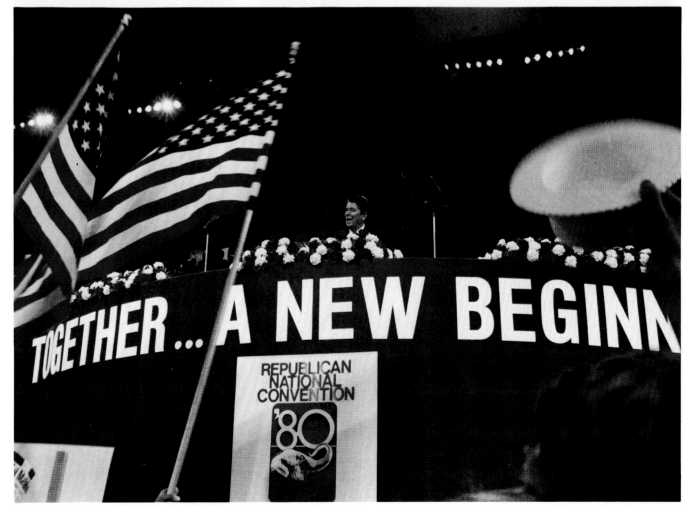

(**above**) Henry Ford II in an "environmental" portrait to celebrate Ford Motor Company's seventy-fifth anniversary.

A portrait capturing the solemn emotion of Mother Teresa during her recent visit to the United States. The Nobel Prize-winning Catholic nun leads the Missionaries of Charity around the world. This photo was taken under the existing light at 1/60 sec. at **f**/8 with the 85mm Nikkor lens and the Nikon F3 camera.

Firemen climbed ladders to rescue the victims of this fire, caused by an explosion. The man helped the woman get on the ladder, and then a fireman carried her down to safety. I used the 180mm lens to get closeups of this action.

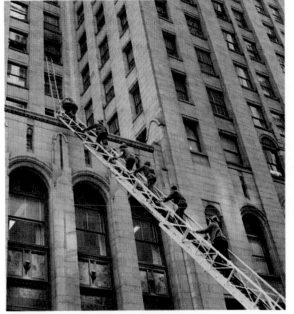

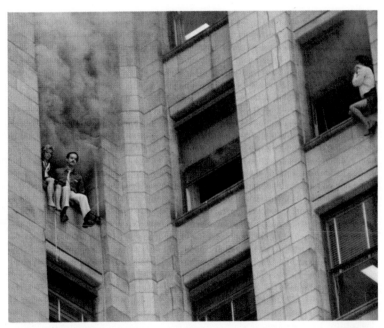

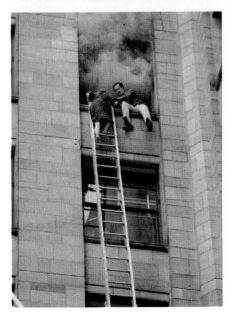

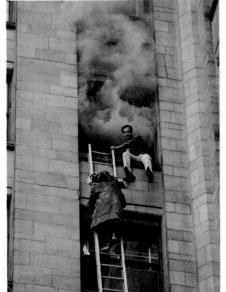

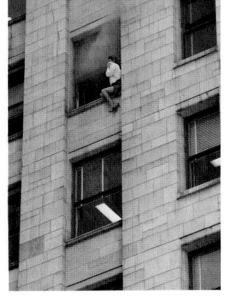

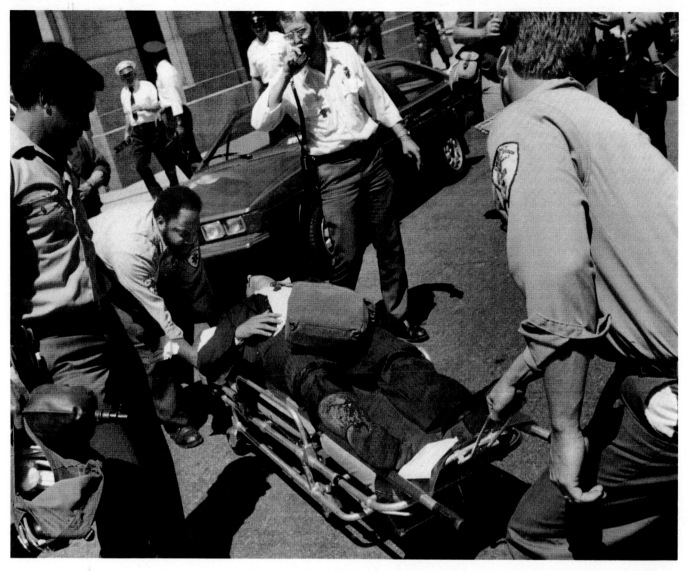

Victims were brought out of the building on stretchers and wheelchairs. I needed a good vantage point to catch all the action, so I asked to stand on top of a fire engine. Often it is the angle from which you take pictures that makes all the difference in their content.

The Buhl Building Inferno

ASSIGNMENT: Fast-breaking, spot news story to hurry to Buhl Building fire in downtown Detroit.

On Friday, June 12, 1982, when most of the tenants, lawyers and business people, were winding up their week's work, the 38-story Buhl Building was suddenly firebombed on the eighth floor.

When the first call came in at the city desk, the report was that someone was being held hostage on the eighth floor of the Buhl Building. I rushed out to the scene with two Nikon F3's and the 24mm, 35mm, 180mm, and 300mm lenses. I also made sure that I had a police press card with me. Without it, I probably wouldn't have been able to enter the area. When I arrived the police had set up barricades to keep the crowd out of the fire zone. I saw smoke coming from the eighth-floor windows and quickly took an overall view. Then I saw victims sitting on the window ledges to escape the flames and intense smoke. I used the 180mm lenses because I wanted to get a little more than just closeups of the victims. I wanted to show part of the building and the smoke bellowing from it. I shot all of the photos on Kodacolor 400 film.

See color photographs on pages 127–128.

The Detroit Grand Prix, 1982

ASSIGNMENT: Plan to make arrangements to cover Grand Prix Formula One car race.

Arrangements for photo coverage of the Grand Prix had to be made several months in advance. Then each photographer had to individually pick up his credentials and sign an insurance waiver whereby the Grand Prix would not be responsible for any accident. The best credential is the Green, which allows the photographer to go into any area, including the pits. The Yellow credential only admits the holder to certain restricted places and does not allow him to enter the pit area. The passes are not interchangeable.

I assigned seven photographers to cover all the major turns, the pits, and the first-aid section. I planned to photograph the start and the first turn. It was a two-and-a-half-mile course through downtown Detroit.

From my position I decided to use the 35mm, 200mm, and 300mm lenses with two Nikon F3's. The key picture was the start, with Detroit and the crowd in the background. The 35mm lens was perfect for this shot.

See color photographs on pages 118–121.

Republican National Convention, 1980

ASSIGNMENT: Assign ten staff photographers to overall daily coverage of convention. Cover activities on convention floor.

The 1980 Republican National Convention was in my hometown, Detroit, Michigan, on July 14 through July 17. As Chief Photographer for the *Free Press*, it was my job to make all the arrangements and to assign 10 staff photographers for daily all-around photo coverage during the convention. My assignment was to cover activities on the convention floor.

Requests for photographic credentials had to be made six months in advance to the United States Senate Press Photographers Gallery. The request had to be made in writing on company stationery and signed by the editor in charge. These credentials are issued only to the working press. The only way a freelance photographer can get credentials is to be hired by a photo agency. Most of the important positions are assigned to priority newspapers and magazines, such as *Time, Newsweek, New York Times, Los Angeles Times, Chicago Tribune, Philadelphia Inquirer, Detroit Free Press* and the *Washington Post*. Since the convention was being held in Detroit, we of the *Free Press* were assigned a position at every vantage point.

Preliminary Planning

Although I've covered every national convention since 1952, I still think political conventions, and other huge conventions too, are some of the toughest assignments to cover. You almost have to be everywhere at the same time because so much is happening simultaneously. You have to be there at the right place, at the right time, and with the right camera and lens. Getting around the jam-packed aisles of the convention floor is almost impossible. You get stuck and have to push your way through with your camera gear, usually by holding it above your head. My choice of lens to work the aisles was the 35mm and the 180mm. It seemed that whenever I came up with a good idea for a shot from an unusual angle, there would always be a dozen other photographers shooting over my shoulders, including TV people. I kept a close eye on situations as they were happening and tried not to go along with the pack. I concentrated on different approaches, composing the photos in ways unlike those of television and the wire services. I feel that the public gets tired of seeing ordinary photos, so I make an effort for the unusual. But I suggest that, before you try for the unusual, be sure and get the usual photo and have that in the can.

Carrying a lot of camera gear on the convention floor isn't a requirement for better pictures. In fact, it can be a handicap in getting around. While working the convention floor I carried two Nikon F3's with three lenses: the 15mm, 35mm, and 180mm. Both cameras had motor drives. I had a small camera case over my right

shoulder that carried the extra lens, film, and the Widelux camera to use for unusual panoramic views. Now it was up to me to come up with good pictures. All my pictures would be taken in color, because the paper uses color on a daily basis. I used Kodacolor 400 film for all my shots. If we needed a black-and-white print, it was very easily made on Panalure paper.

Shooting

The most difficult lens to use on this assignment was the 15mm wide-angle. When you choose to use the wide-angle approach you must know what you are doing. I've seen more bad pictures taken with this lens than with all other lenses combined. I don't mean that it's hard simply to get an overall shot. I mean it is hard to use it to capture your feeling in visualizing the picture. For good wide-angle shots you must have a focal point and try to escape the problem of "wide-angles"—everything blends in together and so the picture does not look sharp. Be creative and move in close, getting a good-sized image in the foreground with the overall view in the background. You can easily get an overall view with a wide-angle lens for documentary purposes. I use it to give me impact combined with good imaginative composition.

Besides pictures in the convention arena, there are many other picture opportunities. These include street scenes, candidates at their hotels, parades, demonstrations, celebrities, and people on the streets selling campaign buttons and souvenirs.

Because Michigan was the key and host state, it was given the center front location on the convention floor. I asked William Milliken, Governor of Michigan, if I could position myself along the center aisle without being harassed by the ushers and delegates, who continually ordered people to clear the aisles. The Governor welcomed me. This was a great advantage because it was up front near the center, directly in front of the speaker's podium.

My key shots were to be on the final day of the convention. I planned to use my Widelux camera for this dramatic moment. It is very effective when used correctly, when the scene warrants it—for a special effect when the angle is important to capture the entire area in one shot. I wanted to get a full sweep of the demonstrators in front with Reagan on the podium. This would be my lead picture. After this shot I was in a good position to shoot demonstrators and delegates with all the hoopla taking place right in front of me.

See color photographs on pages 124–125.

Old Union Depot

ASSIGNMENT: Take some shots of Union Depot showing its traditional character, to go with story about its destruction.

The historic Union Depot in downtown Detroit was about ready for the wrecking ball to make way for a community college. The most famous landmark was the large clock on its tower. My assignment was to capture some of its traditional and familiar scenes that would be recognizable to our readers.

I took the usual exterior overall view, along with shots of the lobby, for the record. I also wanted to capture, in a single photograph, the feeling I had for this old railroad station. I walked to the end of the tracks that lead into the station . . . and immediately I saw the photo I wanted: the railroad tracks, with the station in the background and the old clock visible on the tower. This put the depot in the context of its environment, as well as emphasizing its function.

I used the 180mm lens to compress the distance, bringing the background in closer to the foreground. I needed good depth of field and so had to stop down to f/16. Since the depot was backlit, I compensated and exposed for the shadows. This would also overexpose the highlights, making them stand out much brighter.

After this shot, I entered the depot and climbed up to the tower. There I photographed the manager of the building as he adjusted the dials that would disconnect the operation. I also used him to give a sense of proportion, so the viewer would know how huge the clock was. I exposed for the daylight that came in from the clock. This would make the figures stand right out. If I had exposed for the interior, the figures on the clock would have been completely blocked out by overexposure. These two photographs were the strongest in the series. I used Kodak Tri-X film rated at ASA 400 and developed in D-76.

I used the man to indicate the immense size of the clock face. The human figure is a good standard for showing proportion in photographs.

(overleaf) A shot of the depot in the context of its environment. A 180mm lens compressed the distance between foreground and background to create the effect I wanted. Because the depot was backlit, I exposed for the shadows to ensure detail.

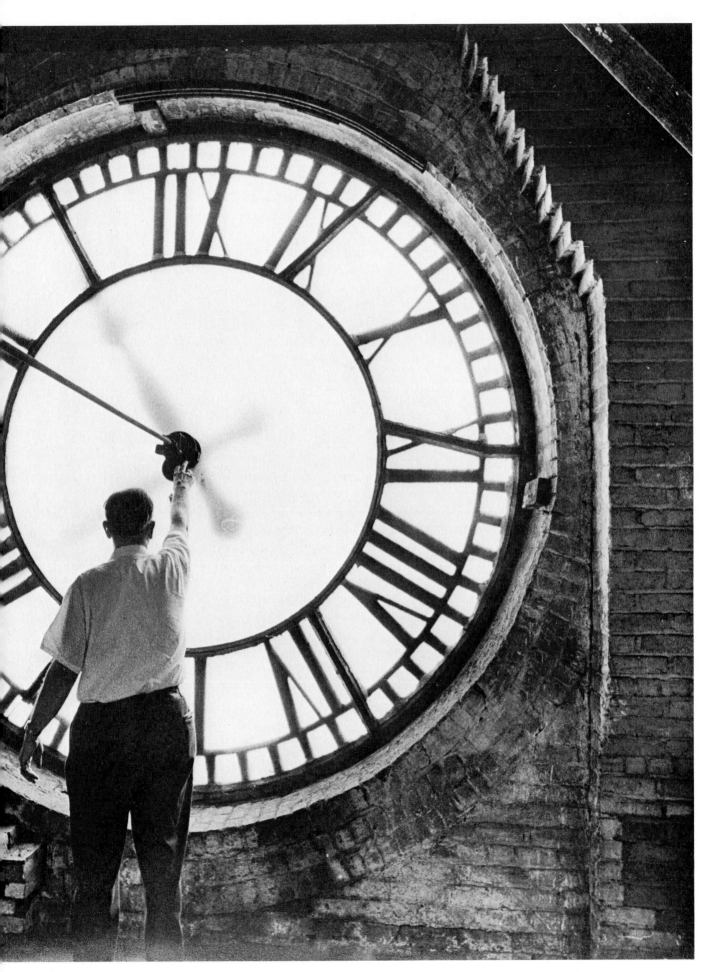

PHOTO STORIES

Virtuoso Performance

ASSIGNMENT : Original idea for series of shots of symphony conductor.

Many photos are taken of symphony conductors during their performances: some from the side, some from the back, and some when they take their bows at the end. I wanted to try a different approach in photographing Aldo Ceccato, conductor of the Detroit Symphony Orchestra. My idea was to sit in the front row with the musicians, resplendent in white tie and tails, as a member of the orchestra . . . to take candids of the maestro in action.

Preparation

I went to the city editor and explained the entire idea to him. He liked it, providing the maestro would agree to permit me to sit in the orchestra during the actual symphony. I then approached the public relations office of the symphony orchestra. I went over in detail with them my plan for photographing conductor Aldo Ceccato. I told them that I would construct a similar music stand, painted the same color as the ones on stage—but it would have a small hole in it for my lens. I assured them that it would be impossible for anyone in the audience to know that I was taking pictures, because the camera would be hidden behind the music stand and would never be raised to eye level. Also, I would be wearing white tie and tails, and so would seem to be part of the orchestra. The public relations director liked the idea very much and said that he would speak with the maestro, who would have the final word of approval.

After a few days, I got a call from the symphony office saying that Mr. Ceccato would like to speak to me personally about the project. I immediately went over and met with him, explaining the idea again. He was dubious as to how I would do it, so we went out on the stage for a practical demonstration. I told him that I would use the existing light and play the part of a musician. He chuckled and agreed. We set Saturday evening as the date. He then warned me that if there were a problem he would point his baton at me, meaning he wanted me to leave. Also, I would have to stay for the entire performance.

When I got back to the *Free Press*, I went to the carpenter shop to see about having a music stand made like the ones used by the symphony. I took the carpenter over to the auditorium to see the music stands and take measurements. I then drew my design for a small platform on the stand to rest my camera on while taking pictures. A hole, the diameter of the lens, was cut out on the front part of the stand. When completed the music stand was painted black, and I could hardly tell the difference from the other stands on stage.

I took the stand over to the Ford Auditorium on Saturday afternoon for a trial run and left it there for my night's performance. I met with the manager of the orchestra so that he could place the

music stand and my chair in the proper spot. I then told him that I wanted to take some test shots and asked him if he would pose for me on the maestro's podium. For my test, I wanted the same lights turned on that would be used during the performance.

Equipment

I had to choose the right camera for this assignment. I had to use a camera with as little shutter noise as possible. I also had to select the right lens—fast enough to be able to shoot at a fast shutter speed under a very bad lighting situation. I decided to use my Leica M-5, with selective through-the-lens metering that would provide me with an accurate exposure measurement of light on the conductor's face. I knew that the light was of high contrast range with an uneven distribution of bright and dark areas, caused by the strong backlights.

For this special assignment I needed the fastest lens made, so I called my good friend, Walter Heun of Leica. (We call him "Mr. Leica.") I discussed the assignment with him and told him what I needed. He suggested the "Noctilux" 50mm, f/1.2. With this lens he said that I could shoot with a wide-open aperture and the image would be sharp, from corner to corner. I told him to air-express one to me right away. There was complete silence for a moment, and then he asked me if I knew how much the lens would cost. I told him that I didn't care, just get it to me right away. I received the lens the following morning with a bill for $1,025.

I was now ready to make my test. The public relations director agreed to help. With the camera up close to his face on the podium I began to take my reading. I knew I had to shoot at 1/500 sec., so I set the shutter speed and started to take the reading with the ASA set at 400. I couldn't get a reading. I then moved up my ASA to 800 and got an exposure of f/1.2, and that was it, the exposure I needed. I then shot a test roll seated from my position and made him move around like the maestro. I developed the film in Acufine for seven minutes and the results were excellent. I was now ready for the assignment.

Shooting

I arrived at the auditorium an hour before the performance so I could set up my camera before the audience arrived and leave it on the stand. I didn't want to carry my camera when I walked on stage with the musicians. I had four rolls of 36-exposure Tri-X film in my pocket, with one roll already in the camera that was on my stand.

There we were, all lined up and ready for the call to go on stage. I walked out with the musicians and took my place in the front row, violin section. The audience applauded and as the musicians took a bow, I did the same. I played the part of a musician, and no one in the audience suspected that I was a photographer. Because the M5 Leica is a rangefinder camera and not a single-lens-reflex (SLR), I could barely hear the shutter click as I took the pictures.

During the first number I didn't take a picture; I wanted the maestro to get used to my presence, and I hoped he would eventually forget that I was there at all. For a while Ceccato was staring at me as though he were eager to bat me on the head with his

baton. After several numbers, he seemed to become accustomed to me. I saw him drift away and sway with the music, and that's when I started shooting.

Now, the camera was in a fixed position aimed directly at the conductor. I had a little leeway and allowed for some extra movements on both sides of the podium. I kept my eyes on the conductor so that I could see his every move. Occasionally I would glance down at my Leica, making sure that all was in place. After the numbers, when the audience applauded, I would get up and take the same number of bows as the musicians did. I was enjoying every moment. Every now and then I would take a quick look at the audience reaction. I saw someone point in my direction, probably wondering what type of instrument I was playing.

During intermission I changed the film in my camera. I also was ribbed by some of the musicians. I didn't see the maestro during intermission at all. As a matter of fact, I wanted to avoid him because he might have said, "I've had enough." When intermission was over I took my position in the orchestra. Now I really was concentrating on the maestro's expressions and hand movements. I loaded and unloaded the camera without looking at it. I did it so that no one saw any movements of my arms. (I had practiced unloading and loading my camera in the dark so that I wouldn't have any problems doing it on stage during the performance.)

The finale was wonderful. I must have taken at least a dozen bows and then applauded the maestro as he kept coming out to take bows.

I had shot four rolls of film, and I went right back to the paper to process it because I was eager to see how all of the shots had come out. I was still wearing my tuxedo, but with a lab apron over it. I processed the film in Acufine for 11 minutes. I couldn't wait to see the images on the negative after the hypo fix, so I took a peek at several of the rolls during the wash. They looked good.

The following day, I made contacts of all four rolls for editing purposes. I selected about thirty shots to be printed, all with different expressions. These are my favorites, and the pictures speak for themselves.

Here I am seated with the members of the orchestra, camera ready but invisible to the audience.

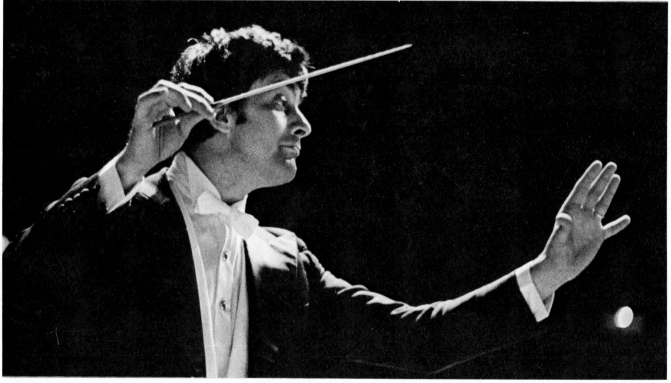

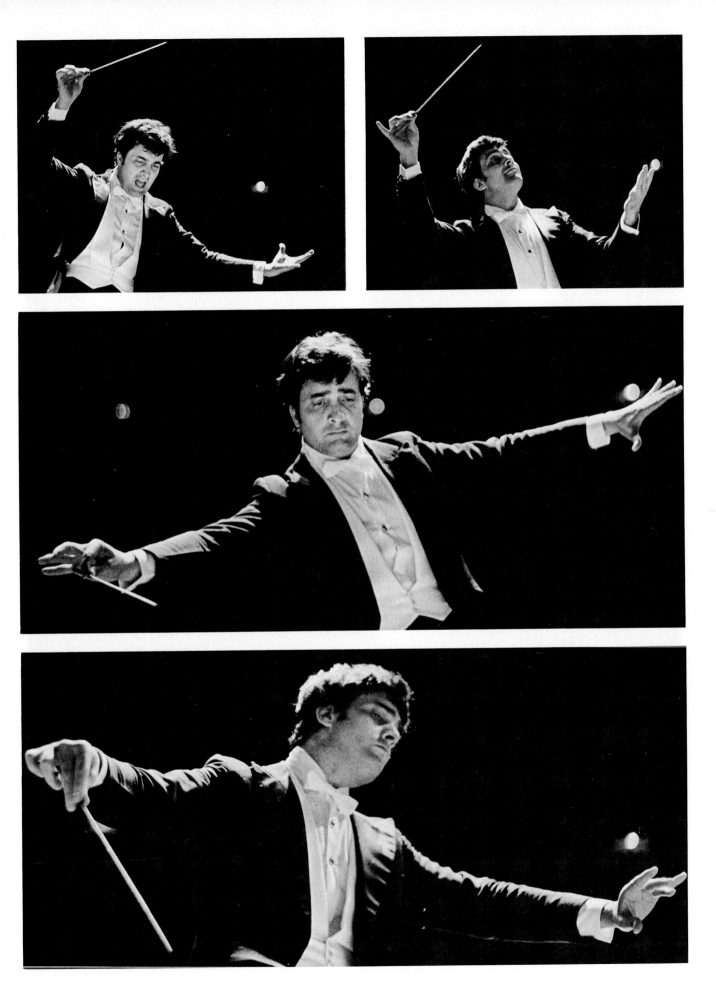

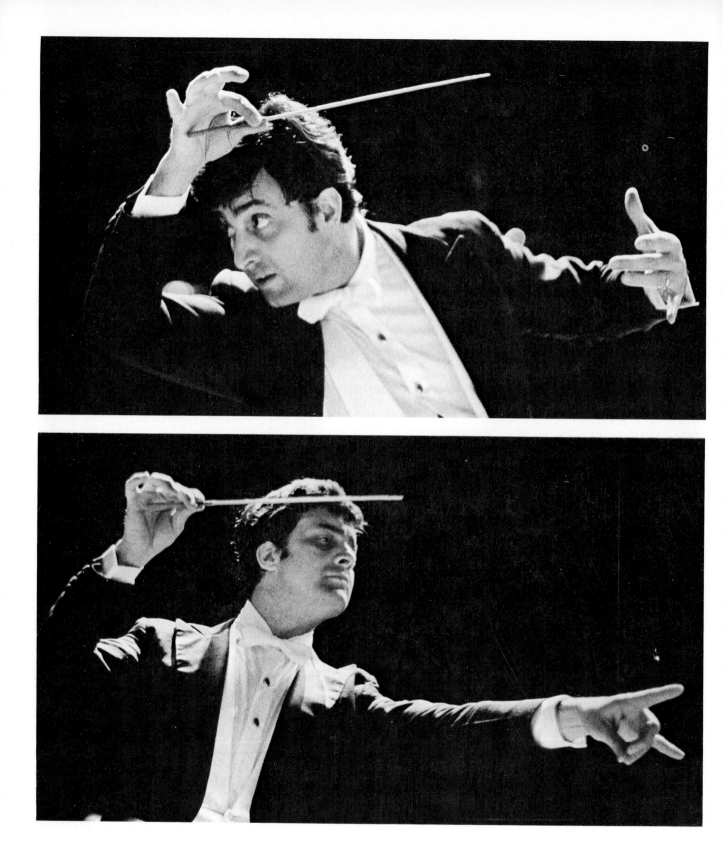

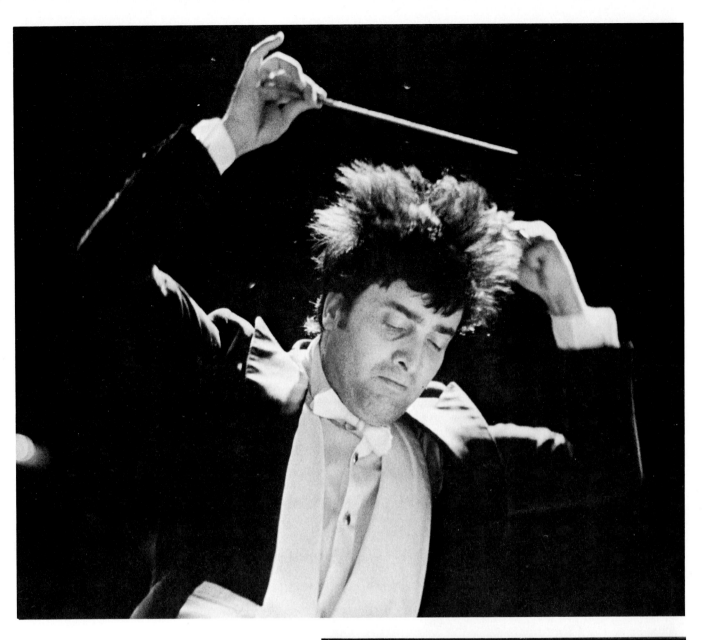

Natural Childbirth

ASSIGNMENT: Photo story on natural childbirth. Make your own arrangements.

I talked with the picture editor about doing this photo story. He liked the idea and asked me if I knew anyone who would agree to be a subject. I didn't, so I called the public relations office of the Crittenton Hospital and explained the project. They told me that the hospital would be agreeable, providing the doctor and the couple would also agree, and gave me the name of a doctor to call. I made an appointment with him to discuss the possibility of the story. The doctor thought it was a good idea and said that he would talk to a couple who were expecting in about two months. The couple agreed, providing it would be done in good taste.

Preparation

I met with the couple to sign a release permitting the paper to publish the pictures. There were some ground rules I had to follow. First, no flash could be used: all the pictures had to be taken in existing light. I also agreed that I would not shoot pictures showing the womb during the delivery. Pictures had to be taken from the side or back.

After all this groundwork, the wait began. The doctor had my phone numbers at home and at the office. He said that he would call me to warn me when the time for the birth came close. After this call came I stayed close to the office and home. If I had to go somewhere important, I left the number where I could be reached.

Late one evening the doctor called to tell me to be at the hospital about 4:00 A.M. He had made arrangements with the hospital personnel for me to go to the surgeons' room, where I had to change from street clothes into surgical garments.

In the Delivery Room

When I arrived at the hospital I was directed to the surgeons' quarters. There I changed clothes and was given a surgical mask to wear while in the operating room. I could carry no extra gear into the room with me—no camera bag or extra lenses. I was told not to use a motor drive because the noise might annoy the patient, the nurses, and the doctor. I took only my Nikon F3 with 35mm lens and four rolls of 36-exposure Tri-X film. All the garments in the operating room were bright green, so my exposure had to be a compromise between green and the flesh tone of the nurses. My reading from the built-in meter of the F3 was a 1/60 sec. between f/4 and f/5.6 on the green garments. The flesh tones were 1/60 sec. at f/4. The ½ f-stop over didn't mean much in the light area, so I shot my pictures at 1/60 sec. at f/4 for the entire sequence.

I was waiting in the delivery room wearing my surgical pants and mask, with my camera ready for the great moment. The mother was wheeled into the delivery room and placed on the table while her husband held her hand through it all. The delivery began. I positioned myself behind the expectant mother's head using a footstool for some elevation. I was very careful of the angles and

didn't want any unfavorable shots (indecent exposures). I moved around quietly and made sure to keep out of the way of the doctor and nurses.

My first picture was of the husband holding his wife's hand during the actual delivery of the newborn. Then I waited for the important moment. From my position behind the head of the mother I captured the entire scene. In the foreground were the mother, the doctor with the baby, and the hand of the father, all in one shot. Then I moved slowly to her left side for my key picture of the doctor placing the baby on its mother's lap for the first time. Her first expressions when she saw her baby were captured on film. The happiness and joy of the moment were recorded.

A little later the nurses handed her the baby as she stepped off the delivery table, to carry back to her room. Because of the careful shooting and no motor drive, I used only two rolls of film.

Editing

I chose four pictures to print and turn in to the picture editor. Be selective and turn in pictures that have impact and good content. One weak picture could weaken the entire layout. Always turn in your best work. If you do turn in a weak picture and the editor uses it, the blame is yours alone. Quality control is a photojournalist's own responsibility.

This was my first shot, the husband holding his wife's hand as the doctor began delivery. I moved in close to get the clasped hands and the expression of pain on the woman's face.

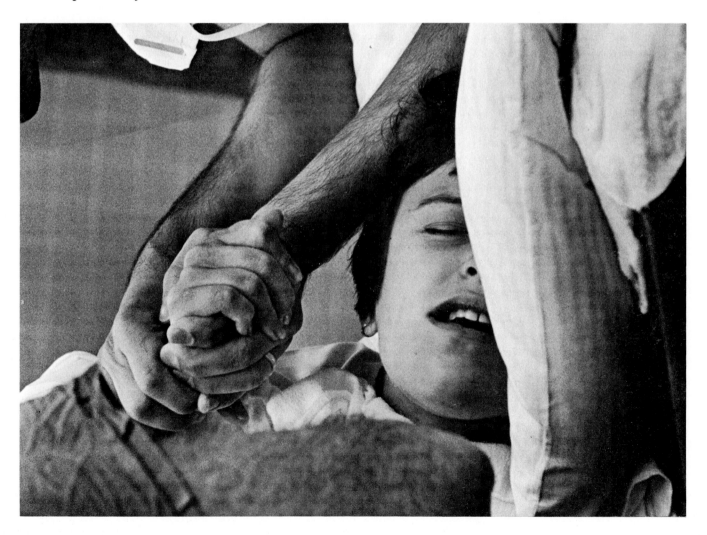

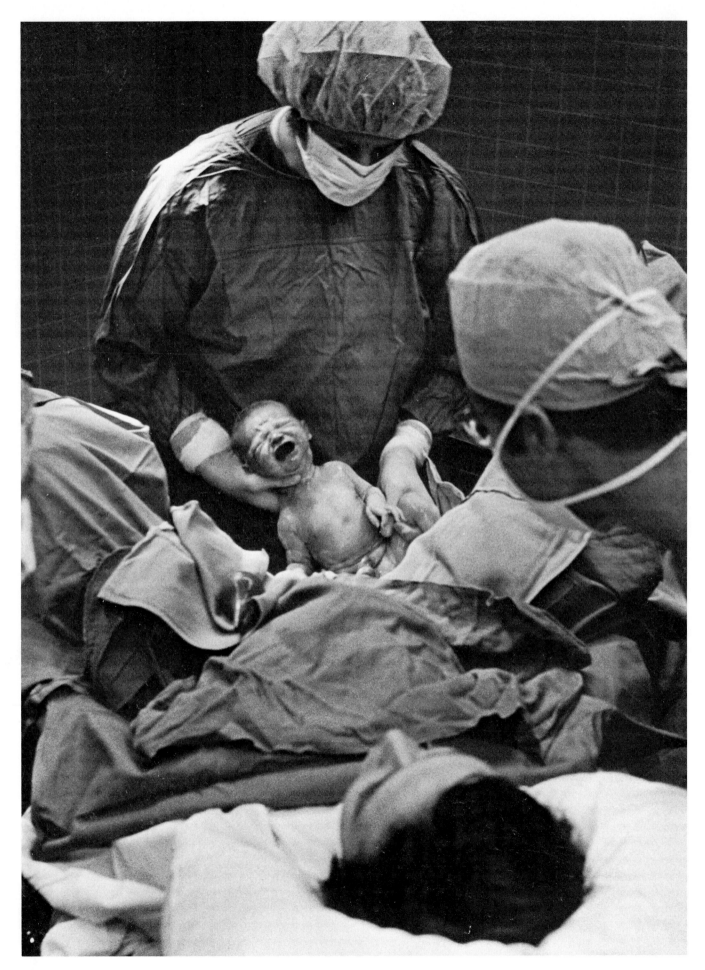

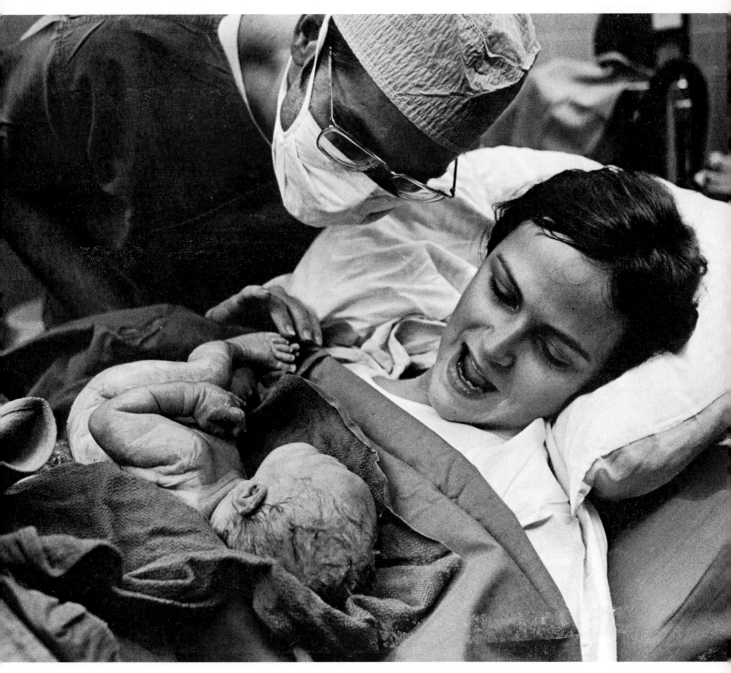

(**above**) This was my key shot: the mother and child immediately after birth as she sees her baby, her husband observing. The expression on her face tells it all. They were completely unaware of my presence.

(**opposite**) For this shot I stood on a small stool to get some elevation. I started shooting when the doctor began and took a sequence of about six shots of the delivery. This was my favorite, as the doctor guided the newborn child from the mother's womb. To the right is the husband overlooking the birth.

(**overleaf**) This was the happy moment. The nurses handed the baby to the mother and she carried it back to her room. I was able to include the operating room in this photo, for an environmental shot.

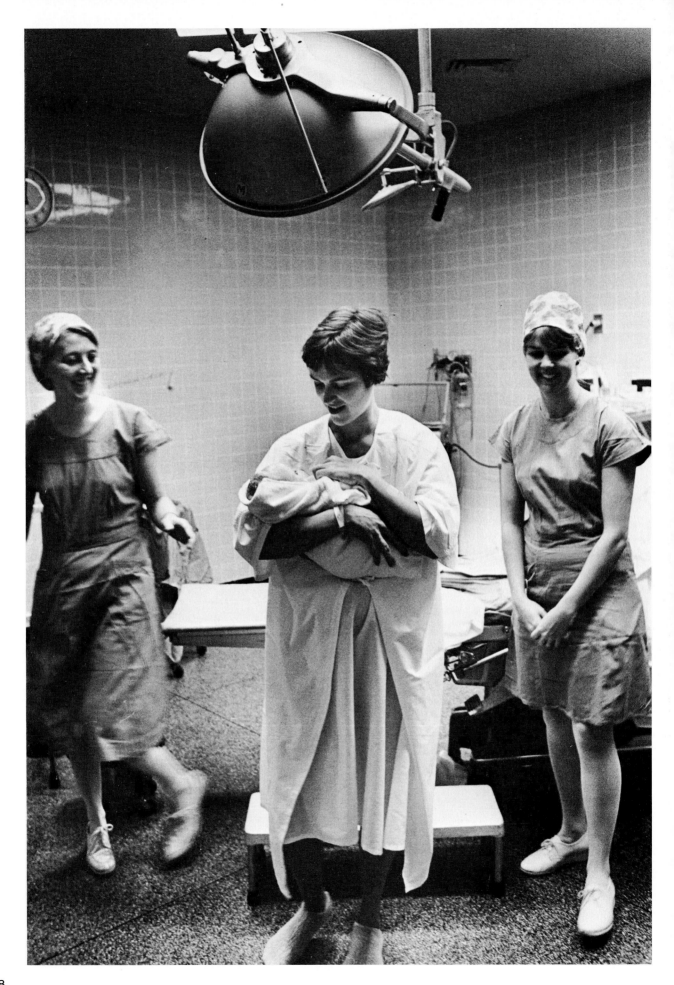

Israel

ASSIGNMENT: Travel to Israel and shoot series for Lenten essay on Holy Land. Deadline is first week in February. Meet with feature editor and graphics editor before going.

In mid-December of 1976, the newspaper was planning a photo essay on the Holy Land in Israel that would be run during the season of Lent. The series was to start with a full back page of photographs on the first day, followed by one photograph every day for the remainder of the season.

Initial Planning

The content of this photo series was entirely up to me. This was a free-wheeling roving assignment. I had to move fast to make all the necessary arrangements, and do some background research. I first went to our travel agent to check schedules and pick up all the literature they had on Israel and the Holy Land. That was the beginning. TWA Airlines had an excellent booklet, "To Israel," compliments of Israel's Government Tourist Office, with an index of exactly what I needed. It listed air fares, calendar of events, helpful hints, Hebrew phrases, map of Israel, principal cities, religious places, shopping. Another helpful bit of information was a list of telephone numbers and addresses of Israeli government tourist information offices in every city in Israel.

This booklet also listed the requirements for entering Israel. You need a valid passport, and citizens of the U.S.A. will receive visitors' and transit visas without charge at the port of entry into Israel. Because you need to show a smallpox vaccination certificate on return to the U.S.A. after visiting the Middle East, they advised that you obtain this before leaving for Israel.

Regular tourists were permitted to bring along a reasonable amount of film, but not more than 10 rolls for ordinary cameras. This would not be enough film for me to do the job of photographing my series. I immediately called the Consulate General of Israel in Chicago and explained that I would be taking about 60 rolls of film with me for the special photo story I would be doing for the Detroit *Free Press*. They told me to write a letter to them with all the details, and a special form would be mailed back to me for clearance at the airport.

The currency in Israel is the Israeli lira (IL) which is made up of 100 units, each called an agora. One Israeli lira is worth about 28 cents U.S. The exchange rate at the time of my departure was $1.00 U.S. = IL3.50. Tourists are permitted to pay for all services and purchases in U.S. dollars. All transactions must be carried out at the official rate of exchange. There is no limit as to the amount of foreign currency a visitor can take into Israel, whether cash or travelers checks, because exchanges are no longer noted on registration cards.

Next I went to a bookstore to look for material on the holy places. I purchased *Easter: A Pictorial Pilgrimage,* published by

the Abingdon Press. This is an excellent book with pictures and text on the historical development of Easter, the meaning and significance of various places, and practically everything I needed to know. I also purchased a Pilgrim's Map of the Holy Land that listed all the holy places from Nazareth to Jerusalem, with exact locations, roads, and boundaries of cities and villages. This map listed in color a starting route and how to travel from place to place.

From the helpful hint booklet I read that transportation facilities were fast and convenient. Buses were the most common means of getting about. In the main cities you could also hire a car and "drive yourself." A driver's license issued in the United States is accepted in Israel. The International Driving License is recognized and preferred, although a valid national license is accepted. Private cars for touring with officially licensed guides are available for hire.

My plan for transportation in Israel was to travel by bus from city to city and hire a private car with a licensed guide for in-city transportation.

With all this information I had gathered, I knew exactly how to plan the entire trip. I completed my itinerary and showed it to my editor for his approval. He liked it and told me to go ahead with the plan. I made about five copies, leaving one with him, one for the travel agent, and left a copy at home.

The entire trip was to be for 14 days. My travel agent started to make reservations. Flying from Detroit to New York, and then nonstop from New York to Israel, landing at Lod Airport, near Jerusalem. From there I would take a bus to Nazareth to start my journey following the footsteps of Christ.

Equipment

Choosing the photographic equipment that would do the job but not burden me was important. Since I would be traveling by bus to main cities in Israel, I didn't want to carry any unnecessary equipment. I decided to take three cameras and five lenses: two Nikon cameras, one Widelux camera, and five Nikkor lenses—the fisheye (180 degree, horizontal and vertical), 24mm, 35mm, 85mm, and 180mm. I also included a small battery-operated strobe with a 20-foot extension cord, in case I needed special lighting.

The major part of this series would be published in black-and-white, with a few color photos for possible use in the Sunday Magazine. I brought 60 rolls of 36-exposure Tri-X film and 20 rolls of 36-exposure Ektachrome film, ASA 200.

Special Arrangements for Travel

Camera equipment has to be registered with U.S. Customs before departure, which entails taking the camera gear to the customs office. You can also register camera equipment before departure at the airport, but you must allow enough time to do it. The customs office is at the international area of the airport. There the agent will check over the cameras and lenses, listing the make and serial numbers of each along with a full description. You then sign the form which lists the port of departure, the date, and signature of the customs official. The certifying officer will draw lines

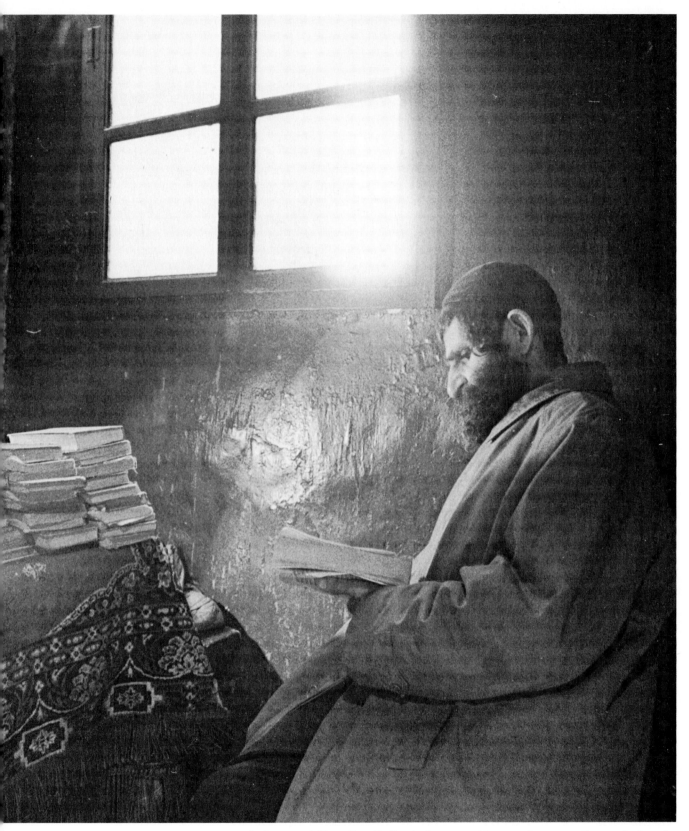

As I entered King David's Tomb, I saw a rabbi seated in a small room before the entrance. There was light coming in through the window and one bare light bulb on the ceiling, enough light for a good exposure. It was very quiet and serene—a precious moment, like an experience in the past.

through all unused spaces with ink or indelible pencil. This certificate of registration is not transferable. I staple this form to the last page of my passport so that I don't lose it.

There are two major problems when traveling overseas. One is theft, the other is possible X-ray damage at the airports. I always carry my equipment with me, that's why I take the minimum of camera gear. When traveling, don't check your camera with your luggage, carry it with you on the plane along with your film.

Airport X-ray Procedures

In all major airports in the United States, the X-ray systems are fairly safe, but in Europe it's a different story. The American Science Engineering Company, supplier of X-ray equipment to U.S. airports, claims its systems will not harm photographic film. But an important factor to consider is that X-ray exposures are cumulative. Since my trip would involve many stops at different airports, I decided to carry all of my film with me in a special lead-foil pouch called FilmShield. The best way to guard film against inadvertent damage when overseas is to have it hand-inspected, even if it is in a protective pouch, because the X-ray systems are fairly strong. In some instances, however, the security people are not cooperative, and if they won't hand-inspect the film, at least you have the protection of the special pouch. Regardless of what the airport authorities say, don't take any chances with your film.

I know of a newspaper photographer who recently returned from an assignment in Europe with more film than he could carry aboard the plane, about 200 rolls. Thinking that the X-ray danger to film applied only at the carry-on-luggage screening checkpoint, he placed most of the film in his check-through luggage. When the film was developed, it had been damaged by the X-ray and was unusable. He didn't know that check-through luggage went through a stronger X-ray.

The FilmShield pouch comes in two sizes—jumbo, holding 60 rolls of 35mm film, and regular size, holding 20 rolls. The outer layer of this pouch is tough, puncture-resistant polyester, the middle layer consists of a lead-foil X-ray barrier, and the inner layer is barium-impregnated for added protection.

I carried a small set of screwdrivers and some extra small screws that fit the camera in order to make minor repairs. I also had the addresses of camera stores in all the main cities, in case any major problems occurred. With my preparations complete and my itinerary finalized, it was now up to me to carry out my assignment well. There would be no one else to make decisions while I was on location.

Writing Captions

Accurate caption material is the responsibility of the photographer. No picture is complete without a caption. To write my captions I use a reporter's notebook. As I go along, I write the roll number on the top of the page and then write the captions in order as the pictures were taken. A good habit to get into is to write the ID's immediately after taking the pictures. You can write them in a hurry, because you can always rewrite them later. I generally rewrite all my captions that same evening and include additional information while it is still fresh in my mind.

My Itinerary

Upon landing at Lod Airport, I would take a bus to Nazareth, the childhood home of Jesus, to begin my series. I would go to Tiberias, on the shores of the Sea of Galilee, and in that same area I would see Can of Galilee, Capernaum—Peter's synagogue, Tobgha, site of the miracle of the loaves and fishes, and Mount of the Beatitudes, the traditional site of Jesus' Sermon on the Mount. This series, I figured, would take about three days. From there I would take a bus and head south to Jerusalem, making it my headquarters for the rest of my trip. In Jerusalem I would hire a guide with a private car whenever I needed him. This would cost about $30 a day.

Jerusalem was the key city, in which I planned to take the most pictures. I wanted to start in Old Jerusalem with the Via Dolorosa—the Way of the Cross—which follows the route taken by Jesus as he carried the cross to Calvary. Along this road are the 14 Stations of the Cross, where pilgrims stop and pray. The Via Dolorosa ends at the Church of the Holy Sepulchre, which Emperor Constantine built over the site of Jesus' crucifixion.

While in Jerusalem, time permitting, I was hoping to do several extra picture stories that the newspaper could use at a later date. I wanted to do a series on Bethlehem for use during Christmas; the Wailing Wall (Western Wall), which is one of the most sacred Jewish sites in the Old City of Jerusalem, to be used during the Jewish holidays; and some "anytime" photo stories at the "Dome of the Rock," where Abraham bound his son Isaac for sacrifice. Tradition holds that Mohammed visited this site before his ascension into heaven.

A short trip from Jerusalem was the mountain at the Dead Sea, where the Dead Sea Scrolls were found, 1200 feet below sea level. Nine miles from Jerusalem was Emmaus, where Jesus met two strangers after his crucifixion. Another bonus picture would be the Allenby Bridge near Jericho, which connects Israel and Jordan.

My assignment was to do a series for the Lenten season only, but I always like to show initiative by including some bonus stories that the newspaper didn't count on getting. I do these extra stories during my free time.

I returned on schedule, meeting my deadline in good time. I had shot 48 rolls of 36-exposure Tri-X film and 12 rolls of color, fortunately encountering no difficulty with customs and no problems at the X-ray checkpoints. All of my pictures were taken at the normal speed rating, not pushing my ASA. The film was developed in D-76 full-strength for 7 minutes at 70 degrees. I then made contact sheets for editing and selection purposes. I met my deadline by one week.

Via Dolorosa

Coming up with a different approach on how to photograph this world-renowned street required a little thought. I had to decide what the average reader wants to see. Most people are familiar with the 14 Stations of the Cross, either in pictures or in drawings. When I entered the Via Dolorosa, I was immediately aware of all the people energetically going about their business. I always like to follow my first impressions, so I decided to walk along the street

and candidly photograph what the people were doing. I chose the 35mm lens because it would include a large picture area with background and have good depth of field.

I had to be careful because most Moslems do not like to have their pictures taken. So I put the camera around my neck, set the focus at 15 feet, and started to walk slowly along the street. I saw children playing jump rope, men carrying heavy goods on their backs, craftsmen playing cards and smoking their water pipes. Along the way I peeked into an Arab school, and I ended my walk at the Church of the Holy Sepulchre. I shot only two 36-exposure rolls of film, making every shot count. For some shots I was able to look through the viewfinder, but most I shot from the hip. My basic exposure was 1/250 sec. between *f*/8 and *f*/11, depending on the light. I don't look at my camera if I have to change my *f*-stop, I do it automatically by the number of clicks on the lens. This enables me to keep my eye on the subject and shoot it at the precise moment for the best picture.

Along the Via Dolorosa the people engage in their everyday activities: **(right)** smoking a water pipe; **(far right)** playing a game.

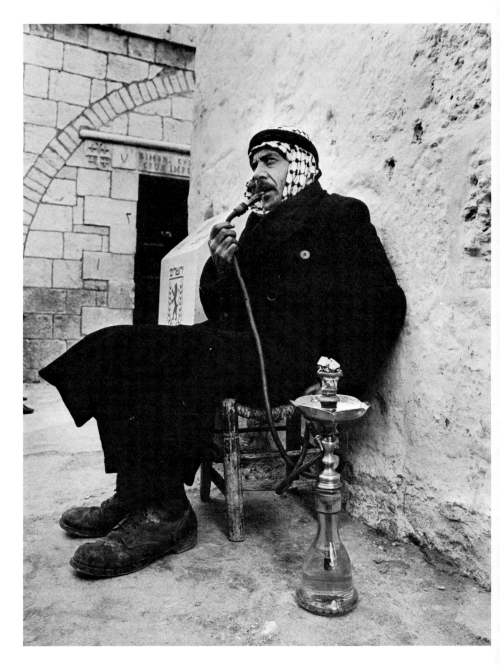

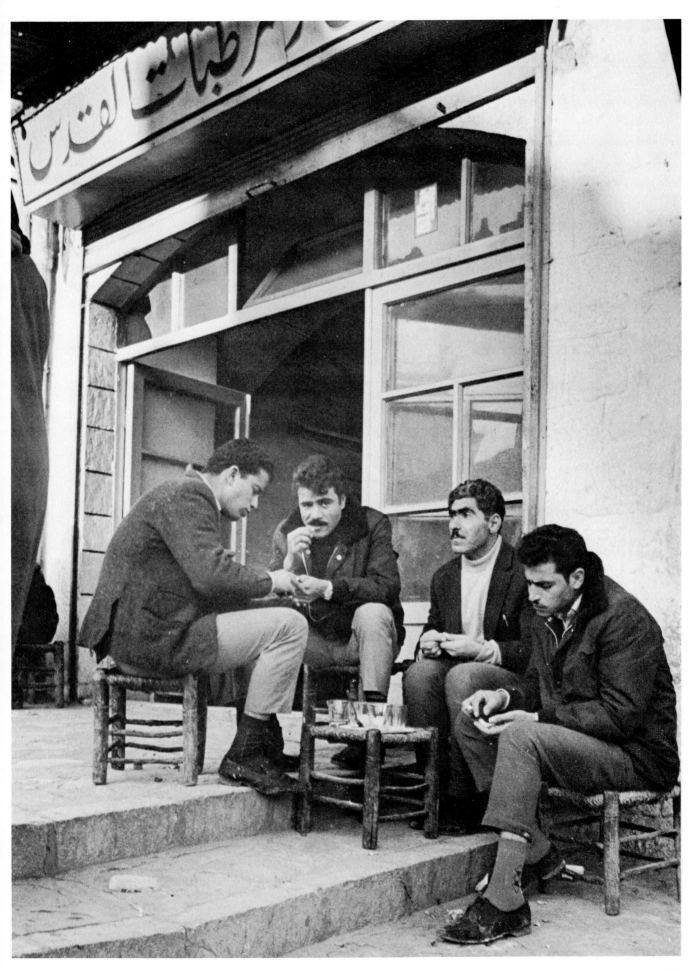

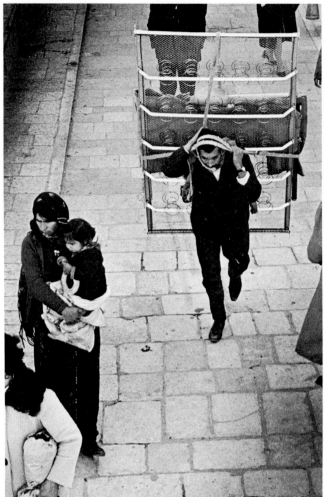

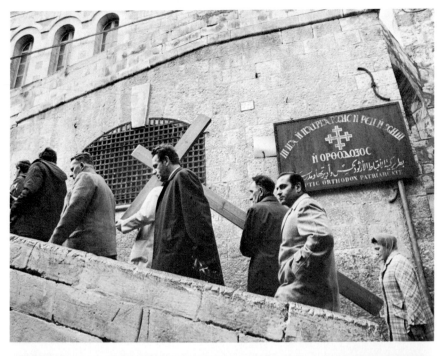

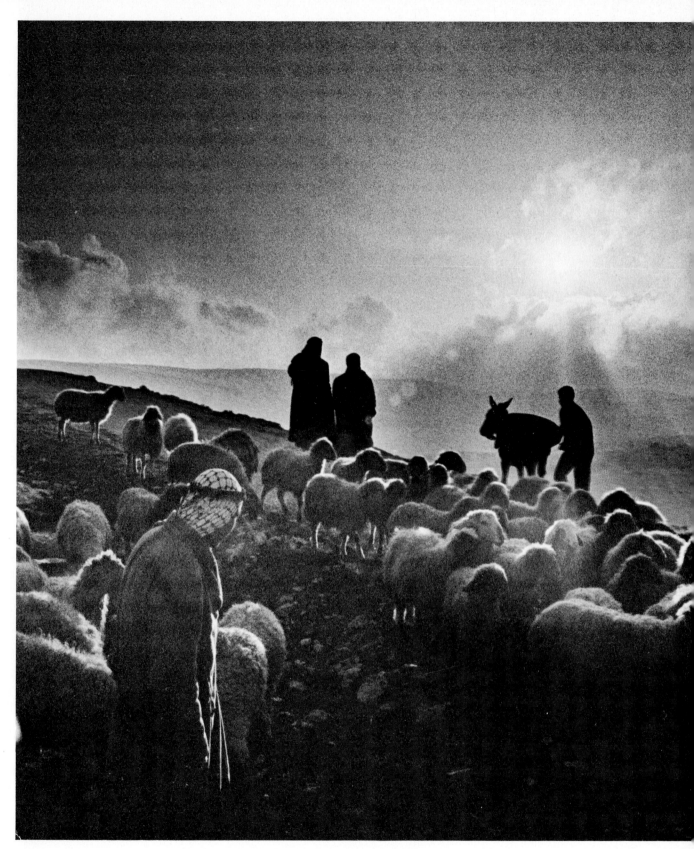

A mood shot of Emmaus, where Christ walked and met two strangers on Easter morning. A yellow filter on the lens allowed details in the sky to show clearly.

Emmaus

One evening I asked the driver about Emmaus, the place where Christ walked and met two strangers on Easter morning. He told me that he knew exactly where it was and that the best time to go there would be about 5:00 P.M. when the sheep return from the pasture. I worked it out with him to drive me there the following day.

Emmaus was about 10 miles from Jerusalem, and I arrived an hour early in order to get a good idea of what the area looked like. The driver and I walked to the hillside believed to be the area where Jesus had walked. He told me that the sheep would come up from the hillside and head back to the small village. I picked out the spot where I wanted to be and decided to use the 35mm lens. Black-and-white film was my first choice because this was what we would be publishing. I had color in my other camera, in case I had time to shoot color. My problem was that the sun was playing hide-and-seek, and I hoped that it would break through the clouds when the sheep arrived. I used my yellow filter to help with some sky detail.

While I was waiting, two men walked to the edge of the hillside. I got a little nervous, afraid that they would ruin my shot of the sheep. It was too late to say anything, so I hoped for the best. I could hear the sheep coming, and I was ready. At that precise moment, a shepherd came up with his donkey and the sun peeked through the misty clouds. I had time to bang off three quick frames before the sheep went by me in a hurry. The whole thing was over in about 30 seconds.

I exposed for the sky in order to get some detail in the sun. The subjects would be silhouetted against the sky and the sheep backlighted. The two men who had walked out to the hillside helped make the picture.

People of Appalachia

The paper assigned me and a reporter, Tom Nugent, to do a feature story on the people in the southern part of Kentucky—Appalachia. The pictures and story were to run on the front of the feature section of our Sunday paper. They could use only six pictures because the story was to run only that one day.

We decided to drive there from Detroit, the location being only about a ten-hour drive. The pictures were to be only in black-and-white. We left on a Tuesday morning and they needed the pictures and story by Friday afternoon for Sunday's paper. We drove directly to Hazard, Kentucky, getting there at about 10:00 P.M.

Shooting

Since we would have just about one day of shooting, it would have to be a full day of work. Making an early start, we went looking for material in rural areas. We stopped first at a home, and a lady came out to talk. She was very friendly during the interview. During the conversation, her two barefooted children came out and stood by her. I had to get in the right position to capture this candid scene. As often happens, the reporter was in the best spot. I nudged him gently with my hips until he got the idea that I wanted him to move a little, and I was able to take a good picture.

On the way to an abandoned coal mine, I saw a young girl with her little brother seated on the steps of her home. I stopped the car on the road for the shot. On the side of the house was a hand-painted sign which read, "I love you." We continued on to Harlan, Kentucky, where most of the coal mines were.

We talked to several people in the city of Harlan and finally ran into an oldtimer who had worked in the coal mines all of his life until they closed. The reporter wanted me to take a couple of pictures of him there. I then asked the unemployed miner if he would take us to the coal mine where he had worked. I wanted to get an environmental shot of him with the closed coal mine in the background. As I drove up to the mine, I immediately noticed that I needed elevation for the picture I had in mind—of the miner with the mine in the background. The best spot was up on the hill and would show the mine, houses, and structures of the conveyors. The area was completely backlighted. I told the miner to stand by a large rock, and to place his right foot on it with his right arm on his knee. After several shots, we walked down to my car and I drove him back to Harlan.

The reporter and I then had lunch and started our drive back to Hazard. On the way, I spotted a small group of people leaving a Baptist Church. I pulled up and took this shot of the people leaving. A special wedding anniversary was being celebrated. In Hazard, I found a man seated on his porch with his grandson seated on

his lap. He had a sort of frozen expression on his face that didn't change all the while I was taking his picture.

At the motel in Hazard that evening, I went over my notes on the pictures I had taken. I knew that I had a good number of pictures for the story, plus a few extra general scenes that I had taken in describing the area. I had shot six rolls of 36 exposures each.

An expressive portrait of grandfather and grandson. The exposure was 1/250 sec. at **f**/8. (180mm lens)

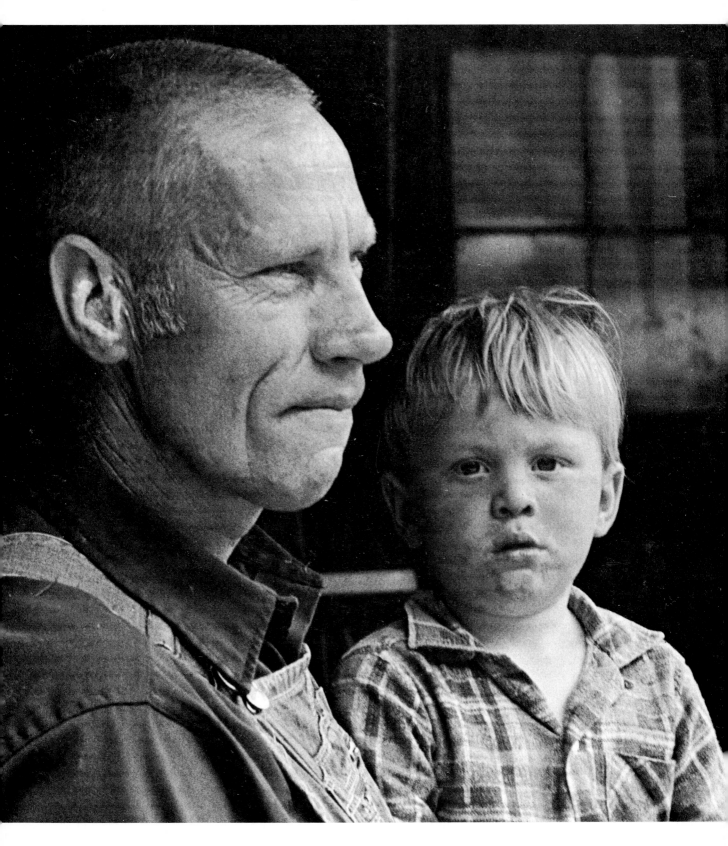

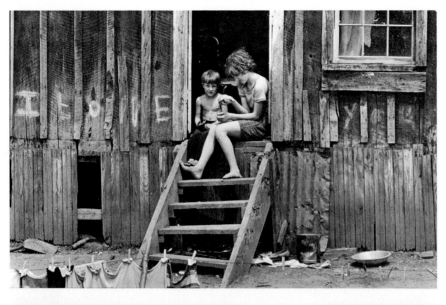

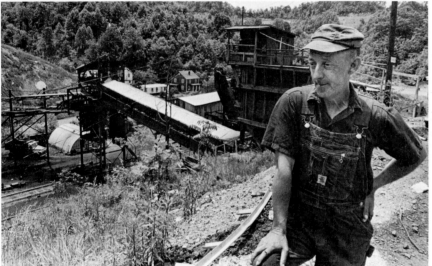

164

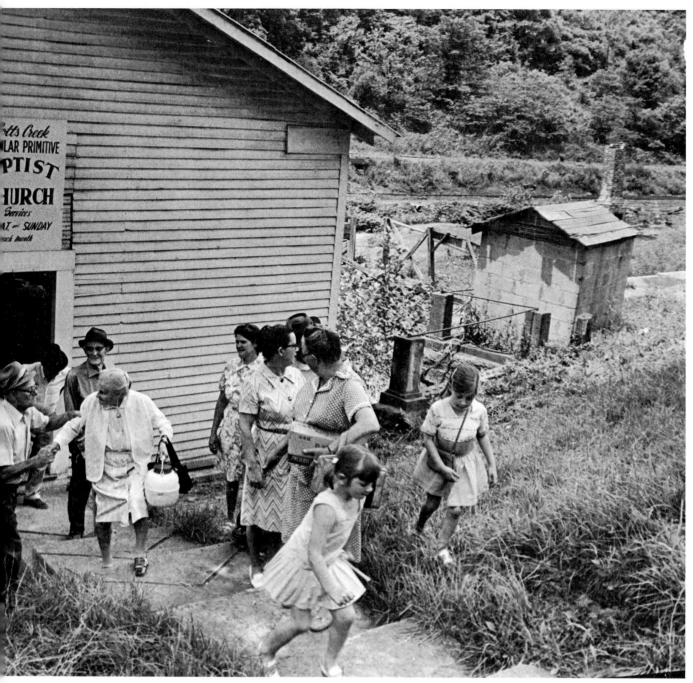

(above) This church scene of a wedding anniversary was taken at 1/250 sec. at **f**/8 in the shade. I shot from this angle in order to get the lady being helped up the steps and some of the background of the area.

(opposite, top) This shot was taken from the road with a 180mm lens. I wanted to be sure to include the hand-painted message on the side of the house.

(opposite, bottom) For this shot I needed depth of field. The subject was completely backlit. Exposure for existing sunlight was 1/500 sec. at **f**/16. I wanted to expose for the shadows, which meant two full **f**-stops' difference. I left the aperture at **f**/16 for depth of field and lowered the shutter speed to 1/125 sec.—equivalent to two **f**-stops. Focus was set at 10 feet, giving me depth of field from 5 feet to infinity.

Pope John Paul II

ASSIGNMENT: Cover visit of Pope to U.S. Need four to six pictures each day.

I was given the assignment to cover Pope John Paul II as he visited six cities in the United States and his major reason for the journey, his address at the United Nations. My assignment was to cover each city on a daily basis and transmit pictures via the Associated Press every day to the *Free Press*.

On this trip I took more equipment with me than I usually take when I go overseas on assignment. I carried only two Nikon camera bodies, and the 15mm, 35mm, 85mm, 180mm, and the Nikkor 500mm Reflex Mirror *f*/5 lenses. I also decided to take along one of my motor drives. I carried a monopod along, but lost it somewhere along the line.

When the Pope visited Battery Park the rain became very heavy and didn't stop. I kept my cameras covered under my plastic raincoat until the Pope arrived. Keeping my lenses shielded from the rain, I began to take pictures in the pouring rain. The Pope stood there on the platform, in the rain, smiling and waving to the crowd.

My next assignment was coverage of the Pope meeting President Carter and the mass on the Mall. These had to be my best shots, and I was selected to be on the Press Pool bus that was taking 20 photographers to the White House for the meeting between the Pope and the President. When we arrived they placed us in a spot about 200 feet from the arrival area, in front of the White House entrance. A short time after our arrival at this area, a Secret Service person tapped me on the shoulder and asked me to follow him. I looked back and noticed how quickly the other photographers took over my spot. I thought I was being led out. We walked around to the front steps of the White House and he gave me a special pass permitting me to take pictures within 12 feet to photograph the meeting of the two. There were only a handful of photographers who were chosen to take these exclusive shots.

Here I was able to use my 35mm lens and the 85mm. I captured the meeting of the First Family meeting the Pope and then President Carter escorting the Pope into the Oval Office. After his private meeting I photographed his departure and as the President waved good-bye. This was my best series of pictures.

(**opposite**) Pope John Paul II prays just before boarding a plane.

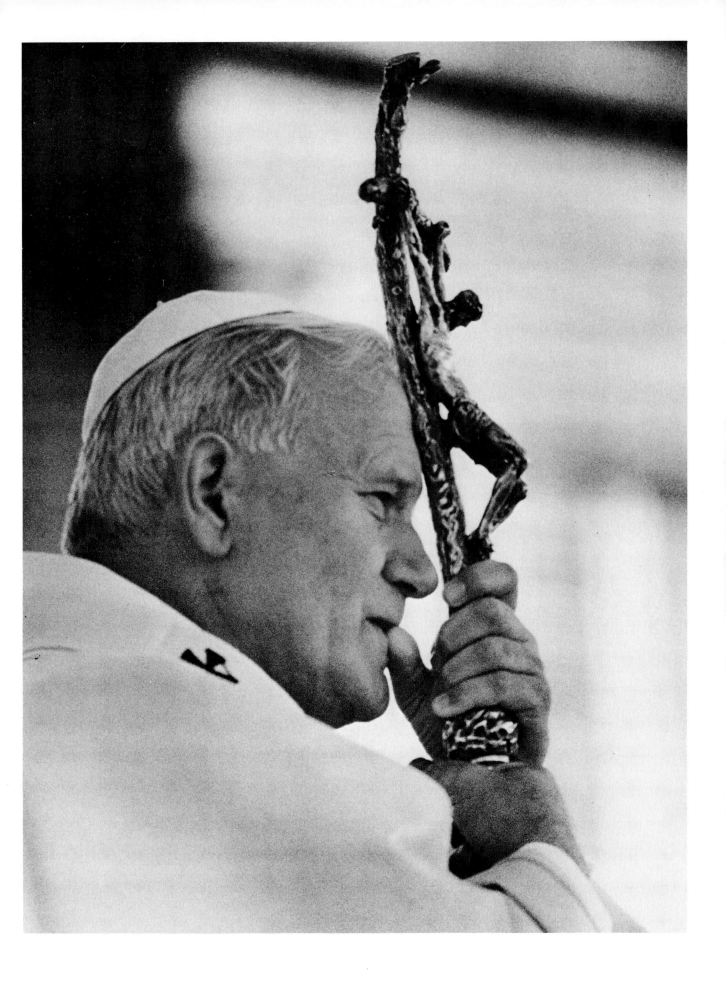

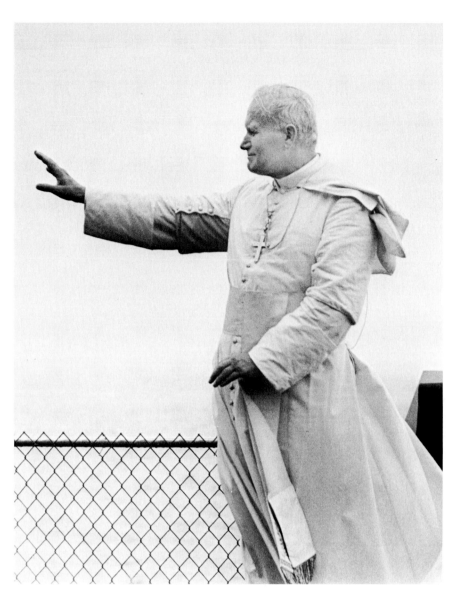

(**above**) At Battery Bark, New York City, the Pope gestures in the rain, saying, "The Pope is not all sunshine."

(**right**) This is my favorite photograph of the Pope with the President and his family.

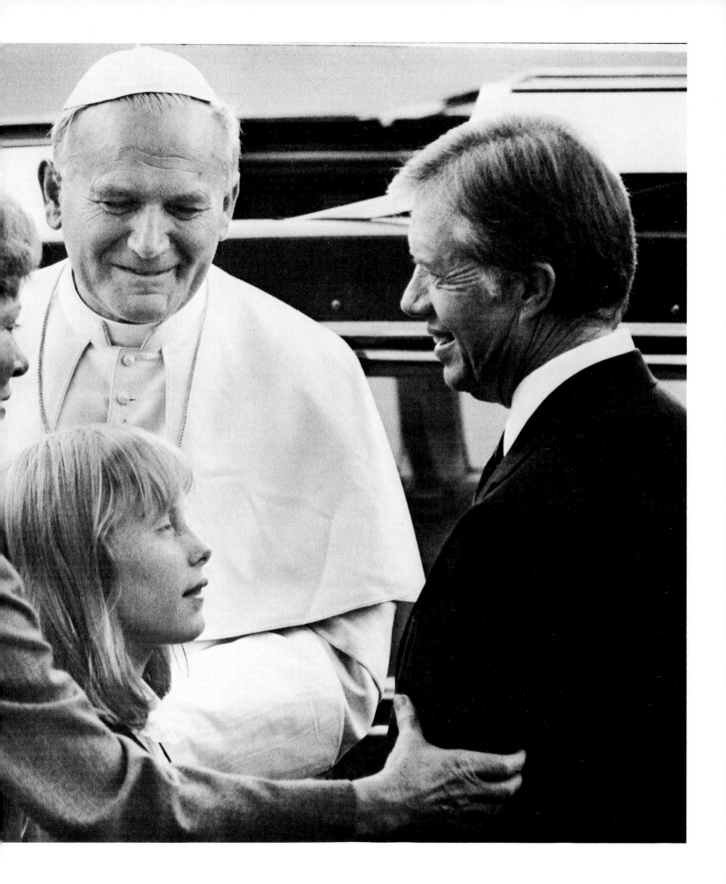

Baptism in the River

ASSIGNMENT: Personal invitation from Martha Jean the Queen to photograph her baptism of initiates.

The Order of the Ministry of the Fishermen, from the Home of Love, were going to have their baptism early Sunday morning at 6:00 A.M. I was personally invited by Martha Jean the Queen to photograph the baptism.

Equipment

I knew that I would have to get into the river at least waist deep in order to be at the right spot for the proceedings. My camera equipment would have to be at least six inches above my waist. I could not carry a camera case, so I decided to use my two Nikon F2's without motor drives and the 35mm and 80–200mm zoom lenses. I would have no extra lenses or film while I was in the water. I took my zoom lens to zoom in on the action as it happened, because it was slow moving in the water.

I was told that I had to wear a white shirt and white pants in order to attend the baptism, which I did. I also wore a pair of old tennis shoes because of the rocks and glass that might be at the bottom of the water. As I entered the water I moved very slowly around the people, who were lined up waiting to be baptized about 50 feet out into the river. I held my camera with the zoom lens most of the time, and the second camera, which was held with a strap around my neck, rested on my chest.

Shooting

I had to pace my shooting and make sure that the two rolls of film, one in each camera, would last until the completion of the ceremony. I was keeping my eye on the line of people who were being baptized. When the last person was baptized I had about 10 shots left. I operated mostly from the sides so that I would be out the way of the ministry.

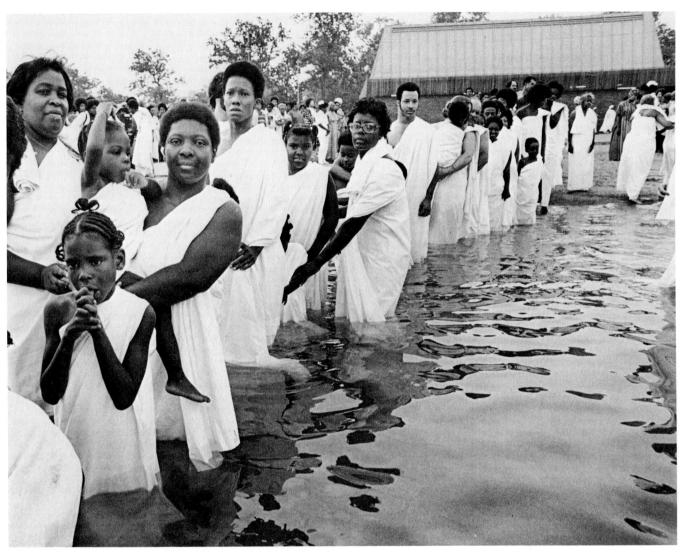

My first picture in this series was of the group as they lined up in the river for the baptismal ceremony. (35mm lens)

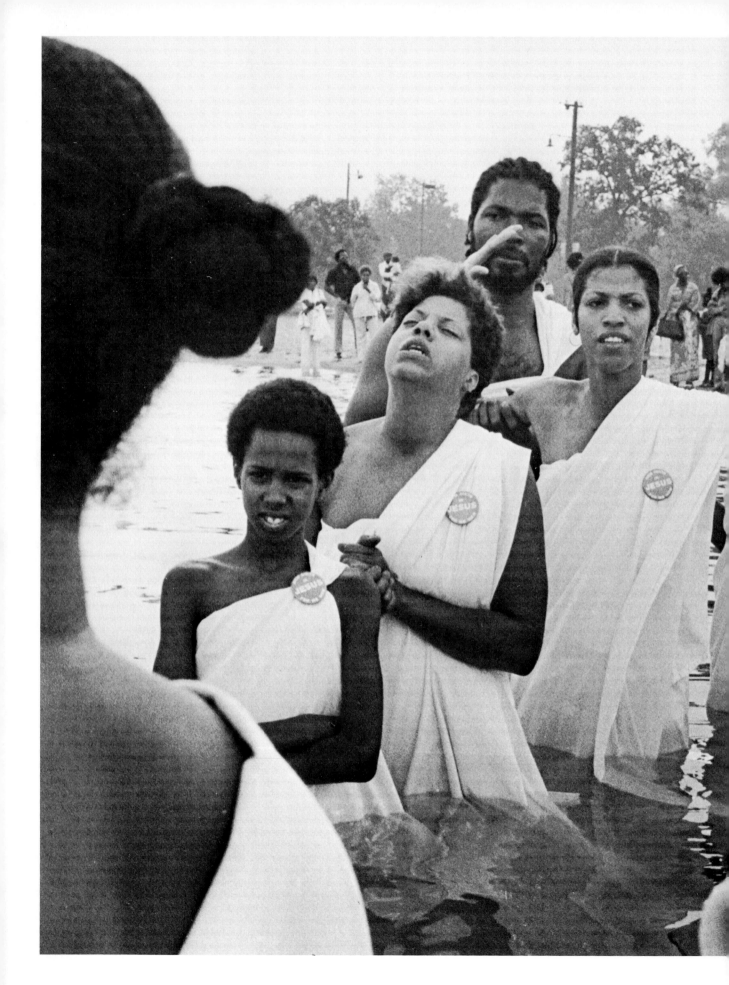

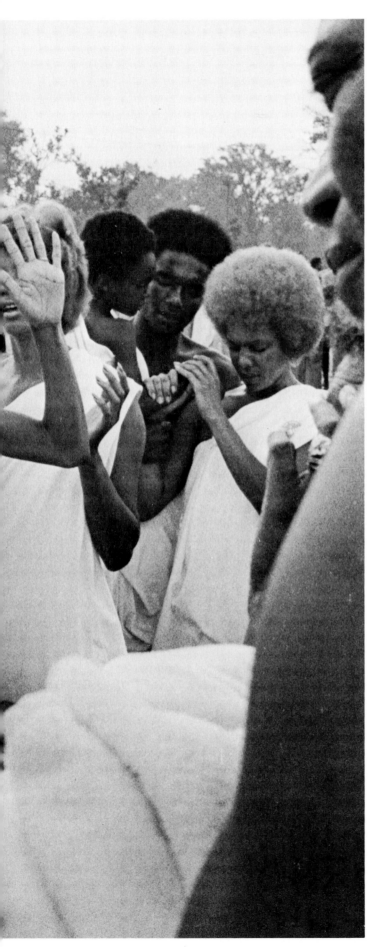

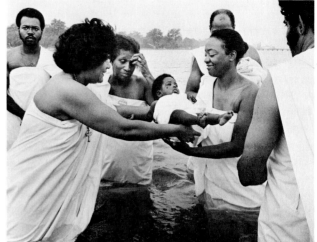

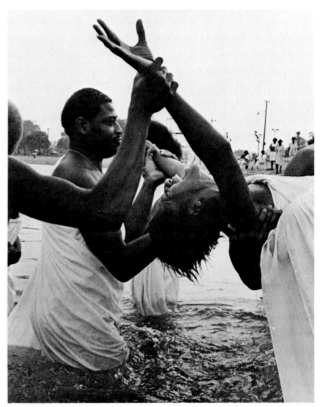

(**left**) The initiates prayed for guidance as they approached the baptismal area.

(**top**) A closeup of a child about to be baptized by Martha Jean the Queen.

(**above**) The head being raised out of the water after the total immersion during the baptism.

(right) Immediately after the baptism, the people screamed and became hysterical for a short time. I used an 80-200mm zoom lens to capture this shot.

(below) The participants had to be led back to shore after the emotional experience of baptism.

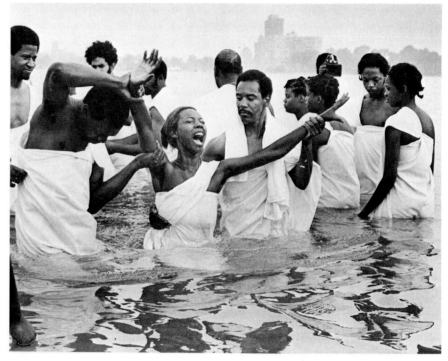

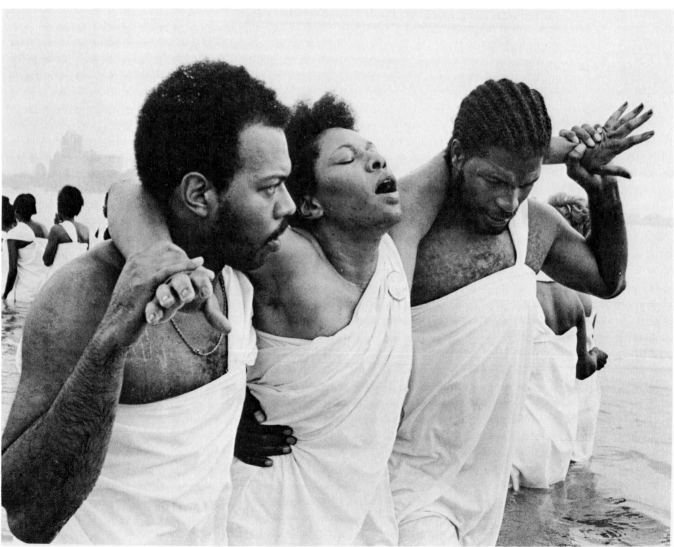

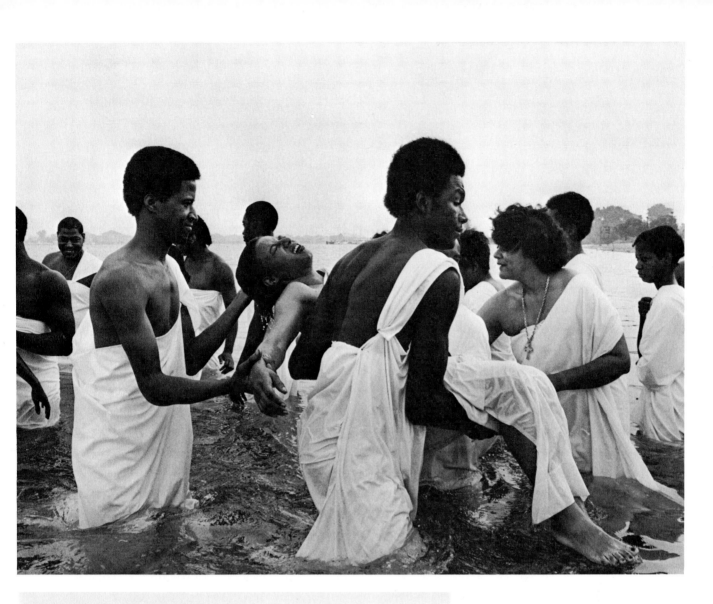

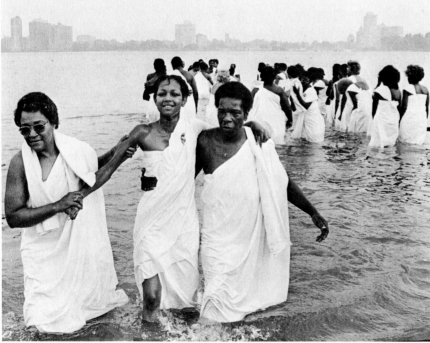

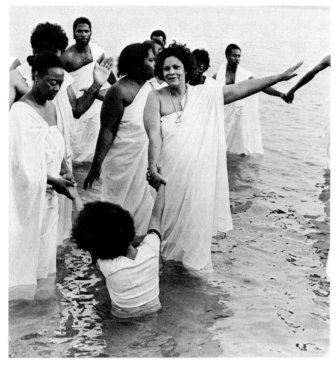

(**above**) A young girl kneeling in the water asked the Queen for forgiveness.

(**right**) The Queen carried a baby to her mother after the baby was baptized.

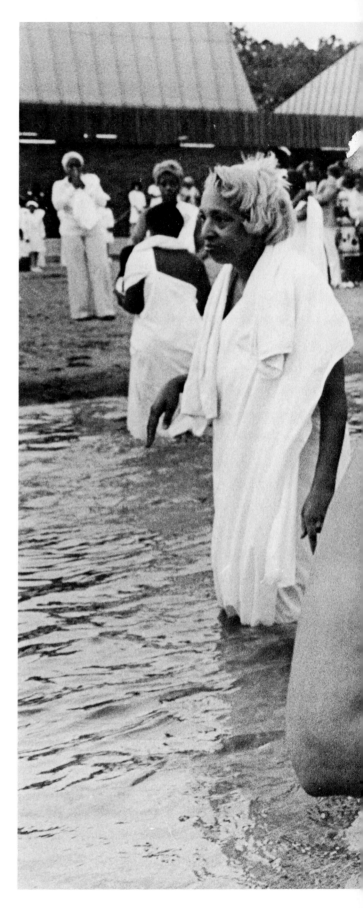

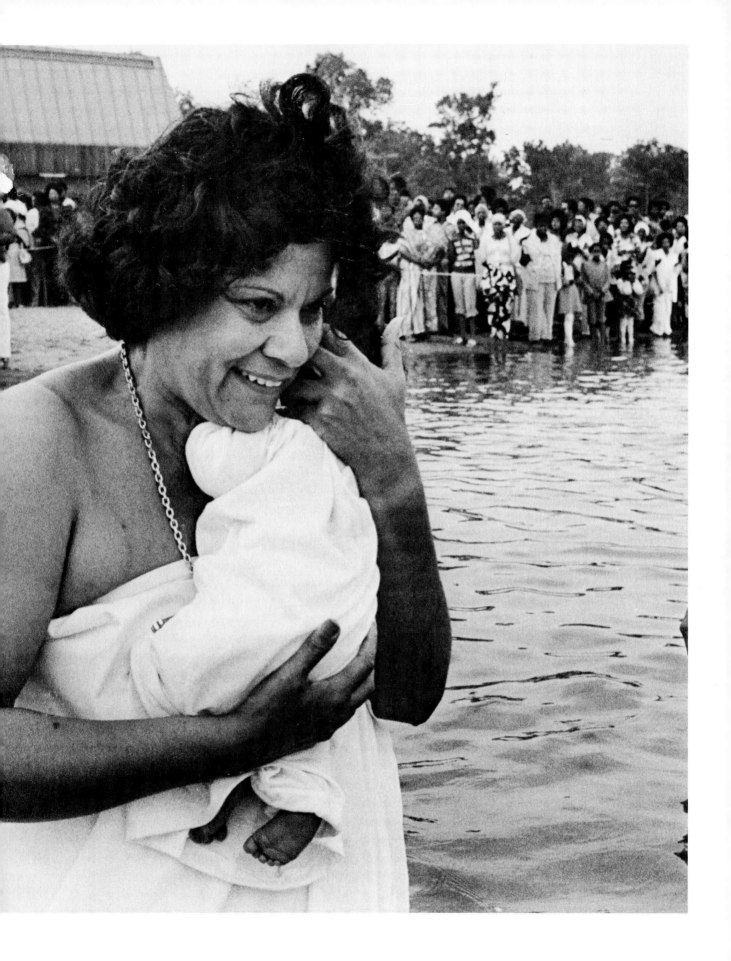

Plymouth Center for Human Development

ASSIGNMENT: There will be an investigation of the Plymouth Center by State Senator Snyder. Meet with Watson and Magnussen for exact time and place.

The State of Michigan launched an investigation of the Plymouth Center for Human Development in Plymouth, Michigan, after a series of articles published by the *Free Press* revealed neglected facility operations and mistreatment of the children under the center's care.

I was invited to visually document the investigation. Arrangements were made for myself and the two reporters who had written the initial series (Susan Watson and Paul Magnusson) to be part of the team. State Senator Joseph M. Snyder was to be in charge of this personal check. It was to take place early in the morning, without prior notice to the institution. One of the ground rules set during the investigation was that no cameras were to be in plain view of anyone; no flash or light of any type could be used. This presented the always interesting obstacle of how to fully and accurately document existing conditions without lifting a camera to eye level, without focusing or seeing images to be photographed through the lens or viewfinder, and of course without letting anyone know that you even have a camera.

Equipment and Shooting

For these extenuating circumstances, I decided to use the Minox E1, a full-frame 35mm camera. The camera is automatic with aperture priority, and I can hold it in the palm of my hand. I had to shoot from the hip, since I couldn't hold the camera at eye level. I had set the aperture at f/4 and the focus at 12 feet. The click of the leaf shutter was noiseless. The best time to shoot was while the senator was talking to the attendants. Acting the part of a member of the investigating team, I casually turned toward the patients and, from the hip, held my camera in that direction. I had to be careful to be inconspicuous.

I shot two rolls of 36-exposure Tri-X film rated at ASA 800. I camouflaged the camera by holding it in my right hand, with the camera against my hip. When I wanted to shoot, I placed my left hand over the lid and flipped it open with my thumb, keeping the camera covered with both hands. I didn't look down at the camera. Instead, I looked directly out at the patients and slowly moved my left hand away from the camera, taking the picture at that precise moment. It was done very quickly, and immediately after I tripped the shutter I brought my left hand back over my right hand and advanced the film for my next shot.

The finished results were excellent. They led to the reorganization and restructuring of the entire facility and enhanced the public's awareness of the existence of such unfortunate situations—which can, and must, be changed.

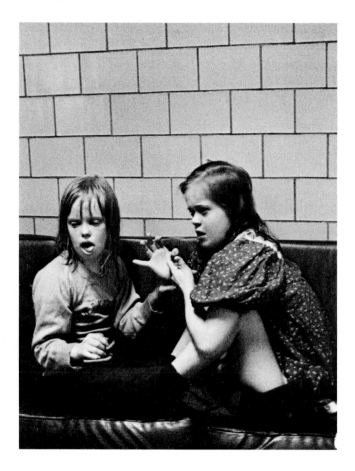

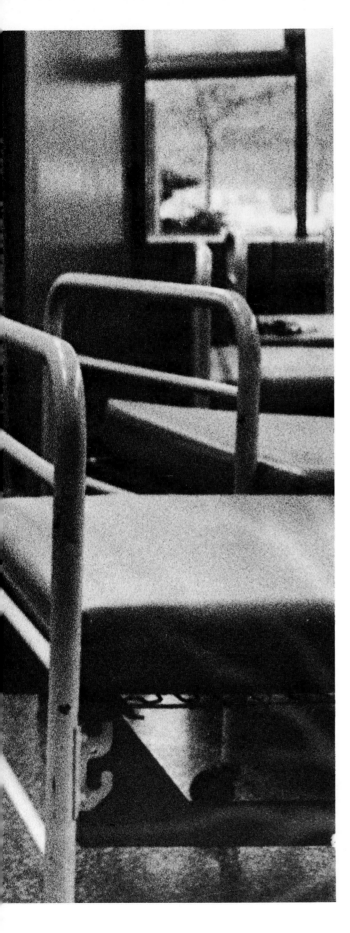

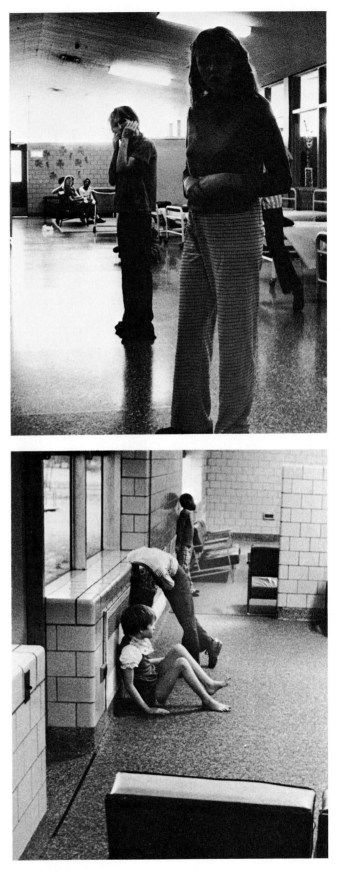

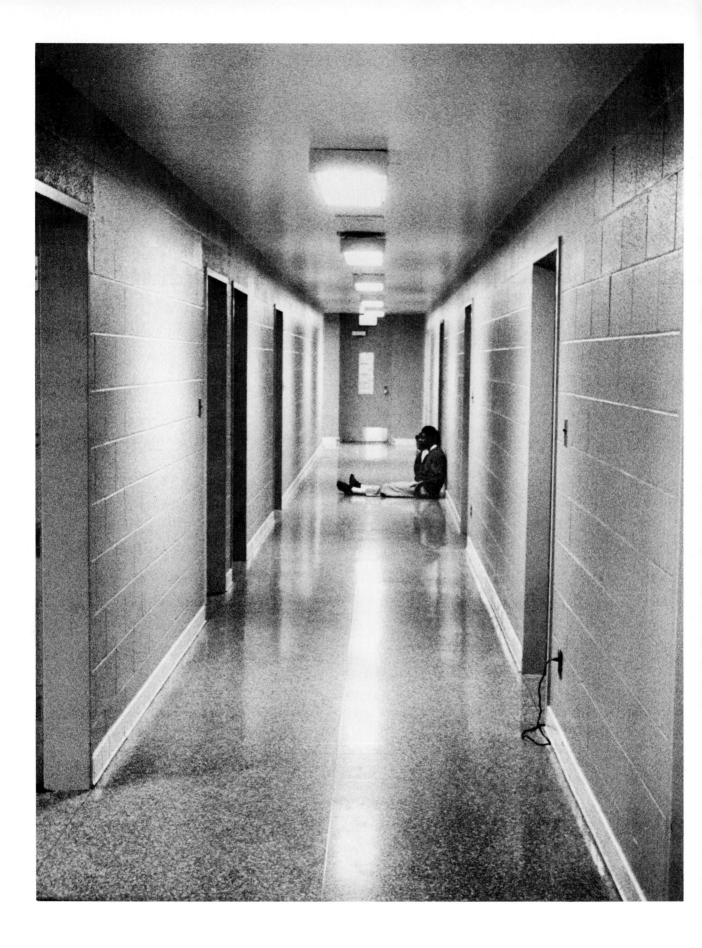

PHOTOJOURNALISM TODAY

Every photojournalist must be capable of producing a good, acceptable picture at all times. To be a successful photojournalist today, you must be versatile and do an excellent job in all the sections of a paper: news, feature, fashions, real estate, food, entertainment, Sunday magazine, religion, women's pages (some papers call it the "Way We Live," "Living," or "People" pages), and the sports section. The "feature" photographic work is one of the most important elements in covering assignments for most of the sections of a newspaper. It is in these sections that the photojournalist can display his or her talents in the interpretation of an assignment, using technique and ability. It is also in feature sections that the photograph has the largest display. The feature photograph establishes the photographer's own style and makes it readily recognizable.

Photojournalists always produce pictures, which is their basic job, so there really isn't a bad photographer among them. I rate a photojournalist as either good, fair, or weak. A good photojournalist performs the job above expectations, using good composition, imagination, and excellent technical ability. A fair photojournalist covers the assignments properly and always turns in an acceptable picture. A weak photojournalist occasionally turns in a good picture but is not consistent.

Equipment

As I write this chapter on photojournalism, advances in camera equipment are continually being made. More rapid access to the photographic image will undoubtedly be one of the principal requirements of the photojournalism of tomorrow. We live in an age of restless photographic experimentation, hearing constantly of newer electronic cameras and using tapes or discs for our photographic work. Already, there is the Autologic APS-4, which spits out more than 800 lines per minute from tape with a sensitized stabilization process to any size type required. It can also digitize a photograph from tape into a zillion dots, the same way it does the type.

For now, the minimum requirement for a photojournalist is two 35mm cameras (one with a motor drive), five lenses ranging from a wide-angle to a telephoto, a strobe, and a tripod. With this equipment you can cover almost any assignment. You can then add to your inventory lenses such as the "fisheye" and longer telephotos, plus extra strobes to be used as sidelights.

Now about lenses: these are the focal lengths I recommend to start. The wide-angle should be a 15mm, a 20mm, or a 24mm. The lens you will use most often is the 35mm. Then you need the 85mm, the 180mm, and the 300mm. These five are the key lenses used most often by seasoned photojournalists.

I think the wide-angle is the most difficult lens to use effectively. I always look at a person's wide-angle work to determine if he or she is an outstanding photographer, because there are more bad

pictures taken with this lens than with all of the others combined. By mastering the wide-angle lens, you become a better photojournalist and take better pictures. Too many photojournalists use this lens carelessly, attempting to jump without the necessary preliminary experimentation. Don't be a photojournalist who uses only the wide-angle and telephoto lenses and nothing in between for your photo stories. Use the wide-angle sparingly and supplement it with a variety of other lenses ranging from the 35mm to the 300mm. You should use the wide-angle when you feel that it will improve the picture possibility. The wide-angle lens has several qualities that make it a good all-purpose lens. There is great depth of field, which means that most of the image will be in focus. This is very helpful when you are working in low light conditions. The 35mm wide-angle is popular because there is little distortion in the image. The 15mm or 24mm lens has noticeable distortion and therefore is not as useful for the photojournalist's purpose.

Don't take the attitude, however, that just because you use a wide-angle lens your picture will automatically be great. Always think and choose the right lens for the right picture, because this is one of the major decisions you will have to make before taking the picture. I use the wide-angle sparingly, supplementing it with a variety of others. On rare occasions, I use the fisheye lens. If you intend to do a lot of work with the wide-angle, think hard, try to understand fully its concept and then, with good creative imagination, you can meet new challenges and improve your photography.

Being a Photojournalist

It takes hard work to build your reputation to a respectable level in the world today. Once you have established your reputation, it then takes twice the effort to stay on top. You have to work twice as hard, because every piece of work you turn out will be examined carefully by the top people, who will be comparing it with your best work of the past. So you must constantly think up new ideas and new approaches, and search for continued orginality. Do not use someone else's thoughts and ideas. A photographer's title usually tells what he does and also reflects his company's opinion of his worth. This, of course, adds more responsibility and should serve to establish a relationship between photographer and co-workers.

These are some of the basic requirements a photojournalist should have before seeking a job in that field:

- ☐ A good portfolio, ranging from 40 to 50 photos.
- ☐ A degree in photojournalism, or comparable experience in the communications field.
- ☐ A well-disciplined mind, capable of handling all assignments equally.
- ☐ A willingness to travel on short notice and ability to stay and work through important news-breaking stories.
- ☐ A knowledge of a foreign language would be helpful, but is not necessary.
- ☐ A complete resume.
- ☐ Be well read, with knowledge of current events.
- ☐ A basic knowledge of most common sports activities.

- Some knowledge of cultural arts.
- An artistic sense for pattern, design, composition, as well as color harmony.
- A personality that is sensitive, curious, inquiring, yet able to handle situations and people.
- Technical competence in the use of photographic equipment, with a vast working knowledge of a variety of cameras, lenses, filters, films, and lighting equipment.
- A thorough knowledge of developing, printing, and reproducing quality photographs.
- A good knowledge of perspective and distortion.
- Last, but not least: ability to make identifications for your photos, using correct names from left to right in your caption information. Captions are important, and the photographer cannot afford to be careless in gathering information.

The camera is a remarkable creative tool. I do not think that one camera is better than another. You have to be the judge of which camera is best for you. You are its commander and it will perform as you want it to perform. The responsibility lies with the photographer.

Development of Photojournalism

More advances have occurred in photography in the last 40 years than in the previous 100 years. With new techniques, each decade has brought different approaches to photojournalism for newspapers, magazines, and photographers. During the mid-1940s, right after World War II, we had concerned photographers but very few schools teaching photojournalism. The beginner had to learn the basics alone — with an apprenticeship, by trial and error, or by starting off as a darkroom helper. It was a difficult period for the press photographer, who had to produce excellent work to get a job. The forties was a period of no excuses — either you had it or you didn't.

The 1950s was a great decade for the press photographer. During that period, the new word *photojournalism* became more common across the country. Newspapers gave photographers big spreads, and *Life* and *Look* magazines were in their prime. Visual reporting of people and events became an important part of the news process. Competition was fierce among photographers and spurred on the development of the art.

During the 1950s television's news coverage of current events increased. Still photographers had to overcome the public's fascination with moving pictures. The still picture had to be better in order to get attention. It had to have impact and drama. I think that the fifties produced imaginative photojournalists who had skill and creativity.

The 1960s was a decade of frustration and confusion over the direction a new breed of photographers would take. It was the do-it-yourself era. Photojournalists wanted a new approach that, at times, led to disaster with editors. Their equipment consisted of wide-angle and telephoto lenses. They were interested more in art-type pictures than informative ones. More silhouettes and sunrise-sunset pictures were taken than ever before. Close-up head shots,

Woody Hayes, football coach for Ohio State University and explosive figure in college sports, stood on the field during this game with the University of Michigan. This, of course, is illegal, but no one except me noticed. (600mm lens)

even cutting off tops of heads, and extreme wide-angle views were their favorite approaches. They meant well, and by the late sixties they really started to get involved in what photojournalism is all about — people and events.

The photojournalists of the 1970s incorporated all the styles and techniques of the past decades. Photographers graduated with degrees from universities. The photographic opportunities became much greater in the art of photography. This truly was the halcyon period in the making of good photojournalists.

The world has need of a universal language, and photographs can speak to everyone. The spoken word and the written word can be understood, but there is always the barrier of different languages. None of this is true of a photograph. Even primitive people are fascinated by a picture, although everything in the image might be different from anything they have ever known.

Since its invention in the early 1800s, the camera has become a tool with many uses — in communications, in business and industry, in government, in education, and in the home. For years there has been controversy over whether photography is an art or a science. The answer is, it can be both.

The camera today is used in all aspects of life. Some use it to record events, while others see it as a means to exert their creative and imaginative impulses upon their environment. Both uses are legitimate, but the former will probably lend itself to the view of photography as a science and the latter to the view of photography as an art.

As a science, photography involves understanding the technical and mechanical operation of the camera as well as the films and chemistry used. As an art, it allows one to interpret the subject matter. Those who use photography only as a science fail to realize that often a thousand personal decisions are made before the shutter is snapped.

Mr. John Szarkowski, director of photography at the Museum of Modern Art, stated: "Photography is a picture-making system; it has therefore been natural to compare it to older picture-making systems, especially to painting, which has a very old and honorable history. In this comparison, it has not been difficult to point out the ways in which painting is different and, by presumption, better. Most of these arguments revolve around two central points: first, the painter can synthesize one picture out of a thousand discrete bits of perception, imagination, and traditional skills and schemes, while the photographer's art is not synthetic but analytic, and depends fundamentally on perception."

Photography has come a long way and is now being appreciated by museums, galleries, and publishers throughout the world. Cornell Capa, founder and director of the International Center for Photography in New York City, has recognized the work of creative photographers and photojournalists and provided space where they can display their photographs.

In closing, I would like to say, always remember the ABC's of photography: "A" for *attitude* and *approach* to the subject; "B" to put the *best* of your technical skills into every picture you take; and "C" for creativity, composition, and full caption material. Pictures without information and identification are pictures torn from

their journalistic context — images in a void.

There is no question that photography can now stand on its own as the interpreter and recorder of our civilization. There is no substitute for the photograph. Let us not forget those who have made vast contributions to the advancement of photojournalism in the past, those who are at present working for the betterment and recognition of our profession, and those who will continue on and incorporate many of our ideals with theirs, knowing that photography has found a respectable place in this world of ours. So we leave to the historian a visual record — the photograph, the true visual recorder of history.

An aerial shot of "My Sweetie" winning the Gold Cup Race.

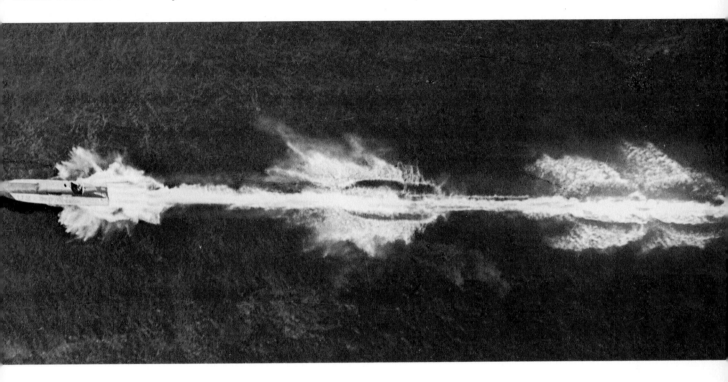

Index

Edited by Judith Royer
Designed by Brian D. Mercer
Text set in 11-point Century Schoolbook